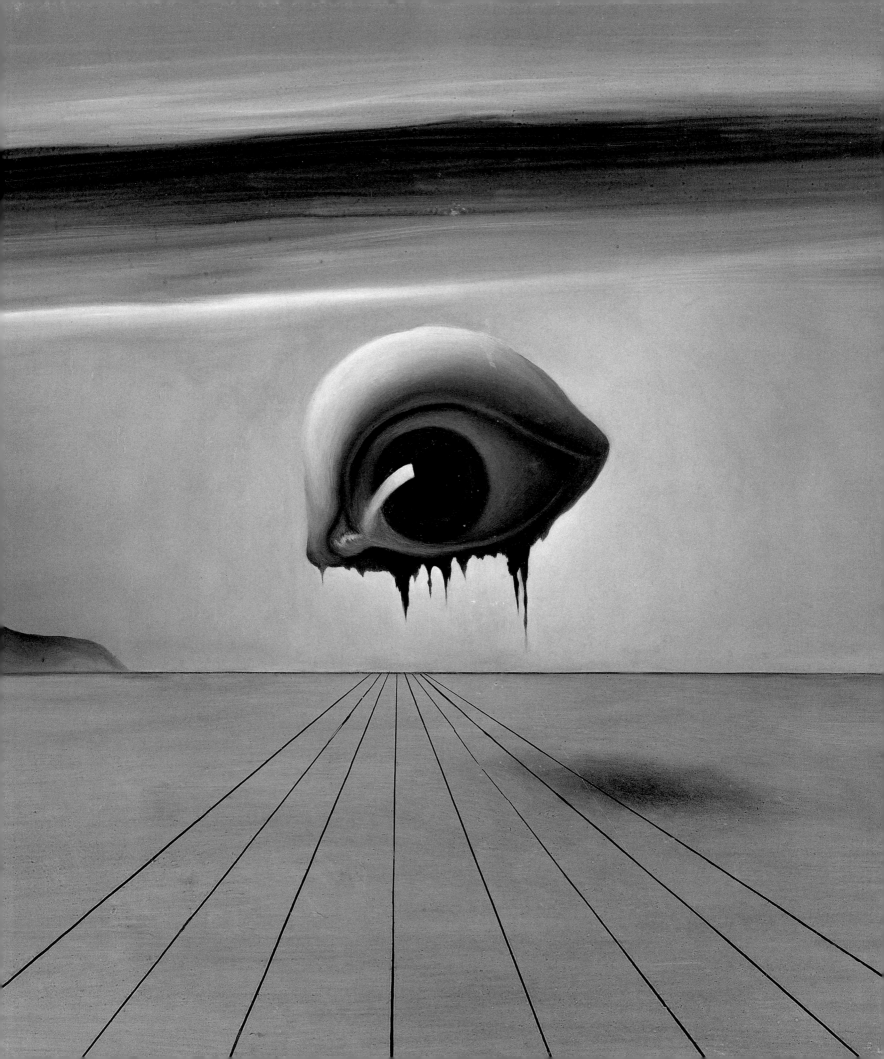

Dalí's Optical Illusions

Edited by Dawn Ades

Wadsworth Atheneum Museum of Art
in association with Yale University Press
New Haven and London

This exhibition is made possible by United Technologies

Organized by the
Wadsworth Atheneum Museum of Art
Hartford, Connecticut

Wadsworth Atheneum Museum of Art
January 21 – March 26, 2000

Hirshhorn Museum and Sculpture Garden
April 19 – June 18, 2000

Scottish National Gallery of Modern Art
July 23 – October 1, 2000

The exhibition is supported by an indemnity from
The Federal Council on the Arts and the Humanities

Designed by Cummings & Good
Typeset in Monotype Walbaum
Printed in Singapore on Lykem matt 150 gsm

Library of Congress Cataloging-in-Publication Data
Dali, Salvador, 1904-1989
 Dali's optical illusions / edited by Dawn Ades
 p. cm.
 Catalog of an exhibition held at the Wadsworth Atheneum,
Hartford, Conn. Jan. 21–Mar. 26. 2000, the Hirshhorn Museum
and Sculpture Garden, Washington, D.C., Apr. 19–June 18, 2000,
and the Scottish National Gallery of Modern Art, Edinburgh,
July 23–Oct. 1, 2000.
 ISBN 0–300–08177–4 (hardback; alk. paper)
 1. Dali, Salvador. 1904–1989 Exhibitions. 2. Optical Illusions
in art Exhibitions. 3. Visual perception Exhibitions. I. Ades,
Dawn. II. Wadsworth Atheneum. III. Hirshhorn Museum and
Sculpture Garden. IV. Scottish National Gallery of Modern Art.
V. Title.

ND813.D3A4 2000
709'.2—dc21 99-38348
 CIP

Cover Illustration (front):
Detail, cat. 31
Apparition of Face and Fruit Dish on a Beach, 1938
Wadsworth Atheneum

Cover Illustration (back):
Cat. 31
Apparition of Face and Fruit Dish on a Beach, 1938
Wadsworth Atheneum

Frontispiece:
Detail, cat. 47
The Eye, 1945
Private Collection

Contents

Director's Foreword

One of the most popular artists of the twentieth century, Salvador Dalí continues to appeal to modern audiences not only for the fascination of his dream-like private symbolism, but also his expressive manipulation of reality and keen sense of pictorial surprise. Although his art is regularly displayed in museums and galleries, this is the first exhibition ever devoted to Dalí's interest in optics and an exploration of the rich variety of his visual perception and illusionism. A central concern of his art throughout his career from the late twenties until his death in 1989, optical illusionism took many forms in Dalí's work: distortions of form and perspective, anamorphism, double images, pointillism, stereometric imagery, photography and cinema, even holograms. The exhibition surveys his interests in illusionistic techniques in various forms and media, and examines how illusionism was used to expressive effect in his personal approach to Surrealism.

We have been very fortunate to have the expert insight and advice of Professor Dawn Ades of the University of Essex in the conception and organization of the exhibition. Professor Ades has served as the primary author of the catalogue and intellectual guide for the show. However the exhibition could not have been realized without the understanding and enthusiastic support of the Salvador Dalí Museum in St. Petersburg, Florida, its Director, Marshall Rousseau, the Fundació Gala–Salvador Dalí in Figureres, Spain, and its Director, Antonio Pitxot. We are also very grateful to Mr. Pitxot and Montse Aguer for sharing the former's personal recollections and observations about Dalí, here published for the first time.

The exhibition's première at the Wadsworth Atheneum is a fitting millennial celebration of the institution's early commitment to Salvador Dalí and his art. As Eric Zafran's essay explains in detail, the Atheneum was the first museum on either side of the Atlantic to acquire a work by Dalí, hosted the artist when he visited Hartford on several occasions, and, through the advocacy and promotion of its farsighted Director, A. Everett "Chick" Austin, played a pioneering role in the introduction of Surrealism to North America with the exhibition *Newer Super-Realism* in 1931. It was in the Atheneum's theater that Dalí first uttered his famous proclamation, "The only difference between me and a madman is that I am not mad." The organizing institution for the exhibition, the Wadsworth Atheneum, is delighted to share the show with the Hirshhorn Museum in Washington, D.C., and the Scottish National Gallery of Modern Art, Edinburgh, and expresses its special gratitude to their respective Directors, James T. Demetrion and Richard Calvocoressi.

All three institutions are profoundly indebted to the many private and institutional lenders to the show, without whose sacrifice and understanding the exhibition could never have come to fruition.

At the Wadsworth Atheneum we wish to thank all of the staff and especially Eric Zafran, Cecil Adams, Alan Barton, Heather Darby, Susan Hood, Betsy Kornhauser, Dina Plapler, Matthew Siegal and Nicole Welsh Wholean.

We are also deeply grateful to our sponsor at the Wadsworth Atheneum, the United Technologies Corporation, which is one of the most enlightened benefactors of the art world. Additional support has been provided to the Wadsworth Atheneum by the Beatrice Fox Auerbach Foundation and the Edward C. and Ann T. Roberts Foundation. Delta Air Lines is the preferred airline of the Wadsworth Atheneum, and the Hilton Hartford is its preferred hotel. The exhibition is also supported by an indemnity from the United States Federal Council on the Arts and Humanities.

At the Hirshhorn Museum and Sculpture Garden, major support has once again been provided by the Holenia Trust in memory of Joseph H. Hirshhorn.

The exhibition at the Scottish National Gallery of Modern Art has been supported by the Dunard Fund.

Peter C. Sutton
Director, Wadsworth Atheneum Museum of Art

Lenders to the exhibition

Buffalo, Albright-Knox Art Gallery
Edinburgh, Scottish National Gallery of Modern Art
Figueres, Fundació Gala–Salvador Dalí
Hartford, The Wadsworth Atheneum Museum of Art
Madrid, Fundación Colección Thyssen-Bornemisza,
 Museo Nacional Centro de Arte Reina Sofia,
Milwaukee, The Patrick & Beatrice Haggerty
 Museum of Art, Marquette University
New Haven, Yale University Art Gallery
New York City, The Metropolitan Museum of Art
Ottawa, National Gallery of Canada
Philadelphia, Philadelphia Museum of Art
Rio de Janiero, Museu Chacara do Ceu.,
 Museus Raymundo Ottoni de Castro Maya
Rotterdam, Museum Boijmans Van Beuningen
San Diego, San Diego Museum of Art
St. Petersburg, Museum of Fine Arts,
 Salvador Dalí Museum
Utica, Munson-Williams-Proctor Institute
 Museum of Art
Venice, Peggy Guggenheim Collection (Solomon R.
 Guggenheim Foundation, New York)
Washington, D.C., Smithsonian Institution:
 Hirshhorn Museum and Sculpture Garden
and private collectors who wish to remain anonymous

Acknowledgments

The organizers of the exhibition and the authors of the catalogue are indebted to many people who have been generous with their help and advice.
At The Hirshhorn Museum and Sculpture Garden:
James T. Demetrion, Director; Neal Benezra, Assistant Director for Art and Public Programs; Judith Zilczer, Curator of Paintings; Carol Parsons, Special Assistant.
At the Scottish National Gallery of Modern Art:
Timothy Clifford, Director; Richard Calvocoressi, Keeper; Patrick Elliott, Assistant Keeper; Janice Slater, Assistant Registrar.
At the Salvador Dalí Museum, St. Petersburg:
T. Marshall Rousseau, Director, Joan Kropf, Curator of Collections; William Jeffett, Curator of Exhibitions; Dirk Armstrong, Preparator.
At the Fundació Gala–Salvador Dalí, Figueres:
Antonio Pitxot, Director; Lluis Penuelas Reixach, Secretary General; Montse Aguer, Curator; Jordi Falgas, Copyright Department.
Individuals:
William Acquavella, Vera de Alencar, Susanna Allen, Don Bacigalupi, Ida Balboul, Laura F. Catano, Curtis L. Carter, Joseph S. Czestochowski, Chris Dercon, Douglas Dreishpoon, Paloma Esteban, Michael Findlay, Wayne Finke, Marta Gonzalez, Jose Guirao, Anika Guntrum, Anne d'Harnoncourt, Piet de Jonge, Tòmas Llorens, Roxana Velasquez Martinez del Campo, Michael Milkovich, Philippe de Montebello, David Norman, Jock Reynolds, Debora W. Ryan, Philip Rylands, Douglas G. Schultz, Paul D. Schweizer, Daisy Stroud, Ann Temkin, Pierre Théberge, and Jonathan Vickery

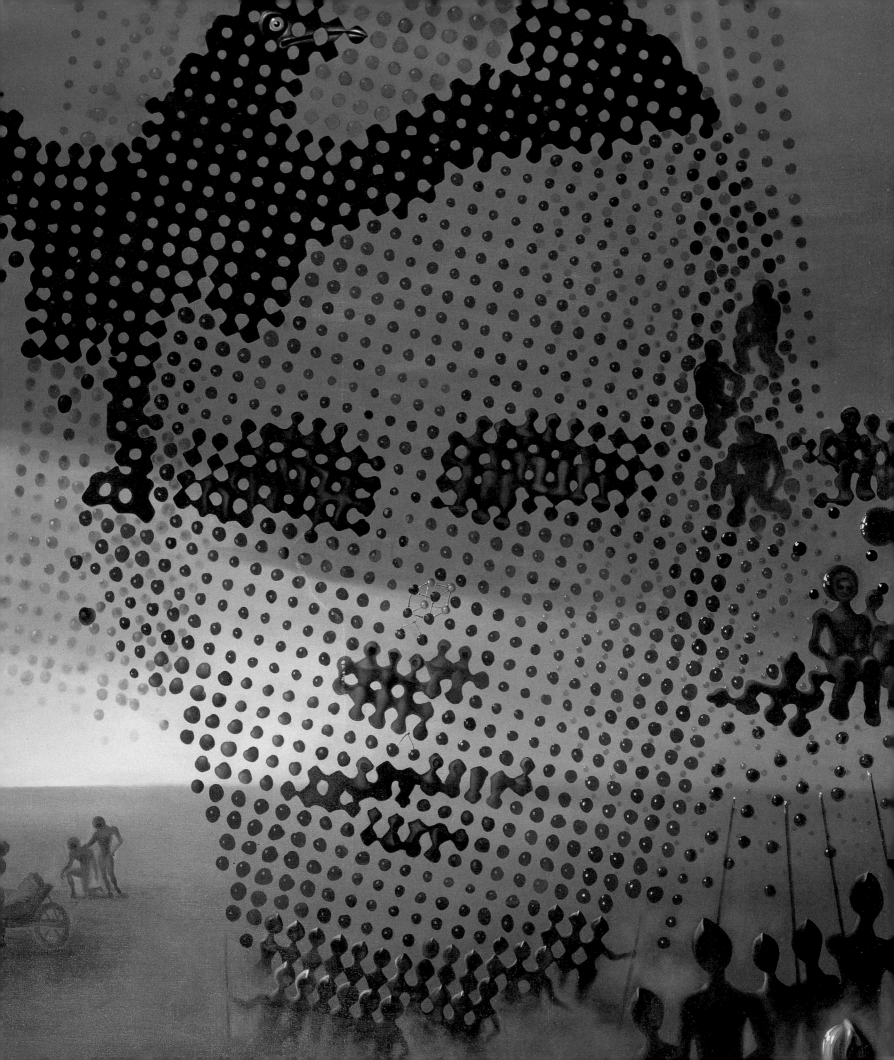

Sponsor's Foreword

Dalí's paintings are among the most recognizable and least understood works of art this century. Certainly they are memorable. These dreamlike images exemplify modern art, and especially Surrealism, for most museum visitors. His experiments with optical illusions and perspective attract *and* repel. Creativity and originality are evident throughout this exhibition. We are delighted to bring these exceptional skills to a wide and, we believe, most interested audience.

George David
Chairman and Chief Executive Officer
United Technologies Corporation

Detail, cat. 57

Dalí's Optical Illusions

Dawn Ades

"A natural perspective,
that is and is not."
Twelfth Night

Sigmund Freud was one of many who have been dazzled, whether in admiration or with disapproval, by Dalí's virtuosity as a painter. By contrast with both modernist and surrealist painters who have tried to unlearn skills in the interests of the spontaneous and the idea of an authenticity of innocence, Dalí unashamedly displayed his gifts and his technical learning as a painter. But about this Dalí was himself ambivalent. The relationship between his ever-increasing command of optical and representational devices and his purposes as an artist was a complex matter.

In late conversations Dalí scorned his own abilities, saying of his pictures that "They don't count pictorially. They're badly painted… If you compare me with any classical painter whatsoever then I'm an absolute nonentity."[1] But his confession — for someone not given to modesty — that he would be incapable of "doing even a mediocre copy of a canvas by Bouguereau or Meissonier"[2] — was made in the full awareness that these nineteenth-century academic painters were the most reviled by twentieth-century artists; no-one else was even trying to emulate them, and moreover if Dalí described his pictures as badly painted, they were still in his estimation and by these unregarded standards incomparably better than anyone else's. The models against which he later measured himself were Vermeer, Velázquez, Raphael and Leonardo. This line of enquiry, in these terms, is a dead end; what mattered in the deployment of skill was its purposes and possibilities. For Dalí "the pictorial means of expression are concentrated on the subject"[3] — not to be wondered at for their own sake.

The pleasure, though, that Dalí took at that baptismal moment in 1929, when he both entered the surrealist movement and a life-long relationship with his future wife Gala, in painting "such tiny things so well, and even better when enlarging them"[4] was a cause of hesitation for the surrealists. Breton, in this ambiguous praise, was weighing up Dalí's pride in painting, among the other "fleas" (or flaws) in his personality (such as his pride in Catalonia and Spain which affronted the surrealists' anti-nationalism), against his unrivalled powers of "voluntary hallucination" and mental liberation. Technical ingenuity or even visual pleasure for its own sake was suspect for the surrealists. There was basic agreement with Dalí that painting should be at the service of an exploration of the labyrinths of the mind, unconscious and conscious. But whereas for them the visual means were ideally meager or transparent — the rudimentary record of a dream, chance gestures, found objects — Dalí increasingly persuaded himself of the imperative to make his paintings as convincing, deceptive and illusionistic as possible. His aim, put crudely, was to give form to the formless and invisible, to dreams, reveries, delusions, desires and fears. His ambition, both in what he was aware of depicting and what remained fortuitous and concealed was to make the world of the imagination "as objectively evident, consistent, durable, as persuasively, cognoscitively, and communicably thick as the exterior world of phenomenal reality."[5] His desire to give substance to the phantoms destined always to remain virtual led to one of the most sustained investigations into the relationship between vision, perception and representation of the century.

To make the irrational concrete was not a matter of illustrating fantasies. Dalí's text *The Conquest of the Irrational* rewards close attention, not least for the conflicting attitudes it reveals to his own work. Impatience and frustration both with its powers and its shortcomings are evident in his verbally abusive comments on "clever tricks," "abjectly *arriviste* and irresistible mimetic art," and "analytically narrative and discredited academicism." While abasing these practices he simultaneously elevates them as part of his pictorial armory. The two main representational modes he annexes here for his own practice

are color photography and what he calls "great realist painting – Velázquez and Vermeer de Delft." These should not be elided – both are regarded as analogies to his own practice as well as resources for a particular kind of materialization of his ideas. It is not a matter of "painting photographically," although "precision" is the aim, for the materialization can only be within and through the process of making an image.

The photographic model for Dalí is that of instantaneity, a sudden and total but hitherto unknown image. The special resources of painting, on the other hand, are to do with texture, light, tone, perspective, scale – manipulable, associative and suggestive. On both of these models Dalí was to draw, linking and expanding both of them in conjunction with the "discoveries" of modern science.

The gap between Freud's appreciation of Dalí and the painter's anticipation of their encounter is poignant and also highlights the difficulty of the role that Dalí intended painting to play. Dalí had taken with him to show Freud his *Metamorphosis of Narcissus*, fully cognizant of Freud's work on the subject of Narcissism and prepared to explain his intentions with all the eloquence of his own poem on the subject, and also his article on paranoia from *Minotaure* (probably "Interpretation paranoiaque-critique de l'image obsédante 'L'Angélus' de Millet"). Freud, old and sick, was also suffering that day from hearing problems; instead of listening to Dalí, he watched him. Afterwards he thanked Stefan Zweig for bringing the young Spaniard "with his candid fanatic's eyes and his undeniable technical mastery,"[6] who led him to revise his low opinion of the surrealists. But Freud's assessment of Dalí was based on a double misapprehension: firstly of the nature of his "technical mastery," and secondly of the consequences of Dalí's familiarity with psychoanalysis. Freud found that Dalí's "mystery was manifested outright," that he had done the work of analysis for himself, and thus that his paintings were the result of conscious rather than unconscious thought. For Freud, the interest of a painting or work of literature lay in what it revealed unconsciously of the mechanisms of dreams or neuroses, though he admits that it "would be most interesting to study analytically the genesis of a picture of this type."[7] Whether this made of Dalí's paintings more or less of a "psycho-pathological document" in Freud's view is

unclear, but it is evident that he misprised Dalí's pictorial ambitions and creative use of psychoanalytical ideas. However cognizant of the ideas of psychoanalysis the painter might be, the pictorial mechanisms by which they are made manifest remains a matter for invention. Moreover psychoanalysis is only one of many sets of ideas cannibalized by Dalí. "The new frenzied images of concrete irrationality tend toward their real and physical possibility." They go beyond the domain of psychoanalyzable "virtual hallucinations and manifestations."[8]

Although Dalí was one of the most prolific of twentieth-century painters, he has, curiously, much in common with one of the most restrained and fastidious, Marcel Duchamp. Both rejected the idea that painting should address itself only to the eye – the dominance since Courbet of the "retinal frisson" as Duchamp called it[9] – while at the same time exploring purely optical phenomena as part of an investigation into the complex nature of perception. To re-engage visual art with the mind and with human experience as a whole runs counter to the idea of the autonomy of visual experience that has by and large conditioned modernism. Both artists also envisaged a close dialogue between their writing and their visual work, another divergence from modernist orthodoxy. Dalí was, in fact, as prolific and diverse a writer as he was an artist,[10] and his writings both undermine the idea of the autonomy and self-sufficiency of the paintings, and reveal his ideas about the problems and possibilities of art and visual representation in a mechanical and post-Freudian world subject to scientific rather than metaphysical definitions.

Dalí regarded himself as "swimming between two kinds of water, the cold water of art and the warm water of science."[11] His work was sustained by an omnivorous and eclectic curiosity in contemporary science: physics, genetics and mathematics, and a passion for observing the natural world and especially insect and marine life. His interests in the field of optics, of perception, of vision and the visible also brought his art into conjunction with science. Dalí was, though, deeply skeptical of the claims of rational science to explain the real.

The world of logical and allegedly experimental reason, as nineteenth-century science bequeathed it to us, is in immense disrepute. The very method of knowledge is suspect. The equation has been formulated by skipping

over the unknowns… In the end it will finally be
officially recognized that reality as we have baptized
it is a greater illusion than the dream world.[12]

These "unknowns" would have included the relations
between eye and brain, dream and the unconscious, as
well as the physical nature of the universe. From the
perspective of an amateur scientist the latitude for imagi-
native speculation, the possibilities of giving visual form
via the analogical and symbolic to invisible structures,
forces and motions seemed immense. He liked to say that
"fifteen years before Crick and Watson I drew the spiral
of the structure of DNA (the basis of all life),"[13] and
claimed that he was "capable of conceiving the disconti-
nuity of matter by watching flies fly and understanding
the significance of their Brownian movements."[14]

The surrealists underpinned their objection to the
narrow definition of "reality" as it was understood
under the auspices of rationalism and the "reign of
logic" with the ideas of the new science of psycho-
analysis, which they felt had proved beyond doubt the
existence of an extended psychic reality. The mind
contained, as Breton argued in the first *Surrealist
Manifesto*, hidden forces manifested in such things as
dreams, parapraxes and neuroses which are a no less
real experience for the human subject than that of the
external world. Surrealism was a significant part of a
more general movement not only in psychoanalysis but
also in physiology and physics itself that questioned the
empirical foundations of knowledge and sought to under-
stand the concealed mechanisms that condition reality.

It is now generally accepted that the "reality" of the
object world as given to us by immediate experience is
misleading; the "real" character of color, or of matter,
for example, are not derivable from optical or tactical
principles. The incredible speed and complexity of per-
ception gives us knowledge of our own sensations, but
its relation to consciousness, let alone the unconscious, is
still little understood. The fallibility of perception and
the strange role of illusion have been studied equally
avidly by physiologists, psychologists and psychoanalysts.
But the role of memory, of association, and of cultural
patterning in what we see, or the eruption of hypnagogic
images as we fall asleep, or the delusional readings of the
world in paranoia – and here we are squarely in terrain
appropriated by Dalí – remain largely unexplained.

The long pursuit in pictorial representation of
methods of deceiving the eye to persuade it of the
"truth" of what it sees, and the invention of technolo-
gies to replicate the visible world as accurately as
possible always existed in some relation to an idea of
"reality." In the twentieth century it could be said
that "reality" has been sought in the hidden mecha-
nisms of psychic and political life, in what is concealed
rather than revealed. In consequence, the status of the
"visual" has been rendered problematic, even devalued.
Modernism in art is concerned with the abstract, the
formal, the conceptual, the pure material object.
Surrealism alone has systematically sought the inter-
face between internal and external realities, illusion
and vision, perception and thought.

Dalí confronted this problem with energy, not just
in his construction of an iconography rooted in psycho-
analysis but in a closely linked and wide-ranging
exploration of the affective relations between perception,
vision and optical effects. This exploration was con-
ducted both in his extensive writings, and in paintings,
photography, photomontages, collages, films, prints, the
construction of objects, and installations. "Experiment"
is a term frowned on in the context of modern art,
with its connotations of a future aim, a search, not
necessarily achieved, which consorts badly with artistic
practices that value the medium, or accept the found,
in their own right; as Picasso is often quoted as saying
"I never seek, I only find." But Dalí undoubtedly con-
ducted what we and he would understand as visual
experiments, especially towards the end of his life with
holograms and stereoscopy. He also explored the laws
and possibilities of perspective, which "even today poses
unresolved problems,"[15] and the technological inventions
in the photographic field, which provided him with some
of his most sustained and flexible resources.

Photography

In the early decades of the twentieth century photog-
raphy began to be valued not as a reflective but as a
revelatory mechanism. A persistent but theoretically
awkward current began to link it to the idea of an
unconscious, even if metaphorically. André Breton

described automatic writing as a "true photography of thought," and went on in the same 1921 text to recognize a new reality through the camera:

> As the use of slow motion and fast motion cameras becomes more general, as we grow accustomed to seeing oaks spring up and antelopes float though the air, we begin to foresee with extreme emotion what this time-space of which people are talking may be. Soon the expression "as far as the eye can reach" will seem to us devoid of meaning, that is, we shall perceive the passage from birth to death without so much as blinking, and we shall observe infinitesimal variations.[16]

Very early in his career, before making the definitive move to Surrealism, Dalí began to argue for a distinctive role for photography in its capacity to surprise and reveal the unknown or unseen, what Walter Benjamin was later to call its "unconscious optics."[17] Dalí was indebted to Moholy-Nagy, who wrote in *Painting Photography Film:* "The photographic camera [can] make visible existences which cannot be perceived or taken in by our optical instrument, the eye,"[18] and borrowed his examples. For Moholy-Nagy microscopic photography, close-up enlargements, long exposure, X-rays, the instantaneous arrest of movement were the beginning of "objective vision" (fig. 1). Dalí on the other hand perceived the extraordinary register of a new world provided by such photography, not in terms of a futurist utopia of a mechanical device supplementing and complementing man, but of a new poetic medium which would capture the "most delicate osmoses which exist between reality and surreality."[19] He was evidently contemplating, if initially rejecting, a comparison with the unconscious – "Photographic imagination! More agile and rapider in discoveries than the murky subconscious processes!"[20] – but welcomed photography's capacity for total invention and "the capture of an unknown reality."[21] We are in 1928, and Dalí is still testing out his responses to Surrealism, joining the movement the following summer.

By then, he and Buñuel had fully justified the camera as a poetic instrument at the service of Surrealism in their film *An Andalusian Dog,* made in the spring of 1929 (fig. 4). This caused a sensation in Paris avant-garde circles, totally unlike as it was the kind of experimental abstract film then in vogue. *An Andalusian Dog* makes use of close-ups, slow motion, superimposition, montage

Fig. 1
Renger-Patzsch, photograph from Moholy-Nagy
Painting Photography Film
Bauhaus Book, 1925

and fades but always linked concretely to the imaginary, dreams and desires of the protagonists.

Dalí's earliest memory of the magical power of moving pictures was an "optical theater" that he saw at the age of seven in the private study of his ancient school teacher. This must have belonged to the family of scientific optical toys invented during the latter part of the nineteenth century in that urge to add movement to the photographic capturing of "reality" that also produced the cinema. But despite the detailed descriptions in his autobiographies, its exact identity is unclear. The stroboscope, phanakistoscope, and zoetrope all produce the illusions of a moving image, but as Dalí persists in calling it "stereoscopic," it must also have produced the illusion of three-dimensionality: "a kind of stereoscope that took on all the hues of the prism and ran moving

pictures before your eyes,"[22] and again "The pictures themselves were edged and dotted with colored holes lighted from behind and were transformed one into another in an incomprehensible way that could be compared only to the metamorphoses of the so-called 'hypnagogic' images which appear to us in the state of 'half-slumber.'"[23] It may have been the Stereophantoscope, which "Helmholtz described as using 'revolving stroboscopic disks…in the panoramic stereoscope' to create wide-angle views of moving forms in three dimensions."[24] Dalí returned later to stereoscopy himself, but the images of this magical theater had another significance: among them was one of a little Russian girl swathed in white furs, riding in a troika and chased by wolves with phosphorescent eyes. "She was looking out at me,"[25] Dalí remembered, and so strong was the sensation that not only was he looking at her, but that she returned his gaze that this image took on a determining role in his life, and Dalí was to identify it with his Russian wife, Gala, whom he met in the summer of 1929 when she and a party of surrealists visited him at Cadaques, and was to remain his lifelong companion.

The invention of the stereoscope, and of subsequent attempts to create three-dimensional effects in the cinema like Todd–AO, were aimed at producing some of the functions of binocular vision. Stereoscopes, with two lenses through which the viewer looked at two photographs of the same image which magically sprang into three-dimensions became all the rage after the Great Exhibition of 1851. Dalí began to experiment with stereoscopic paintings in the early 1970s, possibly prompted by the three-dimensional construction of a sequence of double images in the "Mae West Room" in his museum in the former Figueres theater. However, it could also be said that the doubling or repetition of images in separate configurations within paintings, which had taken various forms – for example in the *Metamorphosis of Narcissus* where the youth is echoed by the matching form of a bony hand was a precedent to the actual stereoscopic image.

He painted pairs of pictures, virtually identical, and some of enormous scale, which when viewed from the correct distance, using mirrors or a specially constructed lens, would produce a three-dimensional image. One of the very few other artists interested in this field of optical effects was Marcel Duchamp, who altered a pair of found stereoscopic photographs, in his rectified ready-made *Handmade Stereopticon Slide* (1918–19).

The camera was a continuous adjunct to Dalí's activities, and he was on several occasions to become involved in films, such as Hitchcock's *Spellbound* (fig. 5), but the invention of the hologram appeared to open a new dimension. In 1972 an exhibition of Dalí's first holograms was held at the Knoedler Gallery in New York. Dr. Dennis Gabor, who contributed a note to the catalogue, had "formulated the concept that coherent light, illuminating an object, could be captured on plate coated with photographic emulsion."[26] Gabor explained that in the first stage of holography objects and scenes "viewed through the resulting holographic plate of film, which itself is invisible, appear in natural size, in three dimensions, and can be viewed from any side, but only in one color."[27] Following the development of the laser, the "first true holograms [were made] using a laser as a light source."[28] But taking photo-realism to its final possibilities in this form was perhaps just to deliver art to the threshold of spectacle, without any real interaction with perception. The application of laser technology has been in other fields (medicine, communications, etc); as Robert Hughes said at the time "The house may be new, but the cupboards are empty. The images are banal…"[29]

When, after making *An Andalusian Dog*, Dalí returned to painting, it was to integrate it with photography in various novel ways. Firstly, he began to incorporate collage elements, but not as hitherto in works like *Female Nude* by adding sand or gravel, nor as in Ernst's collages and photomontages where dismembered fragments are recombined to create disorienting landscapes and interiors. Dalí added photographs, prints or stencils to the painted surface in such a way that they become virtually indistinguishable from it. Although the tiny photograph of himself in *First Days of Spring* (fig. 2A) at the center of the image has its own reality, on the whole the pasted fragments are absorbed into but also set the key for the "photographic" illusion of the painted image.

In the early thirties Dalí began to paint more directly from photographs, sometimes borrowing motifs in a general way, sometimes mimicking the photographic image. Several paintings of Gala, as in *Cardinal, Cardinal!* (cat. 16), don't attempt to disguise their source, but announce themselves as "hand-done color photography."[30]

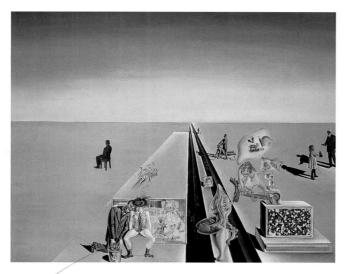

Fig. 2
Salvador Dalí
The First Days of Spring, 1929
Salvador Dalí Museum, St. Petersburg, Florida

Fig. 2A
Detail: *The First Days of Spring*

Dalí often incorporated precisely observed objects from the natural world; his personal pantheon included sea urchins, shells, sea anemones, flies, stones, bones and skulls. This he supplemented with microscopic photographs especially of marine organisms, such as those used by his friend Matila Ghyka to illustrate *The Geometry of Art and Life* (fig. 3). The extraordinary symmetries and patterns of these organisms appear for instance in *The Virgin of Guadalupe* or the *Ascension* of 1958 (cat. 56).

Photography was only part of his optical armory, however, and he remained always a painter, dedicated if perversely to the eye. He told an "interviewer":

> *"I bear with me a precious apparatus which I invented two months ago and by means of which I will realize the greater part of my new pictures. Rather than a horrible, hard and mechanical photographic apparatus, it resembles a minuscule and tender apparatus of television in color. But the most wonderful thing! It is entirely soft!" And as I looked at him with stupefaction, he added: "Yes! An eye!"* [31]

Sights and lights produced by the irritation of the retina were among Dalí's earliest memories. In a childhood game he used to get down on all fours and

> *swing my head left and right until it was gorged with blood and I became dizzy. With eyes wide open, I could see a world that was solid black, suddenly spotted by bright circles that gradually turned into eggs fried "sunnyside down." I was able to see a pair of eggs in this condition, which my attention followed, as if in hallucination… I felt that I was at the source of power, in the cave of great secrets.* [32]

Fig. 3 (right)
Ethmosphaera conosiphonia, from D'Arcy Thompson
On Growth and Form, fig. 58; skeleton of a microscopic organism of the "Radiolaria" group

Although Dalí here is overlaying an intense child-
hood experience with his later fantasies of a return to
the womb, the merging of the physical experience of a
blackness from behind the eyes with the prenatal uncon-
scious is characteristic of his organicist approach to the
eye and the mind. The eggs, however, reappear in various
guises in his paintings, symbolizing both fetus and sun.

In Dalí's drawings for the dream sequences of the
film *Spellbound*, the physical and even repellent aspect
of the eye, as in *An Anadalusian Dog*, is shown (figs. 4, 5).
"What is this eye? A glob of humors, a knot of muscles,
a film of flesh and nerves irrigated by a flow of acid?
Beneath that appearance lurk galaxies of microscopic
electrons, agitated by an impalpable wave, itself the
fluid of a quasi-immaterial energy. At what level, then,
the real?"[33] The fantasy not just of control over the
retina, but of piercing the psychological mysteries of
sight and perception by physiological means, fascinated
Dalí. In the 1960s he consulted a professor of optics,
Jayle, about inserting a kind of thin lens filled with
liquid into the eye which would register images during
sleep, to produce a kind of internal camera.

Perspective

Going against the grain of most twentieth-century art,
Dalí looked back to perspective theories and practices
of the sixteenth and seventeenth centuries for ideas. He
was thus to offend modernists by having recourse to
what seemed to reek of antiquated picture-making, as
well as by utilizing popular visual illusions like hologra-
phy. He was intrigued, like Marcel Duchamp, by the
artifice of the various types of perspective construction
as well as by the imagery in which these were couched
in the treatises on perspective. These are often quite
surrealist in character, as the mechanism often demands
the representation both of the scene or object to be
depicted and of the action of the artist in doing so.
Dürer's demonstration of an artist making a perspective
drawing of a nude using a transparent squared window
is one of the most famous, in which the nude is turned
to the viewer who sees her from the artist's viewpoint,
thereby producing a disjunction in the image. Sometimes
plates include a bewildering variety of figures observing

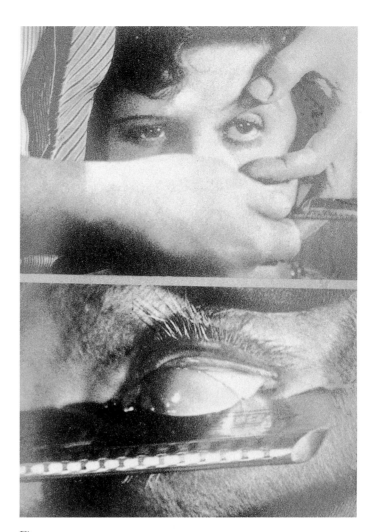

Fig. 4
Stills from Dalí and Buñuel's film, *An Andalusian Dog*, 1929.

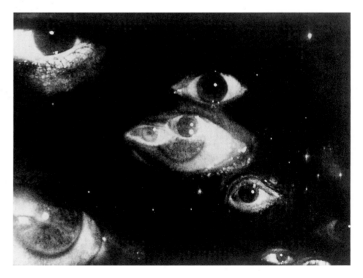

Fig. 5
Still from Hitchcock's film *Spellbound*, 1945.

objects from different viewpoints, or poised with strings attached to one eye representing the "rays" that shoot from the retina to corners of the picture plane (fig. 6), or reversed to represent the single vanishing point.

Dalí recognized that the sixteenth- and seventeenth-century theories of perspective were wrestling with the problem of marrying empirical observation of the natural world with the belief in a world beyond it. Reality, in other words, was a contestable issue, and such inventions as anamorphic perspective, as we shall see, posited a "hidden reality" which was to suggest analogies with the unknowable of the unconscious.

In the designs Dalí made for the dream sequence in *Spellbound* (cat. 47), the perspectively trapped eye recalls those floating organs in perspective treatises, which may symbolize the eye of God (fig. 7), as the hidden seer of the created world, or simply the ideal point from which the optical rays emerge. Other quite direct borrowings include the Cross in *Crucifixion* (*Corpus Hypercubicus*) (cat. 53), which resembles exercises in the perspective

drawing of three-dimensional geometric objects. Niceron, for instance, assembled his drawings of cubes into symmetrical figures that resemble a cross (fig. 8). Dalí's cross similarly is constructed of cubes (elongated by an additional one). Christ is thus shown suspended from the protruding cube, and this produces a collision between physical and metaphysical space.

At some point following his return to Port-Lligat after the war, Dalí had a glass floor installed near his studio, which enabled him to pose his models for the highly foreshortened figures in order to draw from life. He could position them either above or below the glass, depending on the required angle of sight. In the 1958 *Ascension*, he combines a viewpoint from below the glass floor for the male figure, while Gala is seen by contrast from directly above (cat. 56).

But on the whole for Dalí perspective was a means to create not the illusion of a real scene but the reality of illusions. He was to manipulate and distend its devices to construct violent spaces in which objects or

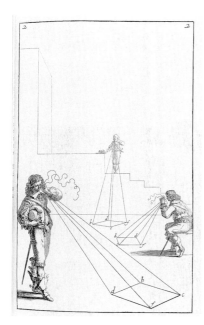

Fig. 6
Abraham Bosse
"The Masters of Perspective"
From *Manière universelle de M. Desargues pour traiter la perspective*, 1648.

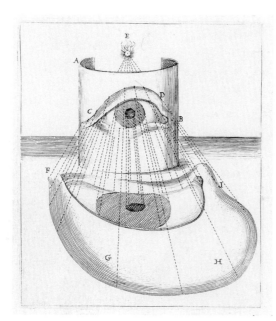

Fig. 7.
Mario Bettino (Bettinus)
Anamorphosis of an eye in a cylindrical mirror
From *Apiaria universae Philosophae*, Prog. 1, pl. 7.

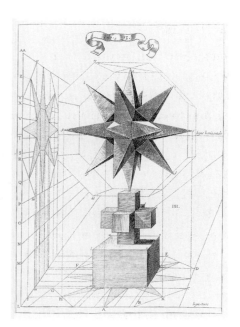

Fig. 8
J. F. Niceron, Star cube
Thaumaturgus Opticus
Paris 1646, pl. 13

figures are often exaggeratedly large or tiny, and whose distances appear vast but impossible to compute or to treat comfortably like a "window."

An early interest in perspective (c. 1925–26) forms a curious link between the divergent styles he was using at the time: on the one hand Cubism, and on the other a detailed Realism indebted to Vermeer and Spanish still-life painting (of which *Basket of Bread* is the culminating example). Drawings of this period with a centrally placed vanishing point (fig. 9) sometimes mix cubist distortion with the deliberate plotting of orthogonals. A visit to Picasso in Paris in 1926 produced some large-scale cubist paintings as well as a renewed interest in the neo-classical, which merge in an oddly defiant "homage to Picasso," the *Sleeping Woman* (cat. 1) in which flesh and drapery are sharply and violently defined with exaggerated receding edges in one of the first examples of the "accelerated perspective" that was to be such a striking feature of his surrealist paintings.

Accelerated perspective dramatized distance by contracting the diminution of scale and raising the horizon, and was a device often used in sixteenth-century theatrical scenery to create an illusion of depth on a shallow stage. In adopting this device on a rectangular two-dimensional canvas Dalí produces a perspective so emphatic as almost to caricature itself: "the clever tricks of a paralyzing foreshortening."[54]

Perspectival illusion is always cast as just that – the artificial creation of space. Like de Chirico, who constructs incompatible architectural vistas – buildings and arcades that do not obey the same perspectival imperatives – Dalí uses conflicting perspectives, but also creates greater ambiguities between settings and objects. In *Apparatus and Hand* (cat. 2), for example, he distorts the classic normal perspective which takes an eye-level horizon line, and fixes on it two points – a central point to which all parallel straight lines converge, and another point along the horizon line to which diagonal lines converge, at right angles from the spectator's viewing position. In *Apparatus and Hand*, neither the receding sides of the foreground platform (which meet in the very center of the picture), nor the lines of the geometric-pyramid figure relate to the horizon line, or to each other. The anthropomorphic geometric figure in the foreground, tottering on its spindly caliper-legs is thus seen from some higher position, which troubles the very idea of a single and unified viewing subject. The stacked cone and pyramid are an odd double parody, firstly of Miró's paintings, in which the set square served as sign for the female figure, and secondly of demonstration drawings in treatises on perspective of the treatment of three-dimensional geometric figures; the shadows they project supplement the perspective to set the figure in space (fig. 10).

Behind Dalí's use of conflicting and of accelerated perspectives lies a more fundamental disjunction. Renaissance perspective usually posited an architectural scene as the model for the secure pictorial space box within which coherent and consistent relations between objects could be established. Landscape painting was to produce its own softer rules for creating distance, including tonal changes and gentle diagonal progressions between foreground and distance. Dalí almost always takes landscape as his setting – specifically the bays and rocks around Cadaques, but then superimposes a

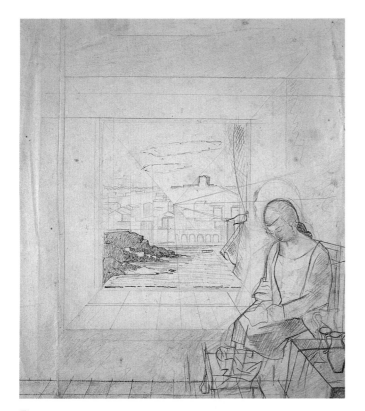

Fig. 9
Salvador Dalí
Study for *Girl Sewing*, 1926
Fundació Gala–Salvador Dalí, Figueres.

perspective schema devised with reference to controlled and finite architectural forms. Huge rectangular platforms or stepped terraces impose structures that should in principle be mathematically measurable onto a broad, virtually limitless landscape, as in *First Days of Spring,* (fig. 2) or *The Invisible Man* (cat. 6). Dalí engineers the transition between these differential spaces, or rather visually renders their incompatibility. The heterogeneity of place and space – walls, terraces, buildings defining the landscape rather than inhabiting it – creates a zone of ungraspable distances. As he said, "I am like the alchemist trying to apprehend the non-measurable through the measurable…"[35]

Shadows were an indispensable perspectival tool, and are a ubiquitous and active element in Dalí's visual vocabulary. He had studied the uses of shadow by de Chirico closely, but was also well versed in their more traditional uses in pictorial construction. Among the many books in Dalí's library on aspects of visual representation are several studies specializing on the effects of shadows (fig. 10), such as Jeaurat's *Traité de perspective à l'usage des artistes* which applies geometry to shadows cast by three-dimensional architecture and architectural forms.[36] Shadows normally are the means of confirming or denying the substantiality of objects, figures or architecture, but Dalí uses them in a variety of ways to exacerbate the conflict between perception and interpretation. Sometimes he withholds the shadow's affirmative mark, even so far as to discredit his own scrupulously rendered illusionistic depiction. In *Morphological Echo* (cat. 19), the skipping girl and the holed rock cast long evening shadows, but the architectural fragment in the foreground is shadow-less.

Length of shadows establishes diurnal or vesperal atmosphere as well as time of day. *Paranoiac-astral Image* (cat. 15) appears to vibrate with the dazzling light of the Mediterranean mid-day, in which shadows contract like snails into the objects. However, the striding man at the left casts a shadow out of proportion temporally speaking with the shriveled smudges under the boat and the bleached bone. This troubles our intuitive reading of an image that appears to have a coherent space-box perspectival structure and thus to depict a singular moment in time. The man is "later," or "earlier," than the other figures in the scene. He does not belong to their time.

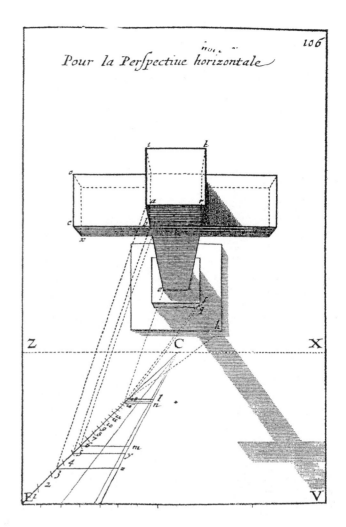

Fig. 10
E. S. Jeaurat
Traité de perspective à l'usage des artistes, pl. 106.

Shadows and the quality of light together produce distinctive atmospheres which Dalí associated with particular reveries: so the greenish light so often diffused through his paintings represents the "luminous transition" between pre-twilight and twilight, a time of day when as a child he regularly listened to the songs of the insects in the fields round Figueres, and imagined the far distant past of the planet, its tertiary age. The "dawn of the world" thus dialectically appeared to him as "crepuscular," what he called the "atavism of twilight," in which the "sentiment of extinction dominates everything."[37] The white light of *Paranoiac-astral Image* by contrast has a timeless, static, arid quality, which is disturbed by the walking man: together with the skull in the foreground the implication may once again refer

to the apprehension of vast time spans, perhaps this time future rather than past, a reversal of the "twilight atavism," but nonetheless with the intrusion of the finite and death.

Dalí alternates between shadows that are sharply defined and clearly attached to their causes and others that are hardly more than a blur or a darkening of the paint, and may not even have a perceptible source. In *Myself at the Age of Ten* (cat. 13) a shadow surges across the foreground of the canvas, partially but not wholly explicable by the table. This dark mass is uncanny because it is unclear whether it depicts a different material from the rest of the ground, or is a shadow cast by an unseen and formless presence occupying the space of the viewer.

Dalí's manipulations of perspective aim to produce the maximum "optical insecurity";[38] perspective, shadows, scale persuade and then undermine perceptual readings. This insecurity reinforces the anxiety, desolation, violence or desire often projected by the gestures and postures of the figures in the paintings; in destabilizing the position of the viewer, it also produces uncertainty about their identity. Viewer and subject become entangled in a dance of displaced positions, in which there is no clear resolution.

We situate ourselves in space by judging distance. If we cannot, we become disorientated. Dalí imagined someone gazing in a contemplative dream at a luminous point in the darkness, which is taken to be a star in the firmament, and suddenly discovers that it is no star but the lighted tip of a cigarette. But the dizzying alteration that follows the shattering of the illusion of deep space is not in his scenario a simple nor a permanent switch; the "cigarette tip" is then imagined as the sole visible element of a vast "atmospheric-anamorphic object" (fig. 11) whose history is immensely complicated but includes the skulls of Richard Wagner and Ludwig II of Bavaria.[39] In place of the alternatives of distance and proximity, what emerges is the formless, which leaves the human eye, the human subject in a limbo.

The "anamorphic" is a pervasive presence in Dalí's paintings, from the formless, spreading stains to slippery and engorged objects or limbs. Anamorphosis was a form of eccentric perspective, popular in the sixteenth and seventeenth centuries, in which an image that was severely distorted, but according to perspectival principles,

if seen "awry," became suddenly legible. The shapes presented to the spectator from a normal viewing point in anamorphic pictures ranged from something immediately legible (but open to an alternative reading) to the utterly formless. The effect of an apparently formless or illegible mass suddenly taking on an identity was miraculous, and the highly sophisticated practice was variously linked to entertainment and to religious transfiguration. As a secret perspective it was thought of as being at the service of hidden powers with a revelatory capacity analogous to that of religion, but it was also discussed in terms of the science of artificial magic and took its place in the Cabinets of Curiosity among the wonders of natural history. Whatever else perspective produced in the form of delights spiritual or secular, it was in the sixteenth and seventeenth centuries an aspect of ontological research, and as such deeply implicated in

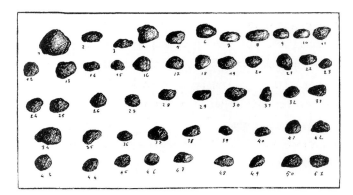

Fig. 11
Salvador Dalí
"Aspect des nouveaux objets 'psycho-atmosphériques-anamorphiques,'" (Aspect of the new psycho-atmospheric-anamorphic objects), *Le Surréalisme au service de la révolution*, no. 5, Paris May 15, 1933

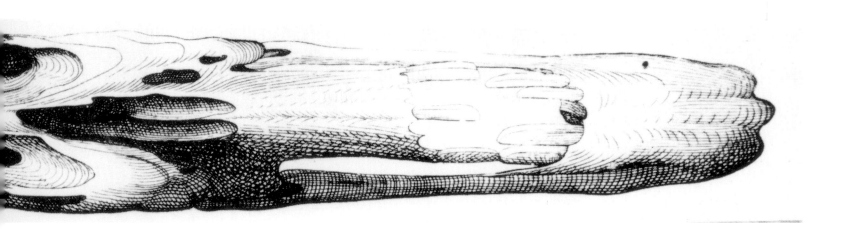

questions of the reality or deceptiveness of the physical world. Science and religion were locked in an increasingly violent embrace, which would end in divorce.[40]

The most famous example of anamorphosis is Holbein's *The Ambassadors* (figs. 30, 30A), but this is also unusual in that both anamorphosis and more normal perspective clash in a single viewing frame so that neither can ever be a complete viewing experience, the one always canceling the other out. In most examples there are alternative but internally consistent viewpoints; seen obliquely, the image resolves itself. In *The Ambassadors*, the blur in the foreground, a shapeless mass, only becomes legible when seen from a sharp angle at the side, but then the two Ambassadors have become invisible. The "phallic ghost,"[41] as Lacan called it, is revealed to be a skull, and this uncanny and unsettling object was to haunt Dalí.

Among the abnormally splayed, distorted or squeezed bodies or objects in his paintings, many are skulls or skull-like forms. *Diurnal Fantasies* (cat. 9), for instance, is an elongated boulder with cranial sockets and cavities (fig. 12). It resembles an "anamorphosis" of the goat skull in the foreground, although there is not a systematic transformation. The form in *Diurnal Fantasies* is close to what Dalí called in a letter to Paul Eluard (fig. 13) the most beautiful and "the most atmospheric of all atmospheric-skulls." This page of distorted skulls is both a triumph of and a triumph over death: they are so sucked and bent and inflated, as though by huge physical pressure or as if they were in fact still malleable, that they appear alive. On the second page of the letter, the sexual implications of anamorphic distortions become explicit (fig. 14).

Fig. 12
Anamorphosis of a skull
From Lucas Brunn, *Praxis Perspectivae*, Leipzig 1615.

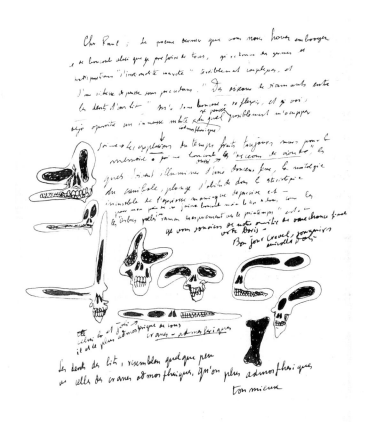

Fig. 13
Salvador Dalí
Letter to Paul Eluard, n.d.

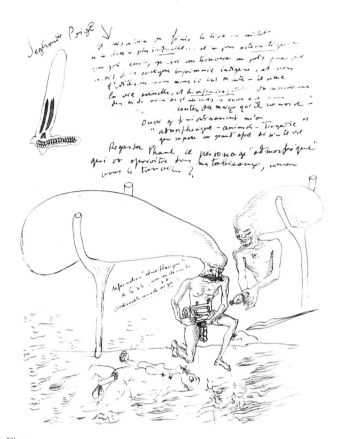

Fig. 14
Salvador Dalí
Letter to Paul Eluard, n.d.

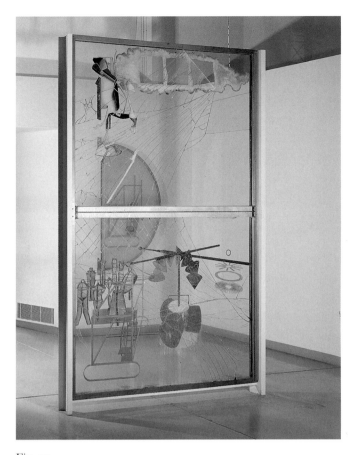

Fig. 15
Marcel Duchamp
The Bride Stripped Bare by Her Bachelors, Even, 1915–23
Philadelphia Museum of Art.

Nowhere is anxiety and desire so troublingly linked with mortality as in the frontispiece to René Char's *Artine* (fig. 13.2). A *perspective fuyante* elongates a bed which is also rendered formless by a creeping canopy of hair. The boy's erect shadow on the left echoes the cross on the coffin glimpsed beneath the bed.

The only other artist in the twentieth century who has systematically exploited and scrutinized perspective with the same critical intensity is Marcel Duchamp. His Large Glass, *The Bride Stripped Bare by her Bachelors, Even* (fig. 15), could be seen as a double speculation on perspective illusion. The lower half, as Duchamp said, is a rehabilitation of single-point perspective, following its virtual abandonment in Cubism. The forms are measurable, if imperfect and sometimes irregular, and appear quite convincingly to stand on the ground beyond the Glass. The upper part (the "airy" realm of the Bride), however, is full of amorphous and we might say anamorphic forms. That Duchamp had in mind some

such model of a "puzzle" perspective – for speculative rather than literal purposes – is confirmed by his note on the *Pendu femelle*, the suspended form on the left: "The Pendu femelle is the form in ordinary perspective of a Pendu femelle for which one could perhaps try to discover the true form / This comes from the fact that any form is the perspective of another form according to a certain *vanishing point* and a certain *distance*."[42] Formless in ordinary perspective – this too recalls the anamorphic blot in Holbein's *Ambassadors*, but with Duchamp's *Bride*, we are left without an alternative viewing point from which to discover the "true form."

The first time that a connection was made between Dalí's work and anamorphosis was in the review *Documents*, in 1929. Two *Bathers* (cat. 3, 4) by Dalí were reproduced on the same page as an anonymous painting, *Saint Anthony of Padua and the Infant Jesus* (fig. 16), of c. 1535. The immediate visual effect of the resemblance between the melting morphology of the

bodies in Dalí's paintings and the distortions of the anamorphic image was arresting and certainly intentional on the part of the review's editor.

A feature of *Documents'* disruptive and subversive character was the deliberate juxtaposition of diverse kinds of visual material, which set up unexpected and disquieting comparisons, aimed at undermining conventional hierarchies of value. Following the shocking success of the film *An Andalusian Dog,* Georges Bataille had hoped to annex Dalí for his review,[43] and gave the young artist extensive coverage. Beside the two *Bathers,* Dalí's 1927 painting *Blood is Sweeter than Honey* was reproduced (together with two illustrations from the pulp fiction crime magazine *L'Oeil de la Police* (fig. 17)), and a dictionary entry on "L'oeil" (Eye), by Bataille, took the notorious scene from the *An Andalusian Dog* of the slitting of the eyeball as an extreme instance of the link between the eye and horror (fig. 4). This challenges the surrealist idea of the power of inner vision, of the belief in the intoxicating and liberating value of the imagination and dream. The scene at the very outset of

Dalí and Buñuel's movie, when the heroine's gaze, intercut with the image of a cloud slicing across the moon, is violently broken by a razor, could be taken as symbolic of the switch from the ordinary world of sight and external everyday reality to a world normally hidden of obsession and passion. The moon/beauty is symptomatic of the banality of conventional poetic metaphor which is abruptly eliminated in favor of the unexpected and irrational but psychologically convincing sequel of erotic and fatal reveries, of inhibition and release. This scene of the eye is thus poised at a moment of alternatives: the eye as symbolic boundary of inner/outer vision, or, as a *friandise cannibale,* the object of irrational repugnance linked to attraction and seduction. Despite Dalí's rejection of *Documents* and his veiled attack on it in *La Femme visible,* Bataille's ideas about the seduction of horror and the mechanism of repulsion are undoubtedly close to his own.[44]

The juxtaposition of the *Bathers* and *Saint Anthony of Padua* is visually suggestive although the short essay by Carl Einstein, the German art historian and critic, is

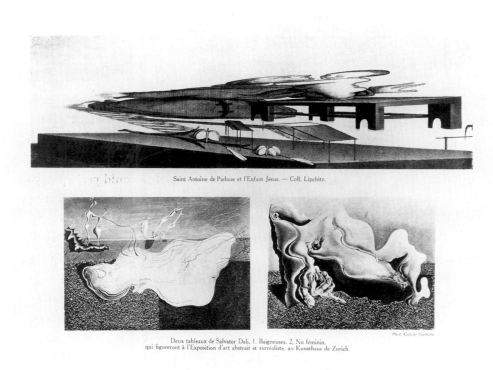

Deux tableaux de Salvador Dali, 1. Baigneuses, 2, Nu féminin,
qui figureront à l'Exposition d'art abstrait et surréaliste, au Kunsthaus de Zurich.

Fig. 17
Page from *Documents,* no. 5, 1929: top, covers of popular magazine *The Eye of the Police,* illustration Bataille's dictionary entry on "Eye"; bottom, Salvador Dalí, *Blood is Sweeter than Honey.*

Fig. 16
Page from *Documents,* no. 4, September 1929: top, anamorphic painting *St. Anthony of Padua and the Infant Jesus* (anon.); bottom: two paintings by Salvador Dalí, 1. *Bathers* (cat. 4), 2. *Female Bather* (cat. 3)

concerned only with the latter. However, his analysis of the sixteenth-century "puzzle picture" must have been of extreme interest to Dalí, for it uncovers a hidden double meaning which has direct parallels with the method Dalí was beginning to explore. Unlike Holbein's *Ambassadors,* it belongs to the type of anamorphosis which "reads" as a whole both from a normal viewing position and from the oblique angle which reveals the "hidden image." There are a number of instances of this kind of anamorphosis, which often at first view appear to represent a landscape, but when seen from the side produce a completely different figuration. Einstein describes the *Saint Anthony* in terms of what he calls a *"perspective fuyante,"* and compares it to distorting mir-

rors; he instructs us to close one eye and look at the picture from as oblique an angle as possible, which should reveal Saint Anthony of Padua being embraced by the Infant Jesus.

The doubled forms have, as Einstein points out, specific iconographical meanings: the Saint's girdle is a bridge, symbol of the ascetic life leading to heaven, and, in an astonishing piece of visual trickery, the "cross, below, is also a bridge because suffering is a bridge to God. To the right, a book represents the Logos which leads to Christ. At the bottom, larvae and insects form the lily of innocence, symbol of the Virgin."[45] Seen from the front, the disfigured saint and god together form a cloud, symbol of heavenly ecstasy.

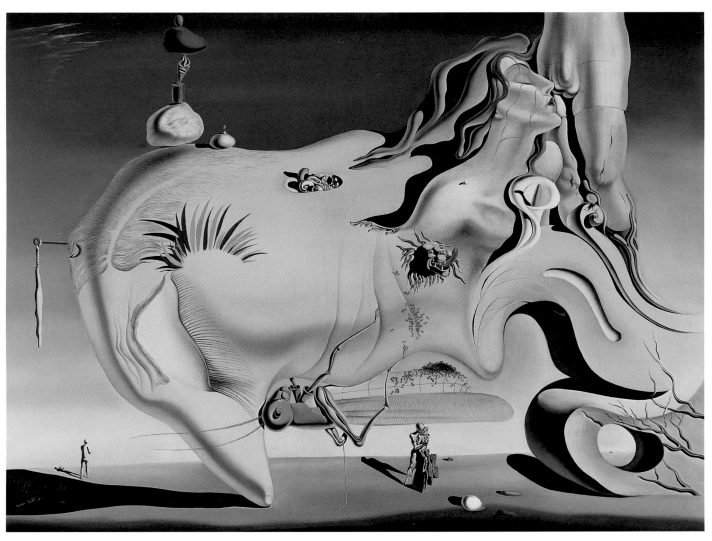

Fig. 18
Salvador Dalí
The Great Masturbator, 1929
Museo Nacional Centro de Arte Reina Sofía, Madrid.

However, the juxtaposition of this image with Dalí's *Bather* (cat. 4) reverberates both ways. A grosser reading leaks into the devotional scene; the disfigured contours of the body exacerbate the secular and suggestive embrace of the saint, which suddenly appears to be with an incubus-like female rather than a Christ Child. In turn, the anamorphic picture affects the way we see Dalí's melting anatomies. In the *Female Bather* (cat. 3) the anatomical distortions, if the picture is viewed obliquely from the left, close up to reveal or emphasize the androgynous character of the body, the pink hump becoming more clearly phallic, while the jagged rocks framing the tiny fish-jawed Picasso-like head take on more of a human profile. The monstrous swellings and enlargements of the nude are like a volcanic eruption of desire, the naked body not presented for another's delectation, but as its own erotic object. The pull of seduction and repulsion that inflates and renders viscous the flesh produces conflict in the spectator, uncertain whether he is included in or excluded from the seduction (fig. 18).

Dalí's phrase "anamorphic hysteria" fits this image, linking distortion to the neurosis as Jacques Lacan defined it. "Whereas obsessional neurosis concerns the question of the subject's existence, hysteria concerns the question of the subject's sexual position. This question may be phrased 'Am I a man or a woman?', or, more precisely, 'What is a woman?'"[46] Hysteria is linked by Lacan to the idea of the "fragmented body," or the division of the body into an "imaginary anatomy." The hysteric may be haunted by "images of castration, emasculation, mutilation, dismemberment, dislocation, evisceration, devouring, bursting open of the body"[47] – all of which are present in Dalí's work. The "Bather," for instance, is a giant and deformed big toe, isolated and floating, precedent of the Boiffard photographs that accompanied Bataille's article on "The Big Toe" (cat. 4).[48]

Paranoia-criticism

Anamorphic hysteria for Dalí was one example of the re-creation of the world through what he called paranoiac activity. Anamorphosis was not only linked to his ambivalent anatomies, but also to the whole paranoiac-critical method which Dalí first described in the texts published as *La Femme visible* in 1930: to, in other words, "double images" like that of St Anthony of Padua.

Dalí demonstrated his idea in *Le Surréalisme au service de la révolution* no. 3 (1931), with "Communication: visage paranoiaque." (fig. 19) Following a period of reflection on Picasso's African-period cubist paintings, he had come upon a photograph in a pile of old papers, while searching for an address, which he instantaneously read as a reproduction of a Picasso. Puzzled by the second "mouth" in the cubist head, he realized that what he had taken for a vertical image was in fact a horizontal snapshot of an African village. The alteration in viewpoint here, shifting from the vertical to the horizontal is not typical of the paranoiac double image, and in this the latter also differs from the anamorphic. The configurations which could be read in multiple ways were normally also viewed from a single position. What struck Dalí about his "paranoiac face" was not only the

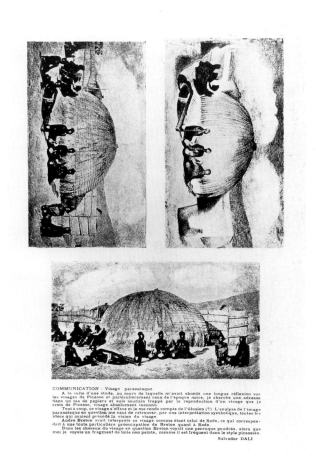

Fig. 19
Salvador Dalí
"Communication: paranoiac face," *Le Surréalism au service de la révolution*, no. 3, Paris December 1931.

momentary illusion of a totally alternative reading, but the fact, confirmed when he showed the photograph to André Breton, that the illusion was directed by a personal obsession; where he saw a Picasso head, Breton saw a bust of the Marquis de Sade, with powdered wig, conforming to his own preoccupations.

Dalí inscribed the paranoiac double image within the surrealist doubt about reality; "The miserable mental expedient hidden behind the word 'reality' is the object today of a systematic denunciation whose revolutionary consequences are indisputable."[49] More specifically, he referred to Breton's "Introduction to the discourse on the paucity of reality" in which Breton proposed inserting dream objects among the utilitarian tools of the world to sow confusion.[50] "I believe the moment is at hand when by a paranoiac and active thought process it will be possible (simultaneously with automatism and other passive states) to systematize confusion and contribute to the total discredit of the real world."[51] Paranoia, Dalí continued, "uses the external world to realize the obsessive idea, with the troubling particularity of making the reality of this idea valid for others. The reality of the external world will serve as illustration and proof, and is put at the service of the reality of our mind."[52] Obviously related to the surrealists' simulations of neurotic and delusional mental states, as in the collection of texts by Breton and Eluard, *Immaculate Conception*, Dalí's paranoiac activity found its most complete and sustained expression in his book *The Tragic Myth of Millet's Angelus*, which is closely and expertly based on Freud.

Two of Dalí's early experiments with the painted double image were *Invisible Sleeper, Lion, Horse* (fig. 20) and *The Invisible Man* (cat. 6). The former, which he also planned as a film scenario, was probably inspired by Fuseli's *The Nightmare* (fig. 21). The dream-pun of Fuseli's gothic scene of a sleeping woman haunted by a mare seems to be the origin of the configuration which produces successively the image of woman with her arm thrown back over her head, a horse whose head is formed by the sleeper's arm, and a lion whose head becomes visible in the horse's tail. Although Dalí never made the Fuseli painting the subject of an extended Freudian study as he was to do for Millet's *Angelus,* its place in the gothic tradition which strained the limits of rational thought and placed value on the marvelous and the dream, as well as its eroticism, links it to surrealist taste.

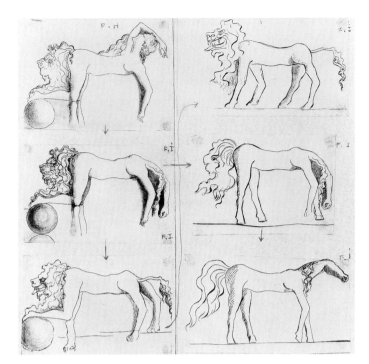

Fig. 20
Salvador Dalí
Schematic drawing for *Invisible Sleeping Woman, Horse, Lion,*
from Dalí's unpublished film script, c. 1931–32
Scottish National Gallery of Modern Art, Edinburgh.

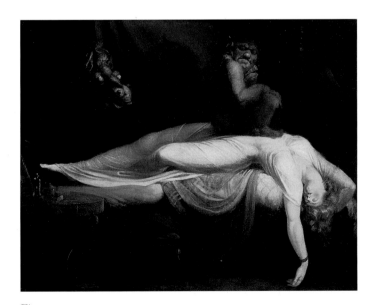

Fig. 21
Henry Fuseli
The Nightmare
Oil on canvas, 1781
The Detroit Institute of Arts, USA

The Invisible Man was conceived as a major painting on which Dalí worked for several years. The image is partially based on a child's picture book of ancient Egyptian architecture, but it was to include iconography from the William Tell and Gradiva themes which Dalí was developing at the same time.

The visual conceits of Arcimboldo intrigued Dalí and have affinities with his "paranoiac-critical method," but there are certain differences between them. Whereas with Arcimboldo and his school there is a binary relationship between the individual objects and the overall head or landscape, with Dalí there are often more than two possible readings of a given configuration. The capacity for a "paranoiac reading-in" of an image was potentially unlimited; the spectator was free in theory to interpret according to his or her delusions, though in practice Dalí directs the readings. A measure of morphological ambiguity, however, is necessary, and the objects are not locked so definitively into a lexical structure as they are with Arcimboldo. Also, the slight "click" of surprise as the "other" image is revealed in Arcimboldo is relatively short, and little in the way of a perceptual switch is necessary to maintain both the "fruits," say, and the head simultaneously in view (fig. 23). With Dalí, sometimes, the switch has to be repeated, as in the "duck-rabbit" puzzle, and the image does not congeal but remains unsettled.

Dalí refined his paranoiac-critical technique by the end of the thirties; one of the remarkable things over and above the multiplicity of alternative readings which reached its apogee with the *Endless Enigma* (fig. 22) is the extremes of scale on which he can operate. *Impressions of Africa* (cat. 27), for instance, has a cluster of images that are virtually invisible from more than a few inches away from the canvas, whereas in *Apparition of a Face* and *Fruit Dish on a Beach* the whole canvas resolves itself into a dog (cat. 31).

Dalí's uses of techniques of illusion to give the world of the imagination the "communicable thickness" of the phenomenal world was never meant to become an end in itself. The furious desire to fix and transmit his vision and his ideas is like a warding off of dissolution and a sense of a void; the ambivalence of his own attitude to his paintings which shifts between abjection and masterly pride, whose alternations are apparent in the extraordinary range of modes, of the sizes of the

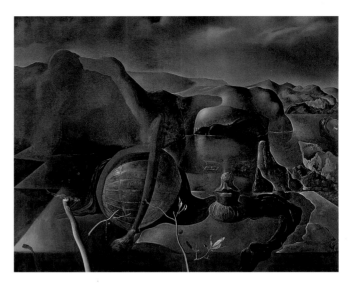

Fig. 22
Salvador Dalí
The Endless Enigma, 1938
Museo Nacional Centro de Arte Reina Sofía, Madrid.

paintings, of the grotesque beside classical harmonies, of subjects and motifs. All manner of forms of representation were explored – cinema, photography, prints, theater, opera, objects, jewelry, installations, as well as words, but always he returned to oil painting as that which came closest to the impossible need to double the world into life:

All painting before oil is dry, harsh and as it were against the grain. It was not possible, as it was later, to scumble with a fleeting badger-hair brush the pigments of gold, of air, the infinitesimal and suprasensitive shades with which reality itself appears to us to be "bathed," that is to say phenomenally solarized with the oils and the honeys of light itself. No atmospheric illusionism was possible. Nor could one paint the mystery of the flesh, the glory of painting, with that subsurface iridescence which characterizes it, nor the mystery of the azure of the sky, which is the very mystery of the transparencies of pictorial technique...[53]

Notes

1 Alain Bosquet, *Conversations with Dalí*, New York 1969, p. 22.

2 ibid.

3 Salvador Dalí, *The Conquest of the Irrational* (*La Conquête de l'irrationnel*, Editions surréalistes, Paris 1935) trans. Joachim Neugroschel in *Conversations with Dalí*, p. 113 (other published translations include Julien Levy (1935) and Haakon Chevalier (1968, see note 11)).

4 André Breton, "Dalí," exh. cat. *Salvador Dalí*, Galerie Goemans, Paris, 20 November – 5 December 1929.

5 *Conquest of the Irrational, op. cit.*

6 Freud, letter to Stefan Zweig as quoted by Dalí in *The Unspeakable Confessions of Salvador Dalí*, London 1977, p. 120. The meeting with Freud took place in London in July 1938.

7 ibid. For a recent reading of *Metamorphosis of Narcissus* see David Lomas, "The Metamorphosis of Narcissus: Dalí's Self-Analysis," in Ades and Bradley, *Salvador Dalí: A Mythology*, exh. cat. Tate Gallery, London, 1998.

8 *Conquest of the Irrational, op. cit.*

9 Pierre Cabanne, *Entretiens avec Marcel Duchamp*, Paris 1967, p. 74.

10 Within the surrealist notion of peinture-poésie fall *La femme visible*, the texts and poem that introduce his notion of "critical paranoia" and have a close bearing on his paintings of 1929–30, and the poem that accompanies *The Metamorphosis of Narcissus;* throughout the thirties he published startlingly original texts in the surrealist journals on themes ranging from psychoanalysis to the Pre-Raphaelites and art nouveau, the latter part of a crusade to undermine modern taste for the "authentic" naive and primitive; *The Tragic Myth of Millet's Angelus* was the first sustained marriage between psychoanalysis and art history; a mammoth "History of surrealist painting through the ages" was never finished, although fragments of his thinking about favorite artists like Arnold Böcklin survive; *Hidden Faces* is in the great tradition of erotic novels, while his autobiographies like the indispensable *Secret Life* are an extraordinary exercise in self-analysis compounded of fact and fantasy. All are closely bound with his visual work, but the latter is in no sense an illustration of them.

11 Salvador Dalí, *The Conquest of the Irrational* (1935) as trans. by Haakon Chevalier in *The Secret Life of Salvador Dalí*, London 1968, p. 446.

12 Salvador Dalí, *The Unspeakable Confessions of Salvador Dalí* (as told to André Parinaud), London 1977, p. 143.

13 ibid. p. 153.

14 See *The Oxford Companion to the Mind*, ed. Richard L. Gregory, 1987; Gregory, *The Intelligent Eye*, 1970.

15 Hubert Damisch, *The Origin of Perspective*, Cambridge Mass., 1994, p. 38.

16 André Breton, "Max Ernst" (1921), in Max Ernst, *Beyond Painting*, New York 1948, p. 177.

17 Walter Benjamin, "The Work of Art in the Age of Mechanical Reproduction," 1936 reprinted in *Illuminations*, 1973, p. 239; "A small history of Photography," 1931; "One Way Street," 1979.

18 Laszlo Moholy-Nagy, *Painting Photography Film* (Bauhaus Book 1925), London 1969, p. 28.

19 Salvador Dalí, "La dada fotogràfica," *Gaseta de les Artes*, Barcelona February 1929, pp. 40–42 trans. as "The photographic donnée," in *Salvador Dalí: The Early Years*, exh. cat., London, South Bank Centre, 1994, p. 227.

20 Salvador Dalí, "La Fotografia, pura creació de l'esperit," *L'Amic de les Arts*, Sitges September 1927, pp. 90–91 trans. as "Photography, pure creation of the mind," ibid. p. 216. Dalí's slighting reference to "murky subconscious processes" was an early sign of a fundamental disagreement with Surrealism over the value and nature of automatism, which had in the first years of the movement, 1924–29, been the established mode of investigating the unconscious. Dalí found it too passive an activity, and contrasted automatic processes like drawing with his own active form of "interpretation," "paranoia-criticism."

21 "La dada fotogràfica," *op. cit.*

22 *Unspeakable confessions*, p. 27.

23 *Secret Life, op. cit.*, p. 41.

24 Martin Kemp, *The Science of Art*, New Haven and London, 1990, p. 217. See also Ian Gibson, *The Shameful Life of Salvador Dalí*, 1997, p. 29.

25 *Unspeakable confessions*, p. 27.

26 "A Brief History of Holography," unsigned press release for Knoedler Gallery, New York, 1972.

27 Dr. Dennis Gabor, Statement in catalogue, Knoedler Gallery 1972, quoted in Robert Descharnes, *Salvador Dalí 1904–1989*, Cologne 1994, p. 663.

28 "A Brief History of Holography."

29 Robert Hughes, review of Holography exhibition, *Time*, 15 May 1972.

30 "Conquest of the Irrational," *op. cit.* p. 417.

31 "The Last Scandal of Salvador Dalí," exh. cat. *Salvador Dalí*, Arts Club of Chicago 1941. The author, "Felipe Jacinto," reports a conversation with Dalí just before the outbreak of war; Felipe Jacinto was Dalí's pseudonym.

32 *Unspeakable Confessions*, p. 34.

33 ibid. p. 144.

34 "Conquest of the Irrational," *op. cit.* (Conversations), p. 113.

35 ibid. p. 159.

36 Among the books related to perspective, stereometry and the study of shadows in Dalí's library: Leroy, *Atlas, Traité de Stéréométrie*, Paris 1844; E.-S. Jeaurat, *Traité de Perspective: l'usage des artistes*, Paris 1750; John Holme, *Sciagraphy*, London 1952; Henry McGooden, *Architectural Shades and Shadows*, London 1904; Rex Vicat Cole, *Perspective as applied to pictures etc.*, London 1921; *Traité de la perspective pratique*, Paris 1725. Dalí also had a dedicated copy of Jurgis Baltrušaitis, *Anamorphoses, ou perspectives curieuses*, 1969.

37 *The Tragic Myth of Millet's Angelus*, written in the 1930s but published in Paris 1968; see Ades and Bradley, *Salvador Dalí: A Mythology*, exh. cat., London, Tate Gallery, 1998.

38 Damisch, *op. cit.*

39 Salvador Dalí, "Objets Psycho-atmosphériques-anamorphiques," *Le Surréalisme au service de la révolution*, no. 5, Paris May 1933, p. 45.

40 Theories about vision and the mysteries of optical devices that would produce illusionistic images were jealously guarded secrets, often in the hands of churchmen, of Jesuits and the Minims. One of its most serious theorists, Jean-François Niceron, described various aspects of optical magic in *La Perspective curieuse ou magie artificielle des effets merveilleux*, which included the "catoptric," involving the use of flat, cylindrical or conical mirrors, and the "dioptric" which used the refractive light from crystals. Dalí was familiar with this text.

41 Jacques Lacan, *The Four Fundamental Concepts of Psycho-Analysis*, London 1986, p. 88.

42 Marcel Duchamp, *The Bride Stripped Bare by her Bachelors, Even*, typographic version of the Green Box, London 1960, n.p.

43 Dalí's appearance in *Documents* at this moment, September 1929, is highly significant. A number of disaffected surrealists had already shifted their allegiance to *Documents*, which was simultaneously encroaching on surrealist territory and mounting a campaign against certain of its ideas. That Bataille had hoped to recruit Dalí is evident from the number of references to him in the September 1929 issue. As a new recruit to Surrealism, however, Dalí resisted the invitation and refused permission for his work *Le Jeu lugubre* to be reproduced in the December 1929 issue of *Documents*. Bataille published instead a diagram of the painting to demonstrate its perverse and ignominious subject matter.

44 On Dalí and theories of repugnance see David Lomas, "Metamorphosis of Narcissus," in *Salvador Dalí: A Mythology, op. cit.*

45 Carl Einstein, "Saint Antoine de Padoue et l'enfant Jesus," *Documents* no. 4, September 1929, p. 230.

46 Dylan Evans, *A Introductory Dictionary of Lacanian Psychoanalysis*, London and New York 1996, p. 78.

47 Jacques Lacan, *Ecrits: A Selection*, trans. Alan Sheridan, London 1977.

48 Georges Bataille, "Le gros orteil," *Documents* no. 6, Paris November 1929.

49 André Breton and Paul Eluard, Preface to *La Femme visible*, Paris 1930.

50 Dalí is virtually paraphrasing a passage from Breton, "Introduction to the Discourse on the Paucity of Reality," proposing to put into circulation dream objects "to throw further discredit on those creatures and things of 'reason'." *What is Surrealism?* London 1978, ed. Rosemont, p. 26.

51 Salvador Dalí, "L'Ane pourri," *Le Surréalisme au service de la Révolution*, Paris 1930, p. 9 (subsequently published in *La femme visible*).

52 *op. cit.*, p. 10.

53 Salvador Dalí, *50 Secrets of Magic Craftsmanship*, New York 1948; reprinted 1992, p. 23.

"Artificial Magic"

Peter C. Sutton

Salvador Dalí was a learned artist with an extensive knowledge of the history of art. He often made references and allusions to Old Master paintings in his surrealist works and seems to have been directly influenced by several earlier painters of fantasy subjects. The precedents of Giuseppe Arcimboldo's (1527–1650) "composite" heads and figures have often been cited in the search for Surrealism's roots. To modern viewers these works seem merely amusing or whimsically bizarre, but in his own day Arcimboldo was celebrated at the sixteenth-century Hapsburg court as an artist of profound wit and invention. His most influential contribution was the "composite" figure, usually viewed bust-length and in profile but also sometimes depicted full length, made up of numerous individual but symbolically related motifs (fig. 23).[1] Often his composite figures were produced in series and personify concepts, such as the Seasons or the Elements. The many copies and variants of Arcimboldo's art which survive attest to their popularity. Arcimboldo also created "double images" in which two related things were represented at the same time, such as a platter of roasted meat which also can be read as a portrait of a cook. The Swiss artist, Matthäus Merian (1593–1650), the Flemish master Joos de Momper II (1565–1635), and Augsburg painter Anton Mozart (1573–1625) also created double images in the form of anthropomorphic landscapes.[2] Merian, for example, painting a craggy, coastal view that reveals a reclining portrait of a bearded man in profile (fig. 24). Salvador Dalí delighted in this type of double image and made it central to his art in images like *Paranoiac Figure* (fig. 25, see fig. 19) which was inspired by a photograph of an African village with natives seated before huts.

In addition to double imagery Dalí was also keenly interested in more complicated forms of illusionism, some of which involved unusual properties of perspective. One of the phenomena of perspective that most attracted Dalí was anamorphosis.[3] This is a systematically distorted

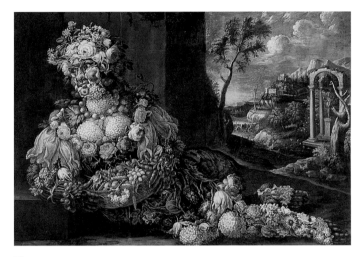

Fig. 23
Follower of Arcimboldo
Spring
Canvas 99 × 140 cm.
Wadsworth Atheneum, Hartford, 1939.212

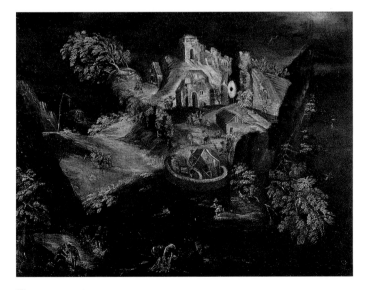

Fig. 24
Matthäus Merian
Anthropomorphic Landscape
Panel 32 × 41 cm.
Mrs. Alfred H. Barr Jr. Collection

image projected on a picture plane which looks odd, even illegible when viewed head on, but which resolves itself and assumes proper proportions when seen from the appropriate angle. The Greek roots of the word (*ana* = again, and *morphoun* = to form) mean "a forming anew," and express the idea of a concealed image recaptured. The radically attenuated, smeared forms of anamorphosis disguise hidden imagery and were well suited to Dalí's interest in visual surprise and discovery. With their concealment followed by revelation, anamorphic images also accord well with the surrealists' fascination with subconscious association and visual double entendre.

Anamorphosis is a form of linear perspective. The optical system that formed the basis of single-point linear perspective was first postulated in the third century B.C. by Euclid, who posited that the field of vision was a pyramid with the apex in the viewer's eye. This idea was revived and developed by the architect and art theorist, Leonbattista Alberti. In 1435, Alberti formulated single-point perspective employing lines of sight (orthogonals) converging in a vanishing point. For Renaissance artists, the picture plane was a window offering a view on the fictional world of the painting. The euclidean optical system that formed the basis of painters' perspectives was superseded in the seventeenth century by Kepler, who correctly based his system on the anatomy of the human retina, but the assumptions of linear perspective (which involves a single, fixed viewing point at a specific distance from the subject) have dominated traditional representational painting to this day.

The idea of anamorphosis apparently arose from early Renaissance artists' investigations of extremely oblique images and wide-angle views. Although Piero della Francesca seems to have understood its principles, Leonardo da Vinci was the first to demonstrate its use. In his *Codex Atlanticus* of c. 1485, he made the earliest known anamorphic drawings – a child's face and a human eye (fig. 26).[4] When one examines these two images from the right-hand side and just above the surface of the paper, their elongation is corrected and they assume normal proportions. Moreover, the lines seem to detach themselves from the paper and float illusionistically. Although now lost, Leonardo also executed an anamorphic painting of a dragon battling a lion for his last royal patron, François I of France.[5]

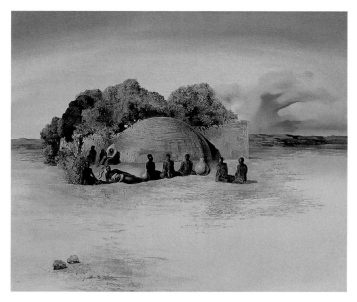

Fig. 25
Salvador Dalí
Paranoiac Figure, 1934-35,
Panel 14.5 × 22.5 cm.
Private Collection

Fig. 26
Leonardo da Vinci
Anthropomorphic Image of a Child's Head and an Eye, ca. 1485,
Codex Atlanticus, Biblioteca Ambrosiana, Milan

During the sixteenth century, anamorphic images were produced with some frequency and growing coherence, especially in Northern Europe. Though often regarded as mere curiosities or pictorial puzzles, anamorphic images also function symbolically. Dürer's pupil, Erhard Schön, made a specialty of woodcuts of anamorphic images concealing high-minded political and religious themes as well as less lofty erotic and scatological subjects. Surprising to modern audiences is his print of 1538 entitled *Was siehst du?* (What Do You See?) (fig. 27), in which a small image of Jonah spat out by the whale is linked symbolically with a hidden figure of a peasant defecating. And in Schön's *Aus, du alter Tor!* (Out, You Old Fool) (fig. 28) of c. 1535, an ill-matched couple embrace beside a tiny hunting scene with a stag driven into a net; the nude scene in anamorphic projection makes explicit the allusion to the old fool's temptation and fate. Schön also executed anamorphic prints with portraits of political leaders hidden in landscapes. While one must experiment with different viewing angles to discover the disguised images in Schön's prints, William Scrots' painted *Portrait of Edward VI* of 1546 (fig. 29) has a hollow in the frame that once held a telescopic device that directed the observer to the correct viewing angle to recognize the anamorphically attenuated likeness of the king. Visitors to Whitehall in the late sixteenth century described the portrait as one of the marvels of the palace.

Scrots was probably influenced by the art of Hans Holbein the Younger, whose painting *The Ambassadors* of 1533 (fig. 30) features perhaps the most famous early example of anamorphosis.[6] The portrait depicts the young French ambassador, Jean de Denteville, and the Bishop of Laveur, Georges de Selve, standing before a table covered with scientific and musical instruments, globes, mathematical treatises, and hymnals, alluding to the two men's shared interests and the political and religious intrigues that brought them together at Henry VIII's court in England. In the immediate foreground there is an anamorphic skull (detail fig. 30A) which is

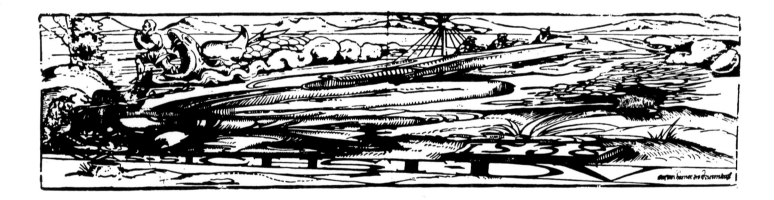

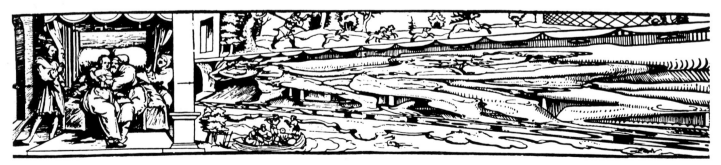

Fig. 27 (top)
Erhard Schön
Was siehst du?, 1538
Woodcut
Graphische Sammlung, Albertina, Vienna

Fig. 28 (bottom)
Erhard Schön
Aus, du alter Tor!
Woodcut
Graphische Sammlung, Albertina, Vienna

optimally viewed from the right of the picture about at the level of the two figures' heads. The original setting of the painting in the ambassador's residence in the Château de Polisy is unknown. Moreover the picture's frame has been lost so it is unclear how it was viewed and whether, like the Scrots, it was outfitted with an optical device, such as a glass cylinder, which when canted would also have revealed a clear image of the skull. Art historians have debated the enigmatic painting's meaning; however it seems probable, especially in the presence of so many symbols of worldly knowledge, that the anamorphic *memento mori* is linked with the salvation promised by the tiny silver crucifix just visible behind the curtain at the upper left.

Fig. 29
William Scrots
Portrait of Edward VI, 1546
Panel
National Portrait Gallery, London

Fig. 30 (below left)
Hans Holbein the Younger
The Ambassadors, 1533
Panel 206 × 209 cm.
National Gallery, London

Fig. 30A (below)
Detail of Holbein's *The Ambassadors*

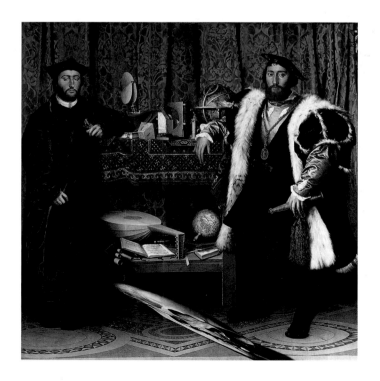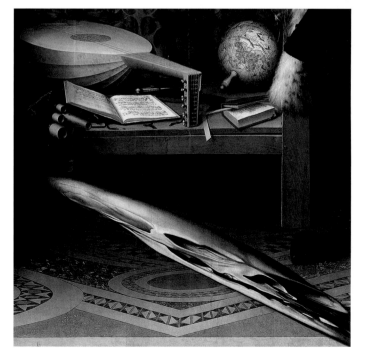

Late sixteenth-century artists' handbooks, such as those of Daniele Barbaro (1569) and Vignola and Danti (1583), offered techniques for constructing anamorphic images even though their authors did not always fully grasp the optical principles involved. Giovanni Paolo Lomazzo's *Trattato dell'arte della pittura* (1584) also mentions anamorphic murals. However, it was Jean François Niceron (1613–46), a geometrical theorist and member of a group of French mathematicians belonging to the Order of Minims, who first fully codified these ideas in two treatises, *Perspective curieuse ou magie artificielle* of 1638 and the posthumously published *Thaumaturgus Opticus* of 1646. These offered a comprehensive discussion of anamorphosis and other forms of what he called "artificial magic." Niceron offered practical instruction in the construction of anamorphoses using a trapezoidal grid (fig. 31) and illustrated how he created a monumental mural of *St John the Evangelist writing the Apocalypse* (now lost) using a perspective machine on a wall in the French convent of Sta. Trinità dei Monti in Rome (fig. 32). A companion piece executed by Niceron's fellow Minim and geometer, Emmanuel Maignan, depicts St Francis of Paola and is the only surviving large-scale perspectival anamorphosis. In both scenes the subjects were secreted in weird-looking landscapes and could only be recognized from an extreme oblique angle at the end of a long wall. In this way the two devout intellectuals conscripted illusionism and science into the service of religion; spiritual agents of God's hidden order, the saints are symbolically visible only to those who know where to look for them.

The great age of anamorphosis was the seventeenth century, particularly c. 1630–50. It was toward the end of this classical phase that the perspective box seems to have been fully developed in the Netherlands. Only a half-dozen of these peepshows have survived; the most famous and sophisticated is Samuel van Hoogstraten's in the National Gallery, London (fig. 33).[7] Perspective boxes featured anamorphic images projected onto the planes of the interior of the box. Hoogstraten's *perspectyfkas* depicts a domestic interior which looks crazily disjointed when examined from the open side of the box but highly naturalistic when viewed through the peepholes provided. Perspective boxes differed from standard two-dimensional anamorphoses, where one must search for the viewpoint which unscrambles an illegible scene, by

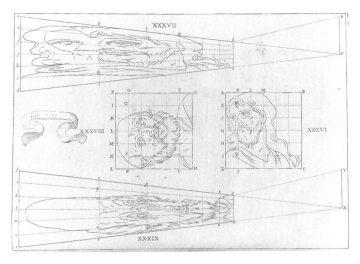

Fig. 31
Jean François Niceron
Anamorphic Distortions of Faces
Illustration from *Thaumaturgus Opticus* (1646)
Yale University Medical Library

Fig. 32
Jean François Niceron
Demonstration of the Construction of an Anamorphic Mural
Illustration from *Thaumaturgus Opticus* (1646)
Yale University Medical Library

requiring the observer to view the illusion from the point, namely the eyepiece or peephole, where the illusion is optimally effective. Part of the peepshow's attraction, therefore, is the magician tipping his hand to his public. The perspective box was one expression of the Dutchman's fascination with naturalism, optical science, perspective, and *tromp-l'oeil*. Cities such as Delft, where Carel Fabritius, Johannes Vermeer (one of Dalí's favorite artists) and Pieter de Hooch were active, became artistic centers for the investigation of optics and illusionism. The Delft scientist Leeuwenhoek, who perfected the microscope, was also the executor of Vermeer's will.

The same era that saw dramatic advances in empirical science also witnessed painters' use of optical aides such as lenses, mirrors and the camera obscura – the precursor of the modern camera.

The Wadsworth Atheneum recently acquired an anamorphic painting (fig. 34) which probably dates from the late seventeenth or early eighteenth century and depicts Adam and Eve embracing before the Tree of Knowledge. The scene also includes a skull and a man's portrait in profile. Each of these scrambled motifs must be deciphered from different oblique viewing points to the right and left of the canvas (fig. 34A).[8] Also visible

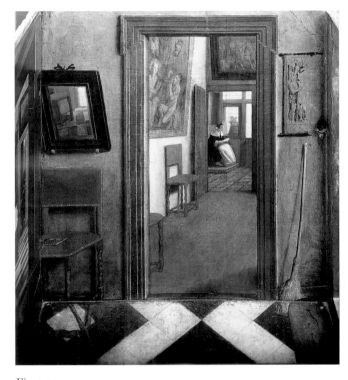

Fig. 33
Samuel van Hoogstraten
Perspective Box
National Gallery, London

Fig. 34 (above right)
Unknown Late Seventeenth-Century Artist
Anamorphic Image of Adam and Eve
Canvas
Wadsworth Atheneum, Hartford

Fig. 34A (right)
Detail of *Adam and Eve*

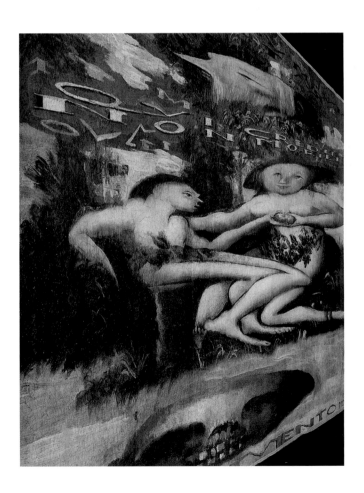

only from this extreme perspective are two biblical inscriptions in Latin from the Gospel of St John quoting the words of Christ which make the subject's religious meaning explicit: EGO SUM VIA [ET] VERITAS [ET VITA] / QUI CREDIT IN ME NON MORIETUR [IN AETERNUM] / MEMENTO MORI (I am the way and the truth and the life (John 14:6) / Whosoever liveth and believeth in me shall never die (John 11:26) / Think on Death). Conjoined with the image of the Fall of Man, the three inscriptions offer a warning against sin, a call to faith and salvation, and an admonition to be mindful of one's own mortality.

Other anamorphic curiosities gained wide popularity in the seventeenth century not only in Western Europe but also in China. These included anamorphoses that depended for their effects upon mirrored cones, cylinders, and pyramids that were placed in the middle of a circular or surrounding design. Reflections in the geometric surface offered the "corrected" view. Niceron and others described, diagrammed and produced these devices and many seventeenth-century examples have survived (see fig. 35). Again they address subjects from pornography to penitent saints and were regarded by some observers as little more than optical toys but were also considered a profoundly serious art form. Three centuries later, Dalí himself executed colored lithographs of cylinder anamorphoses that function on the same principles, depicting everything from a harlequin (fig. 36) to nudes and a skull (fig. 37).

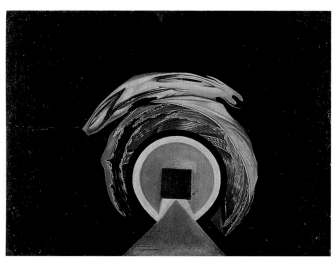

Fig. 35
Jean François Niceron,
Anamorphic Portrait of Louis XIII
Canvas 50 × 66.7 cm
Palazzo Barberini, Rome, inv.1954

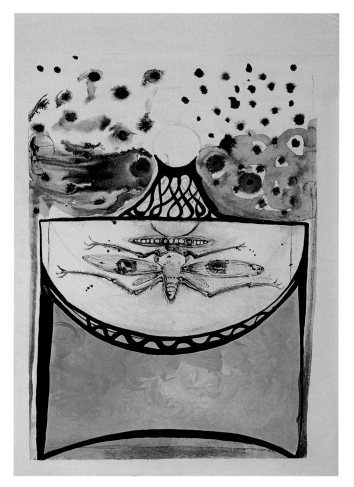

Fig. 36
Salvador Dalí
Anamorphic Image of a Harlequin
Colored Lithograph
Private Collection

However most of Dalí's expressively deformed images are not anamorphic images proper in the sense that they can be resolved simply by discovering the necessary viewpoint. Rather, his manipulation of form took a more liberated, mobile and freely creative approach. Dalí obviously admired the stretched, smeared and elided imagery of traditional anamorphosis as well as its capacity to encode internal visions and personal iconography. But his was a more sophisticated approach to perspective, which not only sought to accommodate the moving eye and the infinitely more complex world of Keplerian binocular sight, but also attempted to give form to the inner vision of modern psychology.

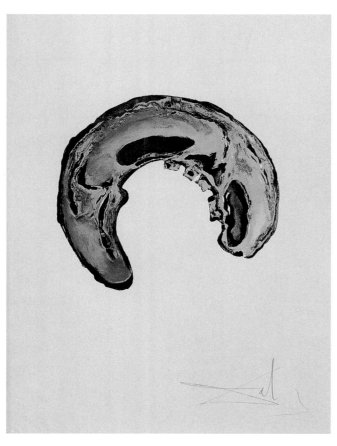

Fig. 37
Salvador Dalí
Anamorphic Image of a Skull
Colored Lithograph
Private Collection

Notes

1 On Arcimboldo, see Thomas Da Costa Kaufmann, "Arcimboldo's Imperial Allegories," *Zeitschrift für Kunstgeschichte*, vol. 39 (1978); Roland Barthes, *Arcimboldo* (1978); A.P. de Mendiargues, *Arcimboldo the Marvelous* (1977); and F. Porzio, *L'Universo Illusorio di Arcimboldi* (1979).

2 On anthropomorphic landscapes, see R. Hocke, *Die Welt als Labyrinth. Manierismus*, I (1957); and P. Hulten et al, *The Arcimboldo Effect; Transformations of the Face from the 16th to the 20th Century* (1987).

3 On anamorphosis, see J. Baltrušaitis, *Anamorphic Art*, trans. W. Strachan, (Cambridge, 1977); Museum of Fine Arts, Boston, *Anamorphoses. Games of Perception and Illusion in Art*, cat. by Michael Schuyt and Joost Elffers, 1975–76; E. B. Gilman, *The Curious Perspective: Literary and Pictorial Wit in the Seventeenth Century*, (New Haven and London, 1978); and Martin Kemp, *The Science of Art. Optical Themes in Western Art from Brunelleschi to Seurat*, (New Haven and London, 1990), esp. pp. 208–12.

4 Leonardo da Vinci, *Codex Atlanticus*, c. 1485, folio 35 verso, Biblioteca Ambrosiana, Milan.

5 C. Pedretti, *Commentary*, 2 vols. (Oxford, 1977), vol. 1, pp. 149-50.

6 See the exhibition catalogue, London, National Gallery, *Making and Meaning. Holbein's Ambassadors*, cat. by Susan Foister, Ashok Roy, and Martin Wyld, 1997–98.

7 See Christopher Brown, David Bomford, Joyce Plesters and John Mills, "Samuel van Hoogstraten: Perspective and Painting," in *National Gallery Technical Bulletin*, vol. 11 (1987), pp. 60–85. On Dutch perspective boxes generally, see Susan Koslow, " 'De wonderlijke perspectyfkas'," *Oud-Holland*, vol. 82 (1967), pp. 33–56.

8 The Atheneum's painting is fitted with a beautiful, early eighteenth-century Italian carved and silver-gilt frame, which features several holes on the vertical sides serving as viewing points. However it is not certain that the frame is from the same period as the painting since the positioning of the viewing holes is not optimally effective as one would expect if the fame was the original.

"I am not a madman":
Salvador Dalí in Hartford

Eric M. Zafran

In November of 1931 the brilliant, thirty-year-old director of the Wadsworth Atheneum, A. Everett ("Chick") Austin, Jr., who was renowned for his forward-looking taste and theatrical flair, drafted the following press release:

> *An event which will prove to be without question the outstanding novelty of the Hartford art season is the approaching exhibition of recent paintings of the French Super-realist School which will be privately opened to members of the Museum at a tea on Sunday afternoon, November fifteenth… About forty pictures borrowed from European and American collectors and dealers will illustrate the work of Andre Masson, Max Ernst, Joan Miro, Leopold Survage, Salvador Dali and Pablo Picasso…*
>
> *The exhibition will particularly feature the work of Salvador Dali, a Spanish painter, who will be introduced to America for the first time by the Wadsworth Atheneum. His pictures excited enormous comment in Paris last summer where his first exhibition amounted to something of a sensation.*[1]

Austin was not totally accurate, for in fact three early paintings by Dalí had been exhibited at the prestigious Carnegie International Exhibition in Pittsburgh during the fall of 1928. These relatively realistic works were *The Basket of Bread, Seated Girl*, and *Anna Maria*,[2] and they were noticed. The Pittsburgh *Post-Gazette* observed that "Dali is so interested in detail that he makes his painting 'Basket of Bread' almost morbid."[3] *The American Magazine of Art*, found that "Salvador Dali y Domenich combines pre-Raphaelite detail with modernist treatment of intersecting planes in a very interesting picture of a girl sewing, infinitely realistic and agreeably decorative."[4]

By the time his early works were being shown in Pittsburgh, Dalí was already evolving his surrealist style and making Paris his center of activity, preparing for the *succès de scandal* to which Austin alluded. Dalí's first Parisian one-man show at which he unveiled his new approach was at Galerie Goemans in the fall of 1929.[5] It was, however, in the summer of 1931 when Dalí showed again, this time at the Pierre Colle Gallery, that he was discovered by an American audience.[6] Chick Austin and his wife, Helen, sailed for Europe on June 6 and went first to Paris. Dalí's exhibition at the Colle Gallery was on view until June 15. We do not definitely know if they saw it, but it is probable, and if Colle had not met Chick, it seems doubtful that he would have responded positively to a cabled request later that year to send five works by Dalí to Hartford. Another American, who definitely did visit the exhibition and may have provided the introduction for Austin, was the young New York art dealer, Julien Levy. During the course of the exhibition Levy paid Colle $250 for *La Persistance de la mémoire*,[7] (fig. 38) which was the one work illustrated in Colle's little pamphlet-like catalogue. Dalí's Paris exhibition and the strange new painting acquired by Levy seem to have inspired him and Austin to plan their own exhibitions to introduce both this advanced movement and Dalí to America.

In later years Levy claimed full credit for creating the exhibition and for then graciously allowing Chick to present it first.[8] However, while Levy did assemble most of the works by Ernst, de Chirico, and several of the other surrealists, it was Austin who took the lead in organizing for Hartford the Dalí section comprising eight paintings and two drawings.[9] A cablegram and a letter of October 14, 1931, from Julien Levy and his gallery assistant, John McAndrew, to Chick indicates how shocking Dalí's work was then considered, McAndrew wrote, "Julien is not quite sure how much Dalí he dares show in the Gallery at once. He would, however, like very much to borrow from your show for one room to go with his room of Ernsts, which he had planned for January, but would adjust to suit you…" He also reported that "Mrs. Barr told me that Mrs. Murray Crane has bought a large Dali, which I thought you might like to look into."[10]

Chick was already eagerly soliciting works for his exhibition. His first cablegram to Pierre Colle inquired without preamble: "Could you lend five Dalis to exhibition at Hartford Museum beginning November 10. Strong possibility of sales. Pictures should leave immediately shipped our expense."[11]

The reply, in English, was positive, "Glad to cooperate with you. Am shipping immediately five pictures Dali."[12] Chick in turn responded, "Delighted. Prefer Dalis of size and quality of Julien Levys. Could you include three fine Massons? Mail titles."[13] In his answer, this time in French, Colle noted that he was sending the

Massons as well as Dalís. In addition he enclosed some photographs of other Dalís that were not being shipped, because they were not the same small size as the Levy one. These he noted were "the most recent paintings that Dali has done." Colle also supplied a list of titles and prices in French francs for the works by Dalí that he was sending:

Fantaisies diurnes	8000
Le Leve du jour	4000
L'Homme poisson	3200
La Solitude	4000
Paysage avec un chaussure	3800[14]

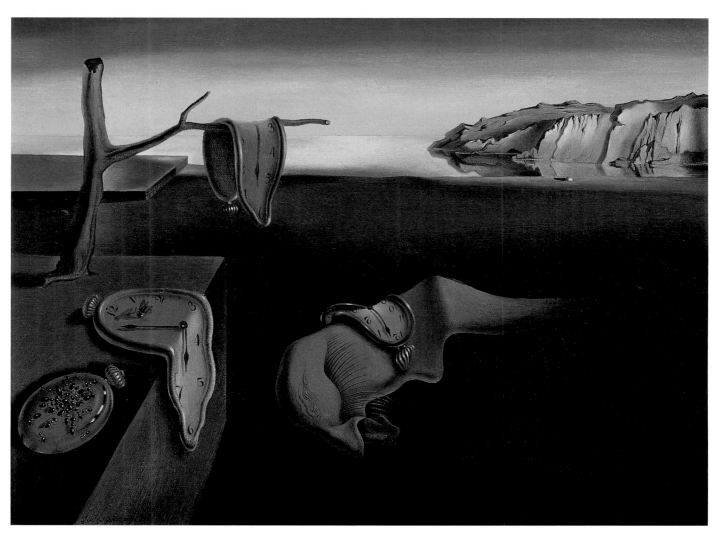

Fig. 38
Salvador Dalí
The Persistence of Memory (*La Persistance de la mémoire*)
Oil on canvas, 1931
The Museum of Modern Art, New York

Chick wrote to John McAndrew on October 16 that "Colle is lending me five Dalis and I hope some Massons, and, of course, Julien is quite welcome to the pictures after our exhibition. I am hoping that some of the Dalis will be sold in Hartford, but, if so, I am sure their owners would consent to lend them."[15]

Due to difficulties of shipping the works from Paris, the exhibition's opening had to be delayed until November 15, but in the meantime Chick tirelessly pursued other potential lenders. To A. Conger Goodyear, the first president of the Museum of Modern Art and a distinguished collector of contemporary art in New York, he wrote:

> I understand that last summer you bought a picture by Salvador Dali… I am wondering, since there are so few examples of his work in America, whether you would be willing to lend us your picture for that time. I am fascinated by Dali's work.[16]

Mr. Goodyear responded, "I will be glad to loan you the picture by Salvador Dali. I have not had it framed yet, but will do so at once," adding that he also had two drawings by Dalí and that "Mrs. Murray Crane has a very good painting by Dali, much better than mine."[17] Chick accepted all three of the Goodyear Dalís and reported that he had already written to Mrs. Crane; as to framing the work, "Julien Levy framed his painting by Dali [*The Persistence of Memory*] in a shadow box, similar to those used on Flemish primitives. The result was very exciting, since the picture was small and represented the utmost perfection of technique."[18] When it came to providing titles for his Dalís, Mr. Goodyear gave Chick a free hand, writing:

> I do not know what my Dali painting is called. Give it some such name as 'Beach' or 'Sea Shore.' Of the drawings one might be called 'Andromeda,' and the other 'Sacred and Profane' [scratched out and changed in pen to 'Sun and Sand']. However, these are only guesses, and I do not know if I can safely christen either of them. If you want to wait until you see them, you can call them what you like.[19]

Following up the leads received from McAndrew and Goodyear, Austin wrote a similar letter of inquiry to Mrs. W. Murray Crane,[20] who responded:

> My picture by Salvador Dali, of which you wrote me, has never been unpacked since I returned from Europe the end of August. It is in my apartment at 820 Fifth Avenue, New York, which is completely closed… However, if you want to leave it open and get in touch with me later on, I might be able to arrange it; though I feel somewhat hesitant having refused to loan it to one or two other exhibitions that wanted it.[21]

He may have wondered who else had been seeking to borrow Dalís, but Chick did get Mrs. Crane's *Le Sentiment de Devenir* (*The Feeling of Becoming*)[22] for the exhibition.

He had less luck with another New York collector, Mrs. Chester Dale. Chick had to write a second time, providing a description of Dalí's work as he then understood it:

> The picture to which I referred was a painting by Salvador Dali, a new Super-Realist painter whose work occasioned some excitement at an exhibition in the Colle Galleries in Paris last summer.
>
> It was rumored in New York that Mrs. Dale had bought one, but this may not be true. Dali's technique is an exact and minute one similar to that of early Flemish painters, and he likes to reproduce limp watches drooping over boards, and many ants and flies. Perhaps this will give you a clue to the picture.[23]

Mrs. Dale had not in fact purchased a picture by Dalí, but the exhibition planning continued. Since in May 1930 James Johnson Sweeney had described the surrealists as "Super-Realists with their predilection for the fantastic and mysterious,"[24] Chick titled his exhibition *Newer Super-Realism*. As James Thrall Soby, a progressive Hartford collector, later remembered Chick "used the word 'newer' primarily because Salvador Dali's advent on the Paris art scene had given surrealist art a new and important impetus." Julien Levy on the other hand argued for the use of the French name "Surréalisme" and would employ it for his own exhibition when it opened in January 1932.[25] In the Hartford show there were fifty works by eight artists including the leading masters, de Chirico, Ernst, Masson, Miró, and of course Dalí. In addition Chick had purchased from Julien Levy a selection of books on Surrealism and made them available to the public in the museum's

library. Among these were two by Dalí, *La Femme visible* and *L'Age d'or*.[26] The latter was also the title of the film by Dalí created in collaboration with Luis Buñuel, which was considered too shocking to show publicly, but Chick screened several films which he claimed were surrealist, as they portrayed "things as they might happen in the world of fancy free…[and] they are very psychological."[27]

The centerpiece of the entire exhibition, not unexpectedly, was Dalí's *La Persistance de la mémoire*. Julien Levy's price for it was $400, reduced to $350 for the museum. Since this was more than he had to spend, Chick acquired instead for only $120 one of Colle's loans – *La Solitude*[28] (cat. 8), making it the first Dalí to enter a museum collection.

In keeping with the French title of Levy's painting and the loans supplied by Mrs. Crane and Pierre Colle,

Chick dubbed Mr. Goodyear's painting *Au Bord de la mer*. This work is now in the Salvador Dalí Museum in St. Petersburg, Florida (fig. 39).[29] The two Goodyear drawings did receive the titles suggested by the owner – *Andromeda* (fig. 40),[30] later given to the Albright-Knox Art Gallery in Buffalo, and *Sun and Sand*. Of the other four works lent by Colle, *Fantaisies diurnes* (cat. 9) is also now in the Salvador Dalí Museum.[31] It is possible that *Le Leve du jour* is the painting in that same collection now titled *Shades of Night Descending*,[32] but more probable that it was the painting reproduced in the *Courant* as *Funereal Sentiment* (fig. 41), which is now generally given the title *Soft Watches*.[33] The work that Colle titled *L'Homme poisson* was also reproduced in the *Courant* (fig. 42). It shows a human head and torso formed by a clock and shoe as well as fish and has more

Fig. 39
Salvador Dalí
Au Bord de la mer
Oil, 1931
Salvador Dalí Museum, St. Petersburg

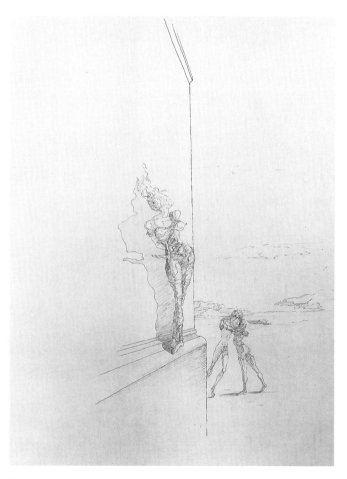

Fig. 40
Salvador Dalí
Andromeda
Pen and ink on paper, 1930
Albright-Knox Art Gallery, Buffalo

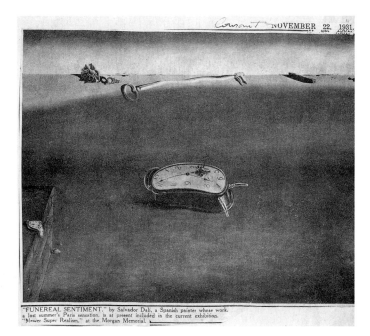

Fig. 41
Salvador Dalí
Funereal Sentiment (Soft Watches)
Reproduced in *Hartford Courant*, November 22, 1931

Fig. 42
Salvador Dalí
L'Homme poisson
Reproduced in *Hartford Courant*, 1931

recently been exhibited as *La Femme poisson*.[34] *Paysage avec un chaussure*, the final work from Colle, has not been identified.

The Hartford newspapers confronted with this, their first exposure to the new and unusual art of Dalí and the other surrealists, reacted on the whole with quite sophisticated responses. The *Courant* wrote on November 16:

> *While Chirico in his paintings destroys the old art, it is the world of common sense which dies a sudden death in the pictures by Dali. Dali paints real objects, for the most part and presents them with a more than photographical reality, so excellent is his technique and delicate his precision. But the objects are distorted or incongruously grouped.*
>
> *Dream landscapes are Dali's subjects, extremely simple, the ground being an absolute plane, extending to a terrifying distance. Into his dream world, he puts a few such natural objects as trees and rocks, exactly painted to give an illusion of reality. Then he inserts such objects as shoes, keys, eggs and clocks, common symbols (says the psychologist) for the hidden things of the subconscious. Delicate shades of blue predominate in the painting...*
>
> *All Dali's landscapes present the dream world in lovely color, form, and delicacy, with an occasional dash of ugliness and suggestion of death. Maggots on a watch, or an animal skull on the desert, are designed to emphasize beauty and life by presenting their opposites. The distant cliffs are sometimes of gold.*[35]

The exhibition, while certainly controversial, was judged a success.[36] Chick's aim to open the eyes of the locals and bring the wider world to town was at least in some small way succeeding.

On November 22 Julien Levy wrote Chick Austin saying, "There is so much material here in the Gallery for my Surrealist Show, that I have decided that it would be unwise for me to borrow the Colle Dalis and Massons to hang and be forced to keep my own things all wrapped up in dark storage. I shall write to Colle withdrawing my request tactfully. You can arrange to have them shipped back directly to Paris."[37] The following month, however, Levy had McAndrew write to inquire if one of the Dalís had been bought in Hartford and if so could he borrow it.[38] This was *La Solitude* (cat. 8), and by the end of the month, it was shipped to the New York exhibition.

In addition to it, and Levy's own *Persistence of Memory*, the only other Dalí on view was Mr. Goodyear's *Au Bord de la mer*. Despite the lesser number of Dalís, Levy's exhibition, as the first major New York showing of the surrealists, did attract attention. The *New York Times* critic called it "one of the most entertaining exhibitions of this season (possibly the most profound)." The following Sunday's art section reproduced the *Persistence of Memory* and noted that "the art of Salvador Dali, however difficult his subject matter may prove, is likewise safely to be recommended."[39] The *Art News* observed:

> *Salvador Dali is a clever painter with macabre yet forceful tendencies. His 'Persistance de la Mémoire' is a curious medley of watch dials which droop and drip all over a charming landscape, one of the foreground timepieces being cosily crowded by ants! Page Mr. Freud!*[40]

In April 1932 Austin organized an exhibition entitled *Trends in Twentieth Century Painting*, an assemblage of seventy-six paintings, drawings, and photographs. The loans included works by Picasso, Braque, Klee, Mondrian, the Neo-Romantics, and the surrealists, and came from the Atheneum, the Museum of Modern Art, and Chick's circle of friends, James Thrall Soby, Julien Levy, Philip Johnson, and Henry-Russell Hitchcock, Jr. The one Dalí included was surprisingly not the Atheneum's *Solitude,* but Levy's *Persistance de la mémoire.*[41]

Austin clearly loved and coveted *The Persistence of Memory*, so he conceived another exhibition for Hartford in 1933 that would bring the painting back yet one more time. This was *Literature and Poetry in Painting Since 1850.*[42] As James Thrall Soby later observed this "was a more difficult and courageous venture than the 1931 exhibition *The New Super-Realism*…[for] it was sheer heresy in 1933 to suggest that literature and poetry influenced painting after 1850."[43] In some cases it could be said that the juxtapositions were purposely meant to be jarringly surreal – a Picasso with a Bouguereau, a Eugène Berman with a Corot, and Gauguin with Arthur B. Davies. A photograph by Soby (fig. 43) reveals Dalí's little *Persistence of Memory* was hung between Gérôme's famous *L'Eminence grise* from the Boston Museum of Fine Arts and an enormous Kandinsky *Improvisation.* In the exhibition catalogue, which also reproduced the

Fig. 43
James Thrall Soby
Photograph of installation of *Literature and Poetry in Painting Since 1850*, Wadsworth Atheneum, 1933, showing works by Gérôme, Dalí, and Kandinsky
Museum of Modern Art Archives

Gérôme and Dalí on the same page, Henry-Russell Hitchcock, Jr. provided the justification:

> *To set apart poetic and literary painting is hardly to create a circumscribed category. For poetic literature has as many subdivisions and contradictory manners as painting itself. The Freudian dreams of Dali are not immediately comparable to the late Romantic musings of Gérôme. But Dumas is literature, and even acceptable literature, as well as Joyce.*[44]

The catalogue note for *Persistance de la mémoire* merely informed readers that Dalí was "a leader of the Surrealist movement, his photographic technique describes a dream world of terrible and fantastic decay."[45] Visitors were invited to vote for their favorite works on view. Bouguereau's academic painting *The Sisters* won, and the Dalí received only one vote.[46]

Levy's receipt for his loans to the exhibition now lists the price of Dalí's painting as $300 less 15%, or $255.00. Clearly it was still under consideration, since on November 10, Allen Porter, who had become Levy's gallery assistant, wrote from New York, "May I remind you that our Dali show is opening the 20th of this

month and that we'd appreciate it greatly if you would return the Dali you have at your earliest convenience next week. If you've decided to keep it, we will send it back immediately after the exhibition."[47] This was not to be. Chick was unable to raise the money, so the painting was shipped back to New York on November 16.[48] Although not included among the twenty-five works listed in the little brochure catalogue of Levy's exhibition, Dalí's first one man showing in America, it was reproduced, and the critic for the *Times* wrote that it was "quite as handsome as ever" and "in some respects still seems the most thoroughly 'representative' of the Dali works."[49] Shortly thereafter *Persistence of Memory* was purchased for the Museum of Modern Art by one of its trustees, Mrs. Stanley Resor,[50] and it has never returned to Hartford.

In November 1933 Austin and Soby decided Hartford was at last ready for a private screening of *L'Age d'or*, which Levy's Film Society had already presented in New York that March. Soby remembered years later that "since the living room in my West Hartford house was larger than his, we showed the movie there, I having hired a professional projectionist and invited a number of friends, mainly from New York, whom Chick and I thought might be interested." As Soby goes on to describe the event:

My living room was jammed with people sitting on funeral-parlor chairs. The audience seemed spellbound; there was loud applause at the end. Russell Hitchcock, a very old friend of mine, had introduced the film with a brilliant speech on the surrealist esthetic or anti-esthetic which ended grandly with the words, 'It is that I have already said too much.' And then he sat down to watch the film.

The evening went off smoothly with two exceptions. The projectionist became terribly nervous as the film wound on, and kept looking at the front door as though he knew the police would soon arrive and take us all away and his license as a projectionist with us. The second mishap occurred when some of our Catholic friends had become rather tipsy drinking at the bar below the living room. As the Prohibition liquor took hold, they became belligerent and began shouting up the stairs that if we didn't stop the film they would come up and destroy it. Fortunately the winding stairway was narrow, and it took only one reasonably fat person to block it entirely. I knew we and the film were safe...

I was fascinated by the imagery of the movie, and I wanted to see it through. All of us did see it to the end, as the battle cries below subsided to faint growls and snarls. The projectionist scurried out the door for home, elated by what he had to tell his wife.[51]

In 1934 the Atheneum borrowed two unsold Dalís from Julien Levy's 1933 show: *Remorses of Solitude*, 1931 and *The Invisible Man* (cat. 6), 1932,[52] and the Hartford *Daily Times* of July 6 made note of the "two small jewel-like Dalis, over which hangs the spirit of unreality and nightmare."[53] A letter of September 1934 from Chick Austin's secretary to Allen Porter at the Levy Gallery, arranging for the return of the loans, reported, "Your Dalis particularly created a stir."[54]

Levy continued to be Dalí's major advocate in New York. In April 1934 his gallery held a showing of Dalí prints, in the fall there was another Dalí solo painting exhibition, in which the Times found the "subject matter vexing," but the "craftsmanship superb."[55] Among the twenty-two works on view, most borrowed from Pierre Colle in Paris were a number of more recent delicate paintings by Dalí inspired by the beach at Rosas. From these Chick Austin selected another to add to the collection of the Wadsworth Atheneum – the exceptionally fine miniature-like *Paranoiac-astral Image* (cat. 15) which cost $620 [56]. Chick was later to write of it that Dalí "often tends, as in this example, to extend his landscapes into vast dreamy realms, haunted by the ghosts of his childhood (in this instance those of his father and nurse), and recalling for us the dreamy beauty of seashore post card views of the 1900's."[57] The painting is still in its original frame (fig. 44) – following the style that Julien Levy employed for his Dalís – a glass shadow box of thin wood, with the picture floating against a burgundy cloth backing.

Dalí and his wife, Gala, personally brought the paintings for Levy's 1934 exhibition, and with much attendant publicity arrived by ship for their first visit to America that November.[58] Undoubtedly encouraged by Julien Levy, the Dalís traveled to Hartford to attended the festive premier performance on December 6 of the Producing Company of the new School of American Ballet founded by Lincoln Kirstein and the choreographer George Balanchine.[59] Dalí and Gala were photographed for the local newspaper (fig. 45). The caption read, "Dalí is that famous modern painter best known in this country

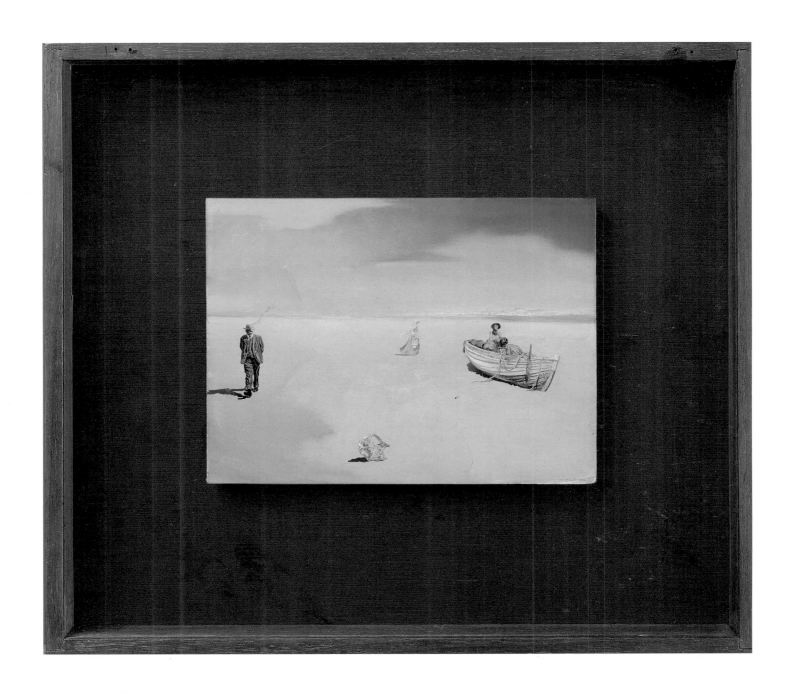

Fig. 44
Salvador Dalí
Paranoiac-astral Image
Framed
Wadsworth Atheneum, Hartford

for the little picture 'Persistence of Memory' some-
times known as 'The Wet Watches' which was shown
at the Morgan Memorial with several others in his
canvasses [sic]."[60]

At the post-performance party in the Sobys' West
Hartford home George Gershwin played selections from
his recently completed *Porgy and Bess,* and Dalí made
himself comfortable with Chick's attractive assistant
Eleanor Howland. As she later recalled, "we were sitting
on a little sofa having a rather animated and loud con-
versation. Dalí spoke ghastly French, but he seemed
to like the buttons on my dress." Eyeing these large
mother-of-pearl buttons, Dalí, his food fetish already
well-established, asked, "Madame, ces boutons – sont-ils
comestibles?" (Madame are those buttons edible?).[61]
It may have been on this occasion that Austin invited

Dalí to return to Hartford and present a lecture on his
art. It was the least the Spanish artist could do to
acknowledge his most loyal American patron. Thus
an invitation (fig. 46) addressed "For Members Only"
announced "A Conference in French with Salvador
Dali" for Tuesday Evening December 18, 1934 at 8:30
p.m. in the museum's Avery Auditorium. This date was
Chick Austin's birthday, and to make it more festive
there was to be "In addition to slides the Dalí Buñuel
film 'Un Chien Andalou' will be shown [and] an exhibi-
tion of Mr. Dalí's recent paintings will be held from
Dec. 18 through Jan. 7."[62]

In the course of his brief New York visit Dalí had
already presented an impromptu talk about his art at
the Casa de las Españas,[63] but for the more formal
setting of the new Avery auditorium some advance

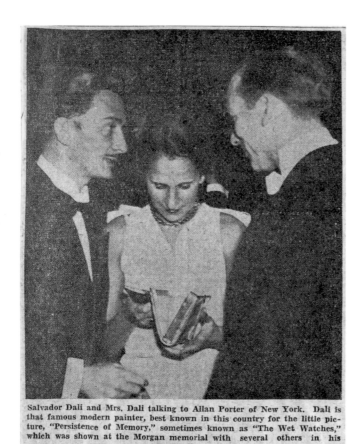

Salvador Dali and Mrs. Dali talking to Allan Porter of New York. Dali is
that famous modern painter, best known in this country for the little pic-
ture, "Persistence of Memory," sometimes known as "The Wet Watches,"
which was shown at the Morgan memorial with several others in his
canvasses.

Fig. 45
Dalí and Gala at Ballet Opening
Wadsworth Atheneum
Hartford Times, December 7, 1934

Fig. 46
Invitation to Dalí's lecture
Wadsworth Atheneum, December, 1934

planning was necessary. Therefore on December 10, 1934, Julien Levy wrote Chick Austin:

Realizing that the 18th is only a week away, I was wondering what arrangements had been made about transportation for the Dalis next Tuesday? Shall they arrive by train or is someone going to be in town to drive them up?

Also he has about twenty photographs which he wants to flash on a screen for illustrations. Last night at Mrs. Crane's we used a magic lantern but it isn't any good for projections over ten feet. Have you any arrangements for photographs? Or shall we have transparencies made here or send the photographs on to you in advance.[64]

As Joella Levy remembered it, she and her husband and the Dalís did travel by train to Hartford, and Dalí was amazed as they sped along by all the Christmas decorations on the houses, which reminded him of funeral parlors.[65]

Many distinguished lectures had been presented in Hartford, and movies were an integral part of Chick's conception of a living museum. However, a program such as this in French was a departure and to prepare the intended audience for the event, we have to assume it was Chick who provided the local journalists with informed advance commentary. An unsigned article in the *Hartford Times* on December 14 headlined "Dali to Lecture at Avery Tuesday," reminded readers that:

Dali is that surrealist painter whose works have created a sensation wherever they have been exhibited either in this country or in Europe, because of their extraordinary imaginative qualities. One of the most typical is 'Persistence of Memory,' wherein watches are draped over walls and limbs of trees, and an amorphous and horrible shape in the foreground further suggests the unreality of dreams.

An exhibition of the painter's work has just been held in New York in which even more startling symbols of psychopathic phenomena have been incorporated. Dali himself speaks of the necessity of painting "edible architecture" and explains the content of his pictures to the interest and satisfaction of a large proportion of contemporary connoisseurs.

Dali is not only a painter, but is well known in the other arts — as poet, writer of books and articles, including

the famous "Femme Visible," and creator, in all fields, of original expressions of twentieth century ideas.[66]

On the day of the lecture the same newspaper noted:

Of his own painting, he has said, 'I do all my work subconsciously. I never use models or paint from life or landscapes. It is all imaginative. That is I see everything in a dream as I am working, and when I have finished a picture, I decide what the title is to be. Sometimes it takes a little time before I can figure out what I have painted.'[67]

The contents of the lecture were thoroughly reported by the *Courant*[68] and were also the subject of a detailed account in the *New York Herald Tribune* of December 20 by Joseph W. Alsop, Jr., who had family ties to Hartford. This article was emblazoned with four headlines: "Dali Is Seeking A Place in Sun For Delirium / Sur-Realist Painter Uses Motion Picture to Explain His Aims in Hartford Talk / Likes his Dead Technique / Thinks His Phantasmagoria Has Surpassed Picasso's."[69] Alsop recounted:

Salvador Dali, youthful Catalan leader of the French sur-realist movement in painting demonstrated the principles of his school here last night at a lecture illustrated with a mildly surprising motion picture and slides of an even more surprising nature. Mme. Dali with her chin resting on an indeterminate cutlet, an ancient nurse sitting on the beach with a night table cut out of her torso standing at her side, a face in which the eyeball was suddenly slit by a razor — these were the commonplaces of the Dali lecture, in which he explained that he was showing how surrealism made dreams concrete...

Providing a complete picture of the evening, Alsop wrote, "The lecture began with an introduction by A. Everett Austin, director of the Atheneum, [who] evidently more apprehensive than at any of his previous efforts to make Hartford the new American Athens, introduced Mr. Dali and politely requested the audience not to be upset by the forthcoming motion picture." Following on his somewhat lengthy description of the Dalí–Buñuel film, Alsop then continued:

The audience gave a windy sigh of relief, which seemed to indicate they were not sorry explanation time had come, and Mr. Dali, a slight, swarthy man, with delicate features and a toothbrush mustache, walked onto the stage.

'It is perfectly natural for the public not to understand my pictures,' he remarked. *'I do not understand them at first myself. Then I begin to grasp the symbols which I can never explain. This is true of most sur-realist paintings.'*

… He says he paints them automatically. He was, he said, brandishing his pointer at a slide in which children, insects, entrails and more nameless objects were inextricably entangled, attempting to put the world of delirium on a par with the world of reality. He was, he explained, recreating dreams, so that one could see them in the midst of every-day objects. The world that he is investigating is the world Freud wrote of.

'The only difference between me and a madman,' he remarked calmly, *'is that I am not a madman. I am able to distinguish between the dream and the real world.'*

After more of Dalí's slides, which he used to stress his superiority to Picasso and to criticize "the angular modern architecture of Le Corbusier," Alsop continued:

Suddenly the last slide had been shown. The lights went on and there was Mr. Dali neat and expressionless as ever, confessing to the audience that whenever he lectured he always complimented himself on his imagination. It is ridiculous he concluded 'to refuse to dream objects the same reality which objects have in the real world.'

The audience, chiefly art students took the lecture …with an admirable calm…and then departed for Mr. Austin's near-by offices, where there was an exhibition of Dali's miniatures of horrors… Undoubtedly they were a little disappointed by the comparative mildness of the lecture. Mr. Dali explained carefully that he had lectured in Barcelona with a loaf of bread on his head, a famous anecdote in art circles, because there was a large audience which needed a brutal demonstration of sur-realist principle. Then there was a little sur-realist reminiscence in the intervals of bewildered congratulations.[70]

In his *Annual Report* for 1934, Austin in describing the year's lecture program, included as one of "the most notable" that on "Surrealist Painting by Salvador Dali, Catalan artist, who visited America for the first time this winter."[71] It was actually more noteworthy than he then realized. In his earlier impromptu talk at the Casa de las Españas, Dalí, as reported by a Spanish language newspaper, had stated, "I paint automatically and it is related to what the mad do with the only difference that I do not confuse the imaginative world with the real one."[72]

But as Dalí or Alsop rephrased this, it became in the Atheneum lecture, the memorable dictum: "The only difference between me and a madman is that I am not a madman." This and a condensed version of Alsop's account were reprinted under the headline "'Not a Madman!' – Dali" in the January 1 issue of *The Art Digest*. Over the succeeding decades this apothegm was to become a veritable mantra for the painter.[73]

Those who wanted to confirm the validity of Dalí's statements on his art could avail themselves over the next two weeks of the opportunity to visit the director's office at the Wadsworth Atheneum, where Austin had installed an exhibition of a group of small works by Dalí. Julien Levy had closed his own Dalí show just a week before and sent nine framed paintings in shadow boxes and two unframed drawings to Hartford.[74] Although there was no published list of these works,

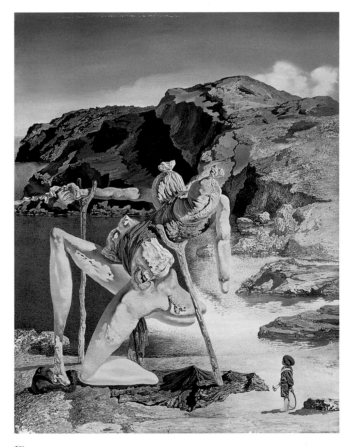

Fig. 47
Salvador Dalí
The Specter of Sex Appeal
Oil on panel, 1934
Fundació Gala-Salvador Dalí, Figueres

it is possible to determine from the newspaper descriptions that they included, in addition to the *Paranoiac-astral Image* (cat. 15) purchased by the Atheneum, the 1929 *Imperial Monument to the Child-Woman*, now in the Reina Sofia, Madrid. *The Specter of Sex Appeal* (fig. 47), now in the Dalí Foundation at Figueres, *Enigmatic Elements in a Landscape* now in a private collection, and *The Specter of Vermeer* (fig. 48) and *The Portrait of Gala* (fig. 49), both now in the Salvador Dalí museum, St. Petersburg. Also now at this last institution and also included in the present exhibition were the two paintings *Skull with its Lyric Appendage Leaning on a Bedside Table which should have the exact Temperature of a Cardinal's Nest* (cat. 18) and *Myself at the Age of Ten When I was the Grasshopper Child* (cat. 13).

After Dalí's presentation in the Avery Theater was finished, he was taken to a party at the home of Paul Cooley, Chick Austin's wealthy assistant and a budding collector and dealer. This must have been a jovial occasion for in the course of it Dalí misplaced his lecture notes. Not until December 26, however, did Julien Levy write to Austin that "Dali has been contracted for a lecture at the Museum of Art Nouveau Jan. 11th, and asks me to ask you if you would lend the slides, sending them down collect in time for the lecture, and also his lecture notes which he forgot chez Cooley?" Levy goes on to say that Dalí "leaves the land of the brave and the dear (U.S.) on the nineteenth of next month, and desires an accounting with me before then. What information can you give me to tell him re. the payment of your pictures? Is it possible for me to assure him payment by some definite date? When also will the pictures be returned?" Chick's assistant replied, "We have sent down the Dali slides and in a separate package, the notes for his lecture. The latter

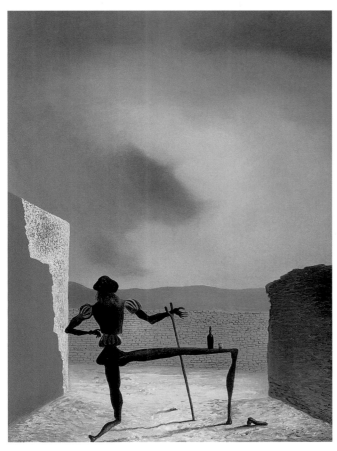

Fig. 48
Salvador Dalí
The Ghost of Vermeer of Delft which Can be Used as a Table
Oil on panel, 1934
Salvador Dalí Museum, St. Petersburg

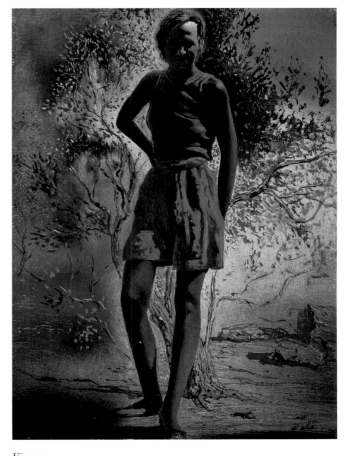

Fig. 49
Salvador Dalí
Portrait of Gala
Oil, 1933
Salvador Dalí Museum, St. Petersburg

finally came to light in the Cooley solarium, where they must have been flung in the heat of the dance… Mr. Austin has been wondering whether any one down there would have the time to translate the notes, particularly those on the slides."[75] Unfortunately no one seems to have done so, and thus the newspaper accounts remain our best source of the Hartford talk. Dalí did give another séance with slides in Spanish at the Casa de las Españas on January 7.[76] This was then followed by his full blown performance at MOMA with Levy himself acting as translator.[77] It became a somewhat surreal event, as Dalí deliberately added indiscreet comments to his prepared text. Then when one of the slides was projected upside down, Dalí "asked the viewers to tip their heads to attain the desired effect, producing several moments of curious amusement."[78]

For Dalí the positive result of his lecture and exhibition in Hartford was the sale of several works. In addition to the *Paranoiac–astral Image*, the Atheneum also acquired for $100 a handsome sheet of Ingres-like pencil studies of the back view of a boy, a female torso, and details of a hand and an arm (fig. 50).[79] Austin later wrote of it, "Dalí's exquisite mastery of line and form is here delicately revealed in an almost academic statement."[80] From among the works shown in Chick's office, James Thrall Soby later purchased his first Dalí, *The Ghost of Vermeer* (fig. 48) for $450. He also added a drawing of figure studies similar to the Atheneum's but dated 1935.[81] Dalí gave or sold his party companion, Nellie Howland, a hitherto unpublished study (fig. 51) for the nurse in his 1934 painting *The Weaning of Furniture–Nutrition*.[82] Dalí's host Paul Cooley also received a vivid ink drawing, *Specter of the Picador* dated 1934 and inscribed "à Paul Cooley très amicallment." On the verso there is a study of a nude woman (figs. 53 A & B).[83] Chick Austin had also acquired, perhaps from Levy's exhibition of Dalí etchings, an impression of the artist's first independent print, *Enfant sauterelle* (or *Grasshopper Child*) of 1933 (cat. 14).[84]

Dalí's ever-increasing fame was evident from many sources. *The Persistence of Memory* rapidly became, in the words of the Museum of Modern Art's Monroe Wheeler, Dalí's "trade mark." It was exhibited in the *Century of Progress* at the Chicago World's Fair, and widely reproduced in everything from the *Columbus Dispatch* to an article by E.M. Benson on "Phases of Fantasy." This author observed that "Dalí's

fantasy – for we must grant that he has it, even though it isn't entirely his – is the offspring of a hyper-literal imagination, somewhat akin to putting one's dreams under a microscope."[85]

In late 1936 Dalí was featured on the cover of *Time Magazine* when he returned to New York City for yet another solo show at Julien Levy's gallery as well as to be present for the opening of the major exhibition organized by Alfred Barr at the Museum of Modern Art, *Fantastic Art Dada Surrealism*. To this Mr. Soby lent his *Ghost of Vermeer of Delft*.[86]

During the course of the next few years, examples of Dalí's work continued to be selected by Austin for inclusion in Atheneum exhibitions. These often stressed

Fig. 50
Salvador Dalí
Back of a Boy, Female Torso, Study of an Arm
Graphite drawing, 1934
Wadsworth Atheneum, Hartford

Fig. 51
Salvador Dalí
Study of the Nurse for *The Weaning of Furniture–Nutrition*
Pencil, 1934
Wadsworth Atheneum, bequest of Eleanor Bunce, 1999

Fig. 52
Salvador Dalí
Geodesical Portrait of Gala
Oil, 1936
Yokohama Museum of Art

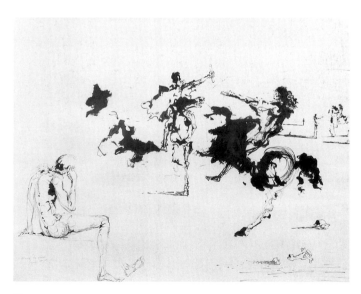

Fig. 53A
Salvador Dalí
The Specter of the Picador, recto
Pen and ink, 1934
Coll. Jeff Cooley

Fig. 53B
Salvador Dalí
Nude in Back View, verso
Pen and ink, 1934
Coll. Jeff Cooley

the continuity between old masters and the moderns, as for example the 1937 exhibition *43 Portraits* in which the forty-third portrait was Dalí's *Geodesical Portrait of Gala*. This haunting back view of Gala (fig. 52) had been exhibited by Julien Levy that same month and was now described as lent through the courtesy of his Gallery "from a private collection."[87] Although the contractual owner was Dalí's English patron, Edward James, the Dalís retained their grip on the work, and Levy sent Chick a note stating that he had "persuaded Dali to say yes on the portrait,"[88] and that he was sending the photo of it, which appeared in the catalogue.

Dalí later described this painting as "one of his best,"[89] and kept it all his life.[90] Copies of the exhibition catalogue were sent to the painter directly and also care of the Levy Gallery, but Dalí does not seem to have received them, or wanted additional ones. He had the gallery request another on May 4,[91] and he himself sent a postcard to Chick and Helen that winter from Austria asking for more (fig. 54).[92]

The most concentrated assemblage of the surrealists, as Chick was now willing to call them, appeared in Hartford early in 1938 as part of his exhibition *The Painters of Still Life*. In the company of Breughel, Chardin, Meléndez, Monet, Picasso, and other old and new masters were to be found examples by Magritte, Miró, Roy, Arp, and Joseph Cornell. By Dalí there was the somewhat unexpected *The Accommodation of Desires* (fig. 55), a key painting of 1929 that had belonged to André Breton and was now owned by Julien Levy.[93] Austin and his co-organizer Henry-Russell Hitchcock, Jr., in their joint introduction, which was also printed in *Art News*, claimed that with the advent of Surrealism: "The object in the startling guise of 'dream object' rose on the analogy of a Freudian parable."[94] The Dalí was

Fig. 54
Postcard from Gala and Salvador Dalí to Chick Austin, 1937

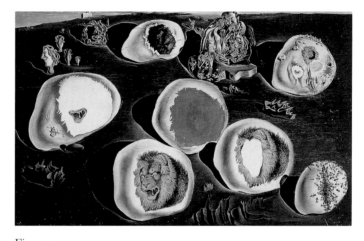

Fig. 55
Salvador Dalí
The Accommodation of Desires
Oil and collage on board, 1929
The Jacques and Natasha Gelman Collection, The Metropolitan Museum of Art, New York

one of the few works illustrated in the catalogue, where it was noted, "The Catalan Dalí, at present the avowed pictorial leader of the surrealist movement, makes concrete the poetic irrationalities of the dream-world with the aid of a microscopic technique related to that of the seventeenth century Dutch painters of still-life."[95]

As he had done before, Chick Austin prepared a questionnaire for the attendees at the opening night gala, and the *Hartford Times* reported that while Heda's "Richly Decked Table" was voted the favorite piece, Dalí's painting was found "least understandable to the greatest number."[96] Despite the popular unpopularity of Señor Dalí, the Atheneum's director and his circle remained enamored of the artist. James Thrall Soby added to his ever-growing holdings a major work of 1937, *The Invention of the Monsters*.[97] The following year, 1939, Austin was able to acquire for the Atheneum one of Dalí's most important paintings. The Spanish artist had returned to America for another showing of his work at Levy's Gallery. With his dealer's help, Dalí set about marketing himself in New York even more aggressively than before, getting arrested for smashing a Bonwit Teller display window and designing for the World's Fair the dubious *Dream of Venus,* which with its bevy of scantily clad mermaids led the *Art Digest* to succinctly observe, "Freud + Minsky = Dalí."[98]

Of more significance was Levy's exhibition for which there was an elaborate large-format catalogue. The group of twenty-one paintings and five drawings comprised mainly what Dalí referred to as his "paranoiac pictures" with their "double-images." In his catalogue text the painter claimed, "the first 'systematic research' of the problem, I may state begins with the picture featured in my present exhibition, *The Endless Enigma* (fig. 22) Therein appear, instead of a double image, six different images – thence to the limits of imminent metamorphoses."[99] *The Endless Enigma* and the six superimposed images that compose it were reproduced in the catalogue (fig. 31.1). *Life Magazine* trumpeted: "New Yorkers stand in line to see Dalí's six-in-one Surrealist painting," and went on to report that "for general popularity there hadn't been such an exhibit since Whistler's *Mother* was shown in 1934." The magazine added, that "after two weeks Dalí, already one of the richest young painters in the world, had sold 21 of his works to private collections for more than $25,000."[100] However, the *Endless Enigma* priced at $3000 did not sell.

The work which Austin chose for the Atheneum was the exhibition's other grand example of complex imagery, *Apparition of a Face and Fruit Dish on a Beach* (cat. 31).[101] Like Dalí, Chick was fascinated by double images and *trompe l'oeil* effects. At the Atheneum he had exhibited Raphaelle Peale's *After the Bath*, and he had already purchased a variety of such inventive works, ranging from Arcimboldo to Harnett and Louis Fernandez (fig. 56).[102] Levy shared this interest and had presented his own exhibition of *trompe l'oeil* in the spring of 1938, for which he borrowed two American paintings from the Atheneum.[103] *The Apparition of Face and Fruit Dish on a Beach*, which *The Art Digest* described as one of Dalí's "visual puns…wherein a dog and a bowl of fruit become a now-you-see-it-now-you-don't landscape,"[104] would be the Atheneum's supreme example of *trompe l'oeil*. At the end of April 1939,

Fig. 56
Louis Fernandez
Still Life
Oil on panel, 1936
Wadsworth Atheneum, Hartford

Julien Levy wrote Chick, "Your Dali is ready for delivery – enormously heavy, equipped with plate glass impossible to take up in the car unless out of the frame – I suppose you wish Budworth to ship it, but please confirm." The bill dated May 1 was for $1750.[105]

In a lengthy article in the *Hartford Times*, Marian Murray announced the purchase of the painting. Her text was undoubtedly derived from statements made by Austin. Under the heading "Paranoiac Phenomenon Seen in Large Surrealist Painting," she wrote:

The picture is, as the title implies, an example of the 'double-image' genre which is Dali's latest mode, and combines images of the face and the fruit-dish, whole or part, worked into a composition which includes small landscapes, many figures, human or fantastic, and numerous small objects. Looking at the painting, the observer sees at one time, for instance, a fruit-dish with its pedestal, at another the human face that emerges from the contours of the dish, and still again the features of the face as unrelated objects. For instance, the left eye is really a small jar lying on the beach; the right eye is the head of a small human figure placed upside down.

Then to explain further, she quotes several paragraphs from Dalí's text for the Levy Gallery's catalogue in which he places the double images in the line of cave paintings, Aristophenes, and the images of Bracelli and Arcimbaldo, concluding, "Since my first paranoiac pictures 'double images' have been distinctly manifest in the bosom of the surrealist movement…"

Ms. Murray concludes by trying to assess Dalí's achievement and place in history:

The general public still does not know just what to think of Dali and his painting. It flocks to see the windows he decorates; it accepts the fantastic feminine hats that were inspired by surrealism; it recognizes the extraordinary craftsmanship in his pictures; it reacts bewilderedly to the fantastic, abnormal and somewhat sinister atmosphere that pervades them; it tries hard to see what the artist is driving at. Some persons rejoice in the beauty of the painting, though they may protest that such perfection of technique is wasted in an unworthy cause; others find satisfying stimulation in the subject matter itself.

Just where surrealism will stand in the light of perspective, no one yet knows. Certainly it is already accepted as a vital movement and given a serious attention which is itself remarkable when one recalls the

hoots of derision that greeted such paintings as 'La Persistence de la Memoire' (those Wet Watches) when they were first shown here nearly ten years ago.[106]

Further approbation of the work came in 1941 when the painting was lent to the Museum of Modern Art and served as a dramatic centerpiece on one wall (fig. 57) in the joint Miró and Dalí exhibitions.[107] *Apparition* was also the most important Dalí in a widely traveled and reviewed exhibition *Abstract and Surrealist Art* of 1944.[108] Austin himself in one of the brief texts he composed on the Atheneum's Sumner collection in the mid-1940s, clearly remembering Dalí's lecture of 1934, wrote insightfully of the painting:

In this picture a quintuple image is fused with great ingenuity and fantastic result. The influence of Leonardo de Vinci may be detected in the drawing of the small figures in the background. Leonardo, who imagined shapes projected by the spots on a moist wall, spasmodic and almost paranoiac inventions of his own imagination, has obviously a particular interest for Dali.[109]

Showman that he was, Chick every winter presented a magic show with himself as The Great Osram, and that for 1939 was the most elaborate he had yet conceived. "The Magic of Tomorrow," was set in 1995, the program noted that Austin as Magician no. 3378 wore "a knitted helmet executed by Mme. Schiaparelli after a design by Salvador Dali."[110] A photograph in the Atheneum's Archives (fig. 58) allows us to obtain a somewhat fuzzy impression of this bizarre headgear, actually a Dalí-inspired Schiaparelli ski mask.[111]

Dalí himself returned to Hartford and environs for several weekend visits, usually with the Sobys in Farmington.[112] On one such occasion, perhaps in May 1939 Soby took a photograph of the furtive-looking artist out of doors at his Farmington home (fig. 62). Soby recalled a time when Dalí, Gala, and their patron, Edward James, all visited (fig. 59). It was not at all easy. Dalí explained that "J'ai une folie de bois," so Soby had to pile logs around the painter's bed before he would go to sleep. Then at breakfast Dalí regaled him with his theory that "Christopher Columbus had been a paranoiac and a Catalan paranoiac at that…[since] being a paranoiac he had to believe that the world was round because then he could circle it forever and keep ahead

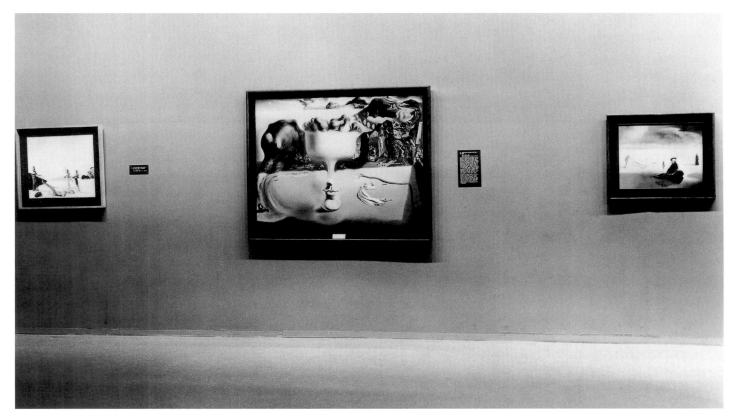

Fig. 57
James Thrall Soby?
Installation of Dalí exhibition, Museum of Modern Art, New York, 1941–42
Museum of Modern Art Archives

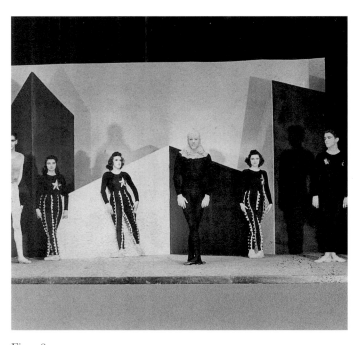

Fig. 58
"The Magic of Tomorrow," Wadsworth Atheneum, 1939
Chick Austin wearing mask by Schiaparelli after Dalí
Atheneum Archives, Hartford

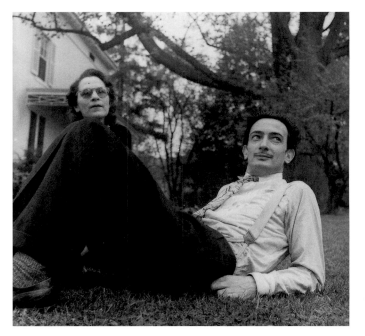

Fig. 59
James Thrall Soby
Dalí and Gala at Soby's Farmington Home, 1939
Private collection

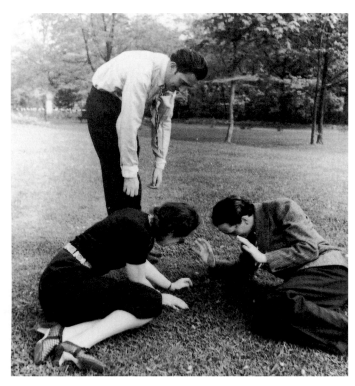

Fig. 60
James Thrall Soby
Dalí, Gala, and Edward James looking for four-leaf
clovers at Soby's Farmington home, 1939
The Museum of Modern Art Archives, New York

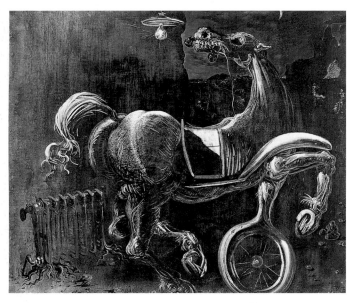

Fig. 61
Salvador Dalí
*Debris of an Automobile Giving Birth to a Blind
Horse Biting a Telephone*
Oil on canvas, 1936
The Museum of Modern Art, New York,
James Thrall Soby Bequest

of his pursuers." When Soby protested that Columbus
was Italian, Dalí heatedly answered, "Impossible, impos-
sible. The Italians dream of love and music. It is only the
Catalans like Columbus and myself who have mad and
impossible dreams." This "curious weekend" continued
when "at Gala Dalí's insistence," the guests "spent most
of their time crawling around the lawn in search of four-
leaf clovers, in whose protective powers Gala believed
implicitly."[113] This unlikely activity was also recorded
by Soby's camera (fig. 60). When they finally tired of
this, Soby took them down town to the Wadsworth
Atheneum, perhaps to see the painter's recently installed
Apparition. In any case for lunch they went to the
nearby bastion of Yankee conservatism, The Hartford
Club, where Soby was a member of long standing.
He relates what then transpired with his characteristic
understated humor:

> *As we walked through the door, Dali suddenly whipped
> out of his pocket a Catalan Hat of Liberty and plunked
> it on his head. It had been a relatively sane hat to begin
> with but on its side Gala or someone else had embroidered
> a plate of fried eggs, for Dali an obsessive symbol at the
> moment. He wore the hat, unperturbed, throughout lunch
> and then rose to make a speech. I looked around in panic
> at the room full of my father's friends and other digni-
> taries of the community and managed somehow to yank
> Dali back into his seat. Otherwise the town elders would
> have been forced to listen to a dissertation on the hidden
> sexual symbolism of Millet's painting, The Angelus.
> This was something I thought they should be spared in
> the middle of their lunch. But Dali glared at me all the
> way home, as though Demosthenes had been stopped in
> mid-sentence spitting out pebbles.*[114]

Soby did manage to remain friends with the painter
for some years yet and continued to collect his work.
From the same Levy exhibition of 1939 at which Chick
had purchased the *Apparition*, Soby bought *Debris
of an Automobile Giving Birth to a Blind Horse Biting
a Telephone* (fig. 61).[115] This he lent to what would be
Chick Austin's last major loan exhibition, *Night Scenes*,

Fig. 62 (right)
James Thrall Soby
Dalí at Soby's Farmington Home, 1939
Atheneum Archives, Hartford

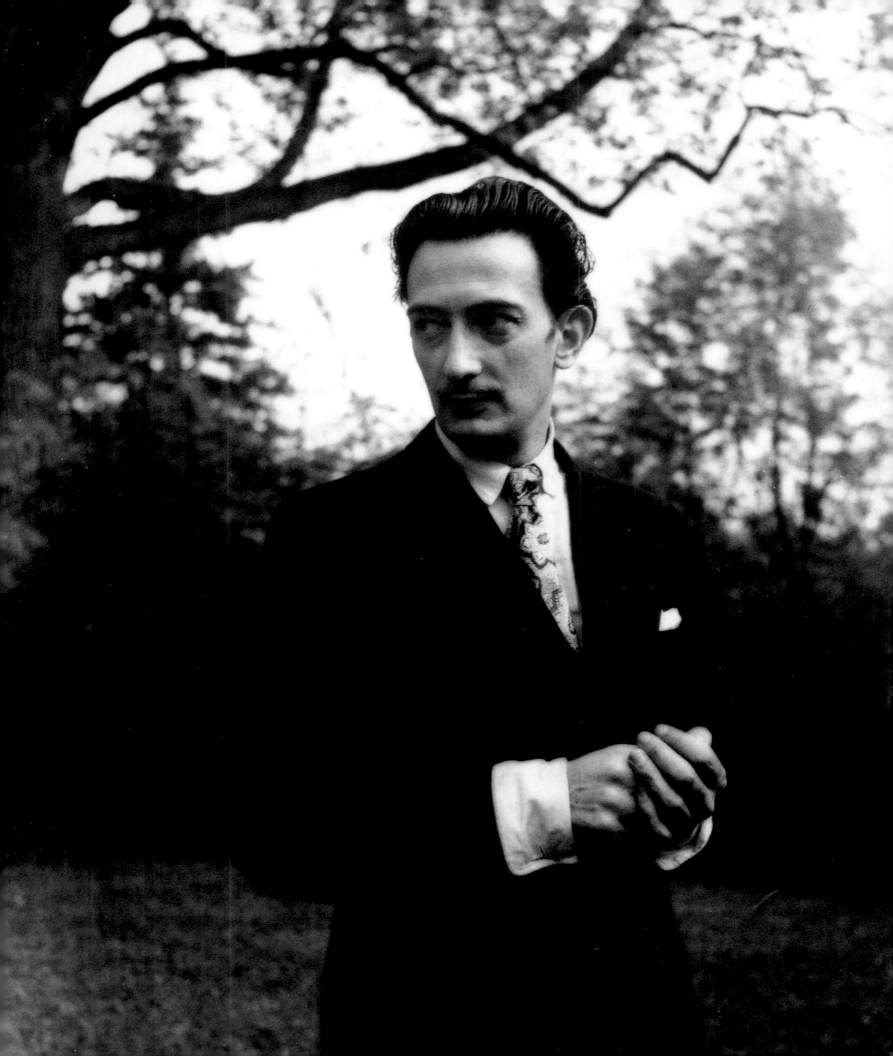

in 1940. The director organized this in part to highlight the great Caravaggio *Ecstasy of St. Francis* that he was eager to add to the museum's collection, but the theme also allowed him to present a wide range of works from the Renaissance through the "third decade of the twentieth century." He noted in his Introduction, "that the Surrealists are not attracted except occasionally by nocturnal subjects, can be explained by the fact that they normally seek to make vivid and concrete in terms of the day the dreamed irrationalities of the night."[116]

It was Soby who organized the Dalí exhibition for the Museum of Modern Art in 1941. From his own collection he was able to lend anonymously five works. These were in addition to *Debris of an Automobile, The Specter of Vermeer, The Invention of the Monsters,* his drawing of a nude, and an early *Basket of Bread* of 1926.[117] Soby found much to his surprise that "of the contemporary artists whose exhibitions I directed at the Museum of Modern Art, the easiest to work with was the first — Salvador Dali." He allowed Soby to install the exhibition without any interference and only arrived to see it at the *vernisage* and then "not once did he object to the installation after he'd seen it."[118]

At the same time as Soby's career was ascending, Chick Austin found his activities at the Atheneum winding down, due to a combination of strained relations with the trustees and limitations imposed by the war. Yet, because of the latter, he was able to mount one last primarily surrealist exhibition. In 1942 a large number of works were transferred from Julien Levy's gallery to the Atheneum for safekeeping. This allowed Chick to present *Painters of Fantasy*.[119] As Marian Murray reported it was "an exposition of contemporary fantastic painting," and she goes on to say that:

> *Many of the best known Surrealist and Neo-Romantic names are represented... There are examples of the 'double-image' which has come to be recognized as one of the most characteristic notes of contemporary fantasy. Here is the way Dali uses it, in a drawing called 'The Image Disappears.'*[120]

This last was most likely one of Dalí's several fine studies for the painting of the same name (cat. 32).[121]

When during the spring of 1943, Julien Levy's gallery, following the pattern of the *Newer Super-Realism* exhibition of 1931, presented an exhibition of paintings by the Mexican artist Jésus Guerrero Galván, which had premiered in Hartford,[122] Levy wrote to Austin, comparing these works to the most recent Dalís:

> *I find them charming and 'digne'. But they haven't the immediate 'buy appeal' that Dali has. Dali's paintings I think are hypnotic. The new ones are certainly a high in brilliant vulgarity. But good or bad the first reaction to a Dali show is to buy quick before the other fellow gets the picture. It is fantastic, how pictures can behave like personalities.*[123]

Thanks to Austin's passionate reaction to Dalí, the Wadsworth Atheneum has three remarkable paintings, one drawing, one print, and a lasting place in the history of Surrealism in America.

*　　*　　*

In preparing this essay I received great help from Eugene R. Gaddis, archivist of the Wadsworth Atheneum, and his assistant, Ann Brandwein. Other resources supplying important information for which I am grateful were the Archives of the Museum of Modern Art, the Getty Research Institute, and the Salvador Dalí Museum. Thanks are also due to Peter Soby for permission to quote from the letters and autobiography of his father.

Notes

1 Typewritten draft with pencil corrections in the Archives of the Wadsworth Atheneum.

2 *Catalogue: Twenty-Seventh Annual International Exhibition of Paintings*, Carnegie Institute Pittsburgh, October 18 – December 9, 1928, nos. 361–63.

3 "Moderns Also Have Part in Show at Carnegie Institute Galleries," *Post–Gazette*, Pittsburgh, October 19, 1928.

4 Elisabeth Luther Cary, "The Carnegie International Exhibition," *The American Magazine of Art*, XIX, no. 12, December 1928, p. 656.

5 *Dali*, La Galerie Goemans, Paris, November 20 – December 5, 1929.

6 *Exposition Salvador Dali*, Pierre Colle, Paris, June 3–15, 1931.

7 See Julien Levy, *Memoir of an Art Gallery*, New York, 1977, pp. 70–71.

8 Levy, 1977, p. 81.

9 Deborah Zlotsky, "Pleasant Madness in Hartford: The First Surrealist Exhibition in America," *Arts Magazine*, v. 60, no. 6, February, 1986, pp. 55–66.

10 Cable and letter from McAndrew to Austin, October 14, 1931.

11 Cable from Austin to Colle, undated October 1931.

12 Cable from Colle to Austin, October 14, 1931.

13 Austin to Colle, October 16, 1931.

14 Colle letters and list to Austin, October 15, 1931 and October 22, 1931.

15 Austin to McAndrew, October 16, 1931.

16 Austin to Goodyear, October 14, 1931.

17 Goodyear to Austin, October 15, 1931.

18 Austin to Goodyear, October 16, 1931.

19 Goodyear to Austin, October 19, 1931.

20 Austin to Mrs. Crane, October 14, 1931.

21 Mrs. Crane to Austin, October 16, 1931.

22 Robert Descharnes, *Salvador Dali: The Paintings 1904–1946*, Cologne, 1997, no. 394. The painting is now in a private collection, for which see exh. cat. *Surrealism: Two Private Eyes*, Solomon R. Guggenheim Museum, New York, June – September 1999, vol. 1, p. 101, no. 47.

23 Austin to Mrs. Bullard, October 20, 1931.

24 J.J. Sweeney , "A Note on Super-Realism," *The Arts*, May 1930, p. 612.

25 James Thrall Soby unpublished autobiography, manuscript in Wadsworth Atheneum Archives, chapter 9, p. 19; and Levy, 1977, p. 137.

26 Invoices and list of books from Julien Levy Gallery to Wadsworth Atheneum, October 27, 1931, December 28, 1931 and February 6, 1932.

27 "Super Realist Films To Be Shown Here," *Hartford Courant*, November 30, 1931. (All Hartford newspaper references are to articles found in the Atheneum Archives' scrapbooks). The films were René Clair's *Le Million*, Cavalcante's *Le petite Lili*, and Ralph Sterner's *Surf and Seaweed* and *Mechanical Principles*.

28 Information from an undated list from Julien Levy Gallery, 1931 and according to the Atheneum's registrarial files.

29 Descharnes, no. 395; According to correspondence of July 9, 1945 from Mr. Goodyear to A. Reynolds Morse in the files of the Salvador Dalí Museum, St. Petersburg, Goodyear purchased the picture from Levy and gave it to his son, who later sold it to the Bignou Gallery, New York who in turn sold it in 1946 to Dr. Charles Roseman of Cleveland. Mr. Goodyear himself went on to buy from Levy another significant Dalí, *The Transparent Simulacrum of the Feigned Image*, 1938, given to the Albright-Knox Art Gallery, Buffalo and included in the present exhibition, cat. no. 30.

30 Descharnes, no. 371.

31 Descharnes, no. 407. Although the spelling of the title is given as "Fantaisies " in Colle's original letter and in Descharnes catalogue, the work is actually inscribed "Fantasies." Since it was shown in Hartford in 1931, its date clearly can not be 1932.

32 Ibid, no. 373.

33 Ibid, no. 455, which should now also be dated to 1931. There was in Colle's 1931 exhibition one work titled *Le Sentiment funebre*.

34 See Guggenheim, 1999 (note 22), vol. 1, p. 93, no. 39.

35 "Super-Realist Works Shown at Memorial," *Hartford Courant*, November 16, 1931, p. 4.

36 See Austin's "Report of the Director," *Wadsworth Atheneum, Annual Report*, 1931, p. 5.

37 Levy to Austin, November 22, 1931.

38 McAndrew to Austin, December, two letters one undated and the other of December 22, 1931.

39 *Surréalisme*, Julien Levy Gallery, New York, January 9–29, 1932, and the following reviews: E. A. Jewell, "A Bewildering Exhibition," *New York Times*, January 13, 1932, p. 27; and idem, "Comment on Current Exhibitions," January 17, 1932, p. X 12. Also see Ingrid Schaffner, "Alchemy of the Gallery," in *Julien Levy: Portrait of an Art Gallery*, Cambridge, MA., 1998, pp. 34–35.

40 "Surrealism – Julien Levy Gallery," *Art News*, January 16, 1932, p. 10.

41 *Trends in Twentieth Century Painting*, Slater Memorial Museum, Norwich, CT, April 11–26, 1932, no. 11.

42 *An Exhibition of Literature and Poetry in Painting Since 1850*, Wadsworth Atheneum, Hartford, January 24 – February 14, 1933.

43 Soby ms. chapter 4, p. 13.

44 H.R. Hitchcock, "Explanation," *An Exhibition of Literature and Poetry in Painting since 1850*, Wadsworth Atheneum, Hartford, 1933, p. 6.

45 Ibid., p. 12.

46 See the Hartford *Courant*, February 6, 1933.

47 Invoice from Julien Levy Gallery, October 14, 1933; and Porter to Austin, November 10, 1933.

48 Cable from Austin's secretary to Julien Levy, November 16, 1933.

49 *Exhibition of Paintings by Salvador Dali*, Julien Levy Gallery, N.Y., November 21 – December 8, 1933. Edward Alden Jewell, "Salvador Dali, Arch-Surrealiste, Has One-Man Show at the Julien Levy Gallery," *New York Times*, November 22, 1933.

50 As reported by Edward Alden Jewell in the *New York Times* on November 20, 1934, p. 19 and again on November 22, 1934, p. 19. See also Fox Weber, 1992, p. 166.

51 Soby ms., chapter 4, pp. 7-10.

52 These had just been lent to the exhibition *Post-War European Paintings* at Vassar; an exhibition list is included in the Atheneum Archive's scrapbook of 1934. The first painting may be either *Remorse* or *Solitude*, Descharnes nos. 366 and 374, and the second *The Invisible Man* is most likely Descharnes 406.

53 *Daily Times*, July 6, 1934.

54 Chick Austin's secretary to Allen Porter, September, 24, 1934.

55 *Salvador Dali, Drawings and Etchings*, Julien Levy Gallery, New York, April 3–25, 1934; *Paintings by Salvador Dali*, Julien Levy Gallery, New York, November 21 – December 10, 1934. See Edward Alden Jewell, "Dali Surrealisme Rampant at Show," *New York Times*, November 22, 1934.

56 Invoice from Julien Levy Gallery, January 18, 1935.

57 Austin text in Atheneum registrarial files.

58 Ian Gibson, *The Shameful Life of Salvador Dali*, New York, 1997, pp. 391–93.

59 See Lincoln Kirstein, "The Ballet in Hartford," in *A. Everett Austin, Jr. A Director's Taste and Achievement*, Hartford, 1958, p. 69; Fox Weber, 1992, pp. 250–57.

60 *Hartford Times*, December 7, 1934.

61 The story is recorded in Jocelyn McClurg, "Atheneum Acquired Dali Early," *Hartford Courant*, January 24, 1989, p. C1, and in the forthcoming Austin biography by Eugene Gaddis.

62 Invitation preserved in Wadsworth Atheneum Archives scrapbook.

63 "Se Dio Una Reception al Pintor Salvador Dali en La Casa de Las Españas," *La Prensa*, New York, December 12, 1934, pp. 4 and 6.

64 Levy to Austin, December 10, 1934.

65 Audio tape interview of Joella Levy, July 1991 in the Atheneum's archives.

66 "Dali to Lecture at Avery Tuesday," *Hartford Times*, December 14, 1934.

67 "Unusual Ideas Voiced by Dali," *Hartford Times*, December 18, 1934.

68 "Dali Gives His Theories on Painting," *Hartford Courant*, December 19, 1934.

69 Joseph W. Alsop, Jr., "Dali is Seeking a Place in the Sun…," *New York Herald Tribune*, December 20, 1934.

70 Ibid.

71 Wadsworth Atheneum, *Report for 1934*, p. 18.

72 *La Prensa*, December 12, 1934. p. 4.

73 "Not a Madman – Dali!" *The Art Digest*, January 1, 1935, p. 16. Hartford is credited with this in such diverse sources as the exhibition catalogues *La Vie publique de Salvador Dali*, Centre Georges Pompidou, Paris, 1979, p. 42; and *Salvador Dali 1904–1989*, Staatsgalerie, Stuttgart, 1989, p. 485; and in such books as Carlos Rojas, *Salvador Dali, Or the Art of Spitting on your Mother's Portrait*, University Park, Pennsylvania, 1993, p. 16; and Gibson, 1997, p. 396.

74 According to the receipts and shipping invoices in the Wadsworth Atheneum's files.

75 Colley? to Levy, January 8, 1935.

76 "Salvador Dali trato del Surrealismo…," *La Prensa*, New York, January 9, 1935, p. 4.

77 "Dali Proclaims Surrealism a Paranoiac Art," *Art Digest*, February 1, 1935, p. 10.

78 Levy, 1977, p. 204; and "Salvador Dali Dio en el Museo de Arte Moderno otra de sus Conferencias," *La Prensa*, New York, January 1, 1935, p. 4.

79 Wadsworth Atheneum graphite drawing, 35.11. Invoice from Julien Levy Gallery of January 18, 1935. See exh. cat. *Salvador Dali*, Museum of Modern Art, New York, 1969 reprint, p. 83.

80 Austin unpublished text in Atheneum files.

81 The full title of the painting, Descharnes no. 498, is *The Ghost of Vermeer van Delft which Can be Used as a Table*. It was sold by Soby to Reynolds Morse in 1946 as detailed in correspondence in the MOMA Soby Archive. For the Soby drawing see Dali, MOMA, 1969, p. 83.

82 The painting and a similar preparatory study are Descharnes, nos. 507 and 508. Eleanor Howland Bunce's drawing was bequeathed to the Wadsworth Atheneum in 1999.

83 Now in the collection of Paul Cooley's son, Jeff.

84 See Ralf Michler and Lutz W. Lopsinger, *Salvador Dali Catalogue Raisonée of Etchings, 1924–1980*, Munich, 1994, p. 18, cat. no. 7.

85 Letter of M. Wheeler to Soby September 5, 1941 in MOMA archives; See the *Columbus Dispatch*, February 3, 1935, and Gibson, 1997, p. 394. E.M. Benson, "Forms of Art: III, Phases of Fantasy," *American Magazine of Art*, May 1935, pp. 298–99.

86 For the *Time* cover of December 14, 1936, see Descharnes, no. 614. Alfred H. Barr, Jr., ed., *Fantastic Art Dada Surrealism*, Museum of Modern Art, New York, December 1936, p. 267, no. 318.

87 *43 Portraits, An Exhibition of the Wadsworth Atheneum*, Hartford, January 26 – February 10, 1937, no. 43.

88 See Gibson, 1997, p. 417, and Levy's undated letter of 1937 to Austin in the Atheneum Archives. The work had been illustrated and included as no. 18 belonging to the Gala Dalí collection in Levy's *Dali Souvenir Catalogue* of 1936.

89 Dalí to Soby in an undated letter of 1941, in the Soby archive of the Getty Research Institute, Los Angeles.

90 Descharnes, no. 608

91 Levy to Austin and FNB to Levy, May 4, 1937

92 Postcard from Dalí and Gala in Austria to Mr. and Mrs. Austin, postmarked "12 IV 37" in the Atheneum Archives.

93 Descharnes, no. 324, now in the collection of the Metropolitan Museum of Art, New York. See also Levy, 1977, p. 72.

94 A. Everett Austin, Jr. and Henry-Russell Hitchcock, Jr., "Foreword," *The Painters of Still Life*, Wadsworth Atheneum, January 25 – February 15, 1938; and "Aesthetic of the Still-Life Over Four Centuries," *Art News*, February 1938, p. 23.

95 *Painters of Still Life*, Wadsworth Atheneum, Hartford, 1938, no. 35.

96 M. Murray, "Avery Exhibition Elicits Acclaim," *Hartford Times*, January 26, 1938.

97 Descharnes no. 650. In 1943 Soby, as documented in the Soby archive at MOMA, sold the work through Kirk Askew of Durlacher Gallery, who was at that moment handling Julien Levy's business, to the Art Institute of Chicago, which as part of the deal exchanged with the gallery Dalí's painting *Shades of Night Descending*, which ended up in the Salvador Dalí Museum. See "Dali's Heterosexual Monster Invades Chicago," *Art Digest*, October 15, 1943.

98 "Sidelights from the New York Fair," *Art Digest*, July 1, 1939, p. 12. See also Gibson, 1997, pp. 446–47.

99 S. Dali, "Dali, Dali!" in *Salvador Dali*, Julien Levy Gallery, New York, March 21 – April 17, 1939.

100 "Art – Salvador Dali," *Life* Magazine, April 17, 1939, p. 45.

101 *Dali*, Julien Levy Gallery, New York, 1939, no. 12.

102 See E.M. Kornhauser, *American Painting Before 1945 in the Wadsworth Atheneum*, 1966, Hartford, v. 1, p. 35, and v. 2., pp. 432-34. For the School of Arcimboldo paintings, *Spring* (fig. 23) and *Summer* see Jean K. Cadogan, ed., *Wadsworth Atheneum Paintings II, Italy and Spain.*, Hartford, 1991, pp. 268-270. The *Still Life* by the Spanish painter Louis Fernandez (fig. 56), which is 4¹¹⁄₁₆ × 56⅞ in., was purchased from the Museum of Modern Art for $125 in May 1937.

103 *Old and New "Trompe L'Oeil,"* Julien Levy Gallery, New York, March 8 – April 3, 1938.

104 "Dali and Miro Jar New York," *Art Digest*, December 1, 1941, p. 6.

105 Levy to Austin undated 1939 and invoice of May 1, 1939.

106 M. Murray, "Avery Acquires Salvador Dali Double Image…," *Hartford Times*, May 18, 1939.

107 The MOMA show is reviewed in *Art Digest*, December 1, 1941, pp. 3 and 5–6, with the Atheneum's painting reproduced. The installation photograph probably by Soby is in the Soby Archives at MOMA.

108 Sidney Janis, *Abstract and Surrealist Art in America*, New York, 1944. Although not reproduced in the book, the Atheneum's painting was included in the traveling show and was seen in Seattle, Denver, Cincinnati, Santa Barbara, and Portland. It was reproduced in the *Cincinnati Enquirer*, February 4, 1944, p. 14 and the *Rocky Mountain News*, April 2, 1944.

109 Austin unpublished catalogue ms, in Atheneum's registrarial file.

110 Program for *Magic on Parade*, Wadsworth Atheneum, 1939, p. 3; Marian Murray, "Artists Create Authentic Décor for 1939 Magic," *Hartford Times*, December 23, 1939, wrote that "Mr. Austin will wear a costume designed by Salvador Dali."

111 A mannequin dressed by Dalí with a "winter sports mask" by Schiaparelli was reproduced in "Surrealism and Fashion," *London Bulletin*, April 1938, pp. 18 and 20. Dalí and Schiaparelli collaborated on several projects, for which see Palmer White, *Elsa Schiaparelli: Empress of Paris Fashion*, New York, 1986, pp. 24, 54, 82 and 140; and Richard Martin, *Fashion and Surrealism*, New York, 1987, pp. 205–6.

112 In May 1939 Dalí came to Hartford for the premier of Ernst Krenek's ballet *Eight-Column Line*. For Dalí's visits to Connecticut references are found on the audio tapes of Eleanor Howland Bunce of March 1975 and Mrs. Naum Gabo of August 1988, both in the Atheneum's Archives. Dalí also visited Westport, CT, as evidenced by a photograph of him reproduced in Meryle Secrest, *Salvador Dali*, New York, 1986.

113 Soby ms., chapter 12, pp. 3-4.

114 Ibid., p. 5.

115 Descharnes, no. 678; Bequeathed by Soby to MOMA. As the shipping bill from Levy to the Wadsworth is for two paintings, it seems likely that both Soby's painting and the *Apparition* were sent together.

116 A. Everett Austin, Jr., "Introduction," *Night Scene*, Wadsworth Atheneum, Hartford, 1940, p. 4.

117 Soby's receipt for his loans to MOMA, November 3, 1941 in the MOMA Soby archives. *The Basket of Bread*, Descharnes 249, now in the Dalí Museum was sold by Soby to Reynolds Morse in 1955 according to the correspondence in the MOMA Soby archive.

118 Soby ms., chapter 2, pp. 1–3.

119 There does not seem to be any printed record of its contents, but in the Atheneum's *News/Bulletin* for October 1942, p. 1 *Painters of Fantasy* is listed as located in Avery Print Room and a second installment is promised for "later in the season."

120 M. Murray, "Exhibit of Fantastic Art," *Hartford Times*, September, 1942.

121 See Dawn Ades, *Bergman Collection*, Chicago, 1997, p. 106, no. 54; and for another drawing in a private collection, see Guggenheim, 1999, vol. 2, p. 471, no. 399.

122 *Jésus Guerrero Galván, Paintings*, Julien Levy Gallery, New York, April 6 – May 4, 1943 and shown at the Atheneum March 16 – April 2, 1943.

123 Levy to Austin, undated letter probably of April 1943.

Dalí's Permanent Provocation

*Antonio Pitxot in conversation
with Montse Aguer*

*Antonio Pitxot is the Director of the Teatro-Museo Dalí,
the museum created by Dalí in his home town of Figueres.
As a young painter, whose artistic and musical family had
been connected with that of Dalí for generations, Sr Pitxot
was a frequent companion of Dalí, who took a special
interest in him, guiding both his reading and his technical
development. Dalí insisted that he read Freud and
Raymond Roussel, and once gave him a book on mythol-
ogy – a rare act of generosity on Dalí's part, it seems.
Above all he talked to Sr Pitxot at length, over the last
twenty years of his life, about painting, pictorial tech-
niques and optics. Even at the very end of his active life as
a painter Dalí was developing new ideas about painting,
which emphasized the role of the spectator. This text is a
distillation of the memories of these conversations and
Sr Pitxot's subsequent study of Dalí's work.*

* * *

As early as the 1920s the presence of enigmatic images,
capable of provoking in our vision as spectators new and
hidden meanings, were characteristic of Dalí's work. The
artist played with reality, decomposing and transforming it.

This need to break with convention continued
through his career and into the sixties and seventies.
Dalí's provocative, innovative attitude was an ongoing
principle whose origin lies in the scene of the knife
cutting the eye in *An Andalusian Dog*, the film he made
in collaboration with Luis Buñuel. This profoundly
symbolic act marked his determination to direct the
senses towards a new vision of the world.

To achieve this special perception of the world of the
senses, Dalí supplemented his artistic technique with the
latest scientific technology. Using various methods and
systems including double images, stereoscopy, holography
or the search for a fourth dimension, and always informed
by scientific advances, Dalí simultaneously represents
external reality and an internal reality. These may or
may not coincide with those of the viewer, in whom a
series of psychic associations are provoked that end in
total immersion in the painter's world.

Dalí's passion for visual effects is particularly evident
in his interest in the double image. He was the first
twentieth-century painter to work on the recreation of
the double image in a concrete way: that is, arriving at
an image that, without altering any of its elements can
represent a second, wholly distinct subject.

The Image disappears (cat. 32), is an outstanding example of the double image. At first glance we see a woman in a room, with a map in the background, a subject almost identical to Vermeer's *Woman reading a Letter*. But at the same time the canvas depicts – through a simple adjustment of our perception – the portrait of Velázquez. With this double resolution within a single canvas, Dalí thus unites the two painters, Vermeer and Velázquez, whom he considered the greatest figures in art history. In his Comparative Table of the values of artists, in *50 Secrets of Magic Craftsmanship*, Dalí awarded these two (together with Raphael) the highest marks in his categories of craftsmanship, inspiration, color, design, genius, composition, originality, mystery and authenticity.

Dalí taught Antonio Pitxot to experiment with the contemplation of a fragment of rocks in the unique geology of Cap Creus, in such a way that, with the passage of time, the sun struck the mineral surface from different angles, and encouraged one to see the distortion of forms and their continuous transformation. This is one of the mechanisms of the methodical observation of a fixed point that, transferred to the world of cinematography, produced Andy Warhol's fixed camera in the filming of the façade of The Factory. For Dalí such experiments always had a philosophical goal: the fixing in images of the indefinite – time.

During the 1960s he was attracted to stereoscopic effects, a purely mechanical procedure in the optics of three dimensional perception. Dalí had already spoken of stereoscopic effects in the work of the Dutch seventeenth-century painter, Gerard Dou. According to Dalí, Dou made one of the first stereoscopic experiments in the history of painting by creating two versions of the same subject (*The Mousetrap*). Dalí was convinced that this was not simply a copy, but that the two pictures were intended to be viewed together. Their corresponding differential of 12 to 15cm (5 to 6 1/2 inches) is the focal distance of a pair of binoculars.

While preparing his own stereoscopic works, Dalí told Antonio Pitxot that one of the things that most fascinated him was the evasion of the controls and limits created by the rules of optical experiment. Stretching the rules could lead to new optical illusions. An anti-academic by nature, one of the principles of Dalí's philosophy was to accumulate rather than select or sift information. In experimenting with stereoscopy he developed new ways of contorting, or provoking surprising images. A good example of this are the two stereoscopic panels *The School of Athens* and *The Fire in the Borgo* (cat. 66, 67), deriving from Raphael's two pictures of the same name. Each affects the vision of one retina, and the final stereoscopic result of the accumulation of the images is dependent on the viewer's powers of interpretation and perception. The colored rectangles in these two panels were added with the help of Roger de Montebello, the brother of Philippe de Montebello, director of the Metropolitan Museum in New York. An expert in geometry, he advised on their placement to aid the illusion of three-dimensional space. The use of mirrors is necessary to achieve the three-dimensional effect in stereoscopy – although Dalí claimed to have tried alternatives to get the effect of relief without mirrors, using an Indian technique.

Dalí was also the first artist to experiment with holography, which he believed would lead to "pure artistic expression," and he collaborated with Dennis Gabor, the Nobel Prize-winning physicist. In the catalogue for the hologram exhibition held in 1972 at the Knoedler Gallery in New York, Dalí wrote: "All artists have been concerned with three-dimensional reality since the time of Velázquez, and in modern times, the analytic cubism of Picasso tried again to capture the three dimensions of Velázquez. Now with the genius of Gabor, the possibility of a new Renaissance in art has been realized with the use of holography. The doors have been opened for me into a new house of creation."

Dalí was relentless in his search for new ideas and perceptions from the field of science that he could adapt to his own purposes, offering him an escape from the stagnation of the art world. In *The Three Glorious Enigmas of Gala* (cat. 70) he explores a four-dimensional space-time. He also used, for example, the "Catastrophe Theory" developed by the mathematician René Thom, with whom he had a friendly relationship, and exchanged ideas. He was also in contact with a number of other scientists: Severo Ochoa, Ilya Prigogine and Frank Salvan. The latter's work with the electron microscope, with which he had obtained the first relief photograph of gold atoms on the surface of silicon, in particular stimulated Dalí's interest.

At the end of his life, Dalí turned to his favorite subjects: Velázquez and the great artists of the Italian Renaissance, especially Michelangelo. He told Antonio Pitxot: "You're reaching the age when you should devote yourself to the great masters... When one reaches maturity, they must be our best companions." But even then he was still exploring new directions in painting.

One of his last canvases the 1983 *We Will Arrive Later, About Five O'clock* (fig. 64), is a curiously enigmatic, almost naturalistic image of a dark interior, whose monochromatic and painterly character also recalls Velázquez. Dalí, Antonio Pitxot remembers, painted it like an automaton, and then met with him and another friend to interpret and name it. They reached accord, agreeing that it represented the interior of a removal van, and an overheard conversation of the driver.

Behind this simple day-to-day subject, though, lurks the theme of mortality, for not only did the image thus interpreted recall André Breton's words: "I demand that they take me to the cemetery in a removal van," but the specific time mentioned, purportedly from an overheard conversation, echoes the opening lines of Lorca's famous lament for the death of the bull fighter, Ignacio Sánchez Mejías:

> *A los cinco de la tarde*
> *Eran los cinco en punto de la tarde*

Although Dalí claimed to remain in ignorance of the subject of the picture its unconscious associations center on death, and his own mortality.

With his optical experiments, Dalí succeeds in stimulating the viewer's ability to scrutinize the visual world. He does so to such effect that some visitors to his Theater-Museum in Figueres see double images even where none exist. As he wrote in *Ten Recipes for Immortality:* "May our internal reality be strong enough to correct external reality"

Fig. 63
Salvador Dalí
We Will Arrive Later, About Five O'Clock, 1983
Museo Nacional Centro de Arte Reina Sofia, Madrid

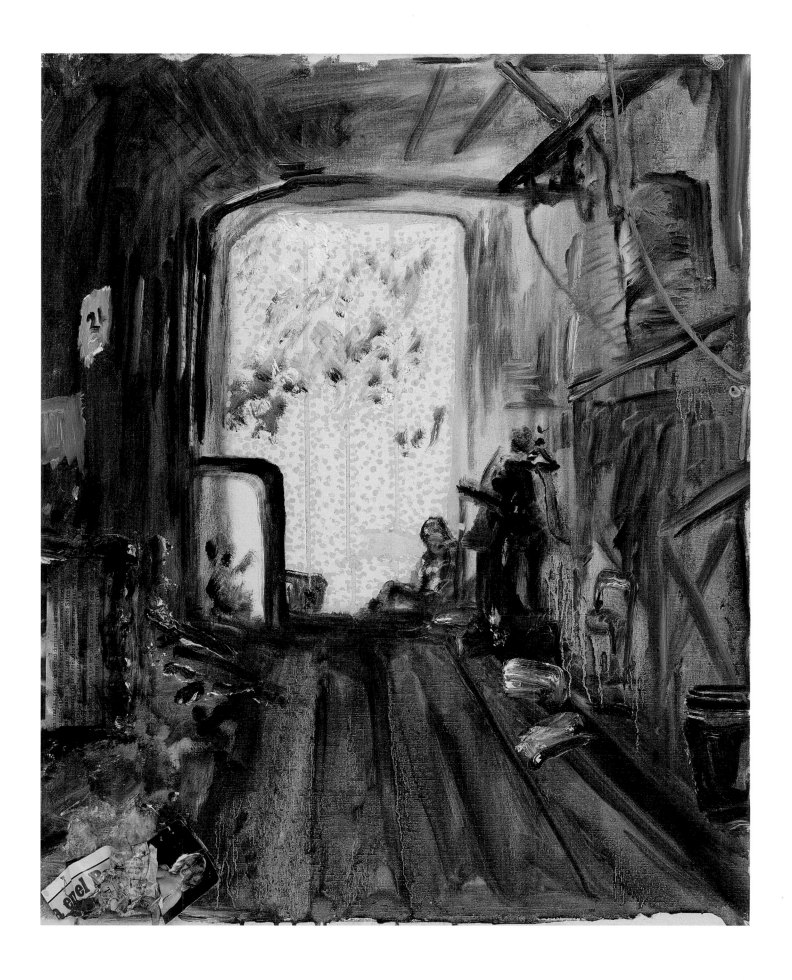

1

Femme Couchée (*Sleeping Woman*), 1926
Oil on panel, 10¾ × 16 in.
Salvador Dalí Museum, St. Petersburg, Florida

In the mid-1920s Dalí was working virtually simulta-
neously in two quite distinct modes – a highly detailed
naturalism, and a more avant-garde cubist-derived
style. At his second one-man exhibition at the Dalmau
Gallery in Barcelona in December 1926, where this
painting was shown, the duality of his production was
emphasized by placing the "cubist and neo-cubist"
works and the "miniaturist" ones, like *Basket of Bread*,
in separate spaces.[1]

A closely related drawing of 1926 was inscribed by
Dalí "Picasso's influence," and this painting violently
combines an angularity derived from Cubism with neo-
classical references to the female bather. Dalí had visited
Picasso in his studio in 1926, and was familiar both with
his post-war classicism and with the continuation of the
cubist language in the mid-1920s.

Although combining these two modes, this painting
is like nothing in Picasso's work. The dramatized per-
spective, which may appear in the form of enlarged or
tiny limbs in Picasso, was never treated by him in this
schematic and abrupt manner, but was to re-appear in
Dalí's surrealist paintings to disquieting effect. The figure
wears crude classical drapery, and the water pouring from
her hand proposes an identification with a mythological
river goddess or a sea nymph. The neo-classical references
were not due only to Picasso – Catalonia had witnessed
a revival of a "mediterranean" tradition to which Dalí
had contributed. This is no imaginary landscape, how-
ever, but already even if in simplified form the sharp
rocky outcrops of the shore around Cadaques which was
to remain Dalí's primary setting for his paintings.

[1] See *Salvador Dalí: The Early Years* (South Bank, London,
 1995), and Felix Fanès, *Salvador Dalí; La construcción de
 la imagen*, Electa, Madrid 1999, for this formative period
 of his work.

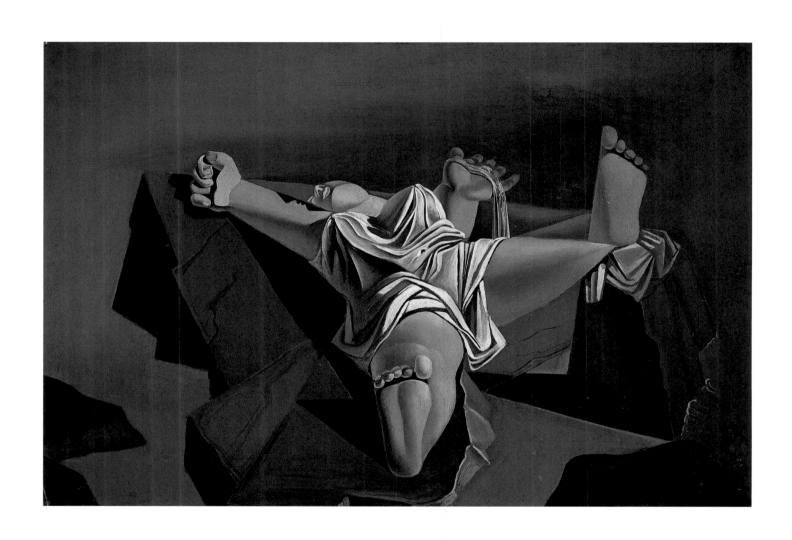



2

Apparatus and Hand, 1927
Oil on panel, 24½ × 18¾ in.
Salvador Dalí Museum, St. Petersburg, Florida

This work and *Honey is Sweeter than Blood* were exhibited at the Barcelona Autumn Salon of 1927, where they excited a good deal of attention. Dalí felt he had reached a new directness and immediacy here, writing to Lorca: "Federico I am painting pictures which make me die for joy, I am creating with an absolute naturalness, without the slightest aesthetic concern."[1] The absence of "aesthetic concern" is a clear reference to the *Surrealist Manifesto,* which had defined Surrealism as "pure psychic automatism…the dictation of thought, either verbally, or in writing, or in any other form, in the absence of any moral or aesthetic considerations."[2] Dalí has evidently not just discovered surrealist painting, especially Tanguy (fig. 2.1), but has also begun to use surrealist ideas to liberate himself from the dual aesthetic he had been working within, of cubism and a classicizing naturalism. Although Dalí was still to experiment with more abstract

Fig. 2.1
Yves Tanguy
Sans Titre (Untitled), 1929
Wadsworth Atheneum,
Hartford,
Bequest of Kay Sage
Tanguy, 1963

Fig. 2.2
Max Ernst
Celebes Elephant, 1921
Tate Gallery, London

morphologies, as in the 1928 "Bathers," many of the elements of the "dream" paintings of 1929 are already present here, and this work was shown in his first Paris exhibition at the Goemans Gallery in November 1929, by which time it was already in Paul Eluard's collection.

The perspectival distortions in *Apparatus and Hand* have already been discussed above (pp. 18–19). The ways in which he freely elaborates on motifs drawn from Tanguy, Ernst, Miró and de Chirico and integrates them with his personal themes announces a wholly individual approach. Geometrical forms or measuring instruments appear in various contexts in the work of all three artists: Miró, for instance, uses the set square as a female symbol in *Madame K.* The heavily veined hand darting flames and bristling with magnetized needles recalls Tanguy's transparent veined figures and detached limbs. The clash between the fleshly organ and the inorganic geometric figure, however, is an early indication of an enduring and highly significant contrast for Dalí between hard and soft, flesh and bone, interior and exterior. Dalí also tries out the Tanguy device of confusing elements of earth, air and sea, for instance by repeating lines of the hills like clouds in the sky. But a particularly unusual quality in this painting is its animation: although another painting clearly evoked, Max Ernst's *Celebes Elephant* (fig. 2.2), implies mobility with the mannequin's hand beckoning the monster forwards, here the whole painting seems in the process of metamorphosis. Figures emerge, dissolve, become transparent in an almost cinematic fashion. The somewhat absurdly teetering, anthropomorphic figure in the center, moreover, casts a shadow on the sky, setting its cloudy forms in a whirl. The "anti-aesthetic" of the painting is also evident in the heterogeneity of the style, with the academically painted nude torso in the sky contrasting with the rudimentary flying figures. The rotting donkey, itself partially anthropomorphized, seems in the process of devouring the fish — both were highly charged symbols for Dalí.[3]

[1] See Ades, "Morphologies of Desire," in *Salvador Dalí; The Early Years, op. cit.,* p. 141.
[2] André Breton, "Second Manifesto of Surrealism," *Manifestoes of Surrealism* (1924, p. 26), trans. Richard Seaver and Helen R. Lane, University of Michigan 1969.
[3] For the rotting donkey/putrefaction motif see "Morphologies of Desire," *op. cit.*

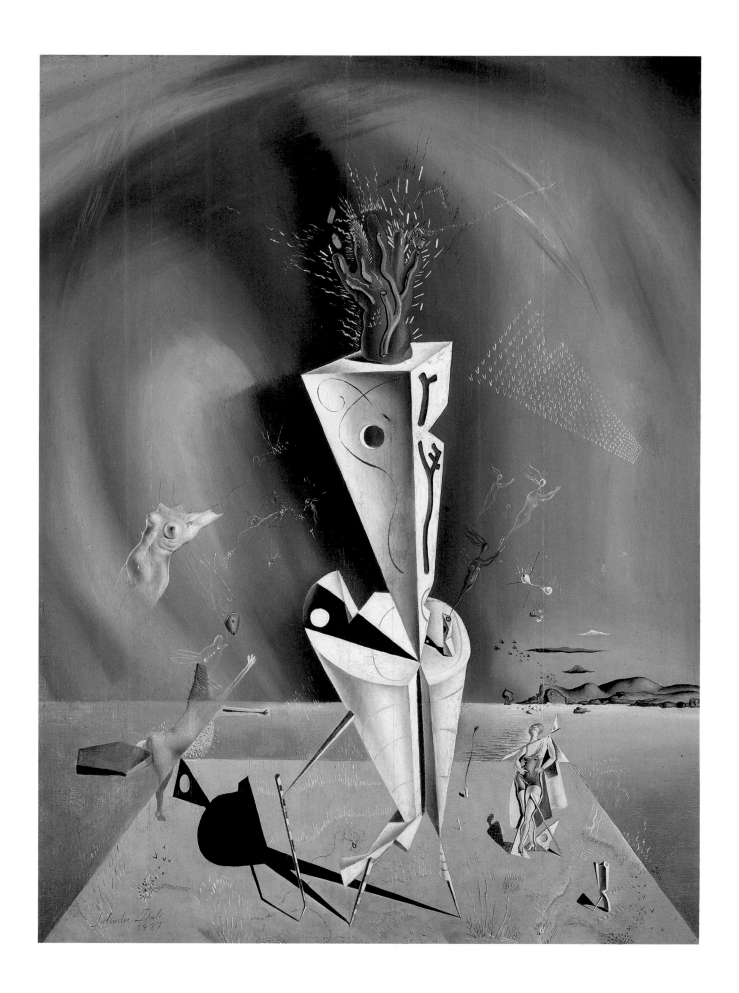

3

Baigneuse (Female Bather), 1928
Oil and sand on panel, 25 × 29½ in.
Salvador Dalí Museum, St. Petersburg, Florida

This was one of two paintings by Dalí reproduced in
Georges Bataille's Paris review *Documents* (no. 4
September 1929; fig. 16) together with an anonymous
sixteenth-century anamorphic painting (see pp. 22–24)
It belongs to a group of paintings which pursue in
apparent contradiction an ever-increasing formal biomor-
phic abstraction and exacerbated and explicit references
to sex. *Baigneuse* reflects Dalí's knowledgeable and
eclectic responses to contemporary painting, especially
Picasso, Miró and Arp. However, the biomorphic free-
doms borrowed from Miró and Arp to re-invent the
human torso are drawn in to more specific physiological
references. This is one of the most clearly anatomical
of these works, although the limbs and features of the
body are contorted and exaggerated in scale. The hand is
enlarged, drawing on the photographic effect of parallax
to convey visually its significance in this masturbatory
image. Legs, feet and torso are variously inflated and
shriveled as though the whole body is implicated in the
sexual sensation. This contributes to the hint of androgyny
in the figure, which has both male and female features.
The nude's flesh color is heightened at the edges of
the contours to a fiery red, which again metaphorically
enhances the body's enflamed character.

The tiny head with its dot eyes recalls Picasso's
cubist paintings, and the dense layer of sand, standing
for the beach, is a highly literal use of collage. Both this
painting and *Baigneuses* (cat. 4) were exhibited at the
exhibition *Abstrakte und Surrealistische Malerei und
Plastik* at the Kunsthaus Zurich in 1929 (October 6 –
November 3) where they were simply listed as Bild 1
and 2. In *Documents*, this painting was titled *Nu
féminin*, and the painting below (cat. 4) had the
feminine plural *Baigneuses*, rather than the singular
Baigneur or *Baigneuse*.

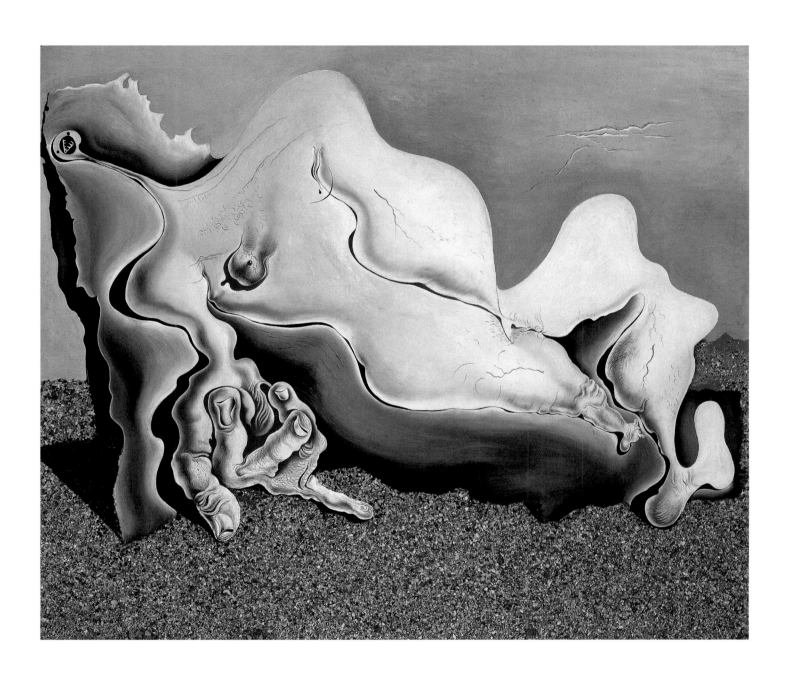

4

Baigneur (Bather), 1928
Oil, sand and gravel on panel, 20½ × 28¼ in.
Salvador Dalí Museum, St. Petersburg, Florida

The amorphous mass of this fragment of a human body, filling the foreground, is one of the first instances of a compositional device Dalí was subsequently to use on many occasions: as for instance in *The Great Masturbator* (fig. 18). Here it represents primarily a big toe, although there are hints of other anatomical body parts, which is linked to two more skeletal and fragmented bodies on the horizon.

Dalí was a prominent member of the Catalan avant-garde at this period, and although not yet affiliated to Surrealism, was familiar with its ideas and already well versed in Freud. His prolific writings in the vanguard magazines have a distinctively turbulent and effervescent character, although his visual works are still experimental and increasingly reductive. Significantly, he was becoming more interested in photography and film. The final issue

of *L'Amic de les Arts,* (March 1929) which is almost entirely taken over by Dalí and Buñuel, is illustrated only with photographs (fig. 4.1), in contrast to earlier issues which had been liberally illustrated with reproductions of paintings, drawings and woodcuts. Dalí's uncertainty about the future of painting at this moment, however, was to dissolve as he began to develop his own visual language in which photographic precision could co-exist with the infinite morphological flexibility of the painted image.

This painting is still poised at a moment of tension between the photographic image and avant garde abstraction. Dalí rejected the poetic and artistic in favor of "the anti-artistic, faithful, objective record of the world of facts, the revelation of whose hidden meaning we constantly demand and hope for," as he wrote in an article in *L'Amic de les Arts,* "…L'alliberament dels dits…" (The Liberation of the Fingers).[1] This records several instances of objects provoking unexplained terror or horror: grasshoppers, a rotting donkey, and then an

Fig. 4.1
Salvador Dalí
"L'alliberament dels dits," *L'Amic de les Arts,*
Sitges, March 31, 1929.

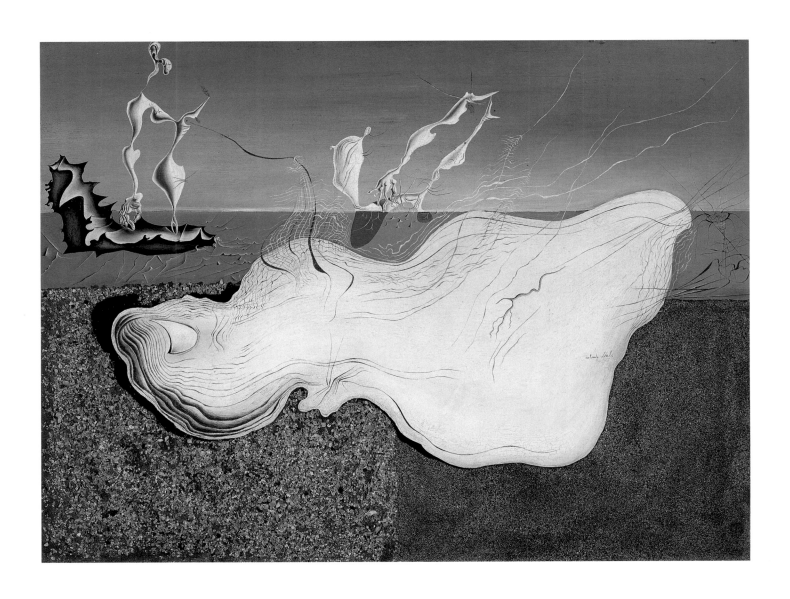

example which seems of a different order to these but which Dalí regards as equally troubling: the isolated finger. Dalí recalls an almost illiterate friend capable of filling pages with automatic writing, who drew a "flying phallus" on the marble cafe table. "My surprise goes without saying, since he could not have known of the existence of the *Winged Phallus* of ancient civilizations, about which I subsequently read Freud's allusions." This is the only acknowledgement of Dalí's recognition of the castration symbolism of the isolated digit. He goes on without further reference to this to mention the troubling sight of his own thumb poking through the hole in his palette, and ends by referring to the "violence" of the single finger which had been the subject of recent paintings and photographs.

Dalí's text and the photographs of isolated fingers illustrating it may have been the inspiration for Georges Bataille's article on "The Big Toe," in *Documents*.

Bataille's interest in Dalí was aroused by the film *An Andalusian Dog*. His emphasis on the base and the horrific in Dalí's work offers a contrast to Breton's embrace of his liberation of the imagination. Bataille's "The Big Toe" draws out the link between seduction and repulsion, and the photographs by Boiffard which accompanied it transpose the implications of Dalí's photographs of fingers to toes (fig. 4.2).

The question of the gender of the nude or fragmented bodies in these two paintings is unresolved; the earliest titles, in *Documents*, indicate that both concern female figures (see cat. 3), but subsequently this painting became known as "Baigneur," male bather, which may indicate a wish to see them as a pair, male and female. However, there are signs of female anatomy here as well as the thumb/phallus associations, and both appear androgynous.

Fig. 4.2
J.A. Boiffard
"Big Toe," from Georges Bataille, "Le gros orteil,"
Documents, no. 6, November 1929.

[1] Salvador Dalí, "L'alliberament dels dits," *L'Amic de les Arts*, March 1929, trans. John London, "The Liberation of the Fingers," in *Salvador Dalí; The Early Years*, p. 228.

Detail, cat. 4

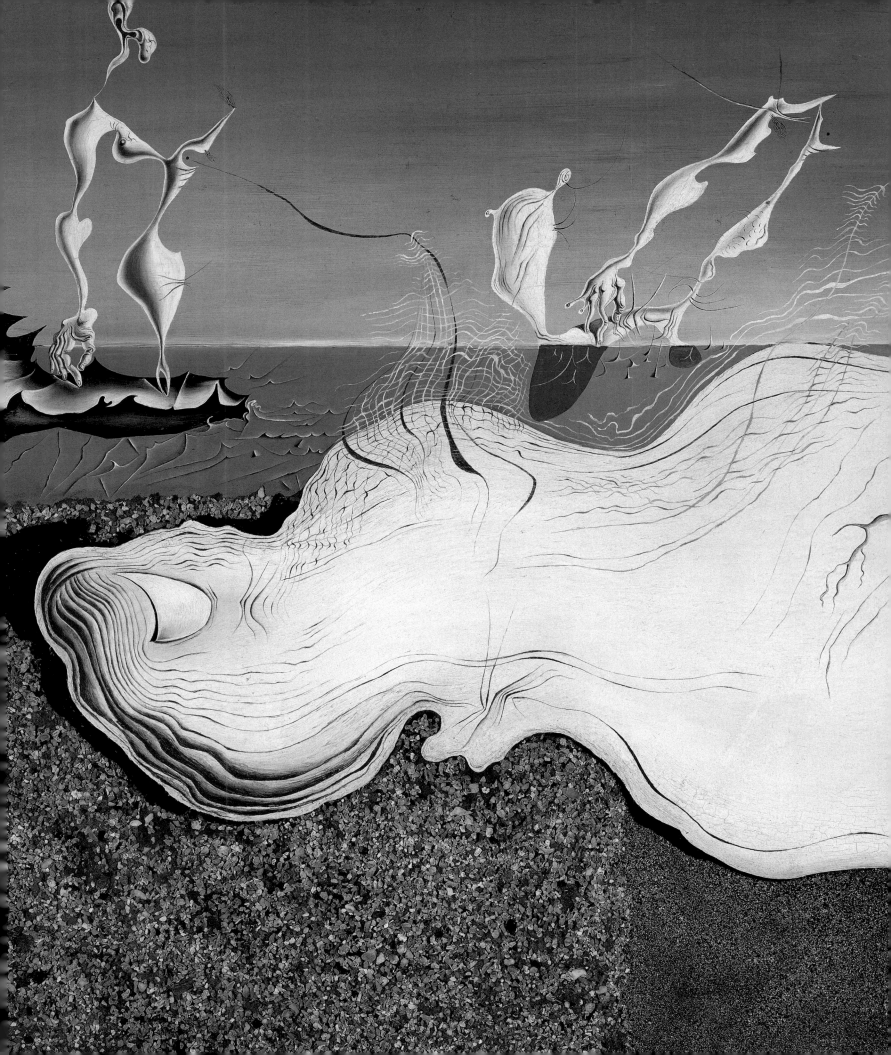

5

Man with Sickly Complexion Listening to the
Sound of the Sea or *The Two Balconies*, 1929
Oil on panel, 9¼ × 13¾ in.
Museus Castro Maya, Rio de Janeiro

The unusual construction of this painting, with the repetition of two identical backless façades, which divide the canvas into three separate scenes, suggests a sequence from a film. The vertical lines created by the narrow white end walls mimic a strip of film frames, while the three compartments are like shots from a sequential narrative, which, given the time lapse needed for the figure on the balcony on the right hand side to appear in the doorway in the center, would have been cut and montaged together.

Dalí may well have known Magritte's *Man with a Newspaper* (1928), in which the canvas is divided into four parts with an identical domestic interior repeated in each, but in only one of which a man appears reading a newspaper. Magritte's painting was reproduced in *Variétés* in January 1929, but in any case both artists were interested in the cinema's capacity for magical appearances and disappearances, and Dalí had had direct experience of film-making earlier that year with *An Andalusian Dog*.

As with all Dalí's paintings in this climactic year it is strongly autobiographical, although not in any simply illustrational sense. Dalí's paintings have a complex relationship with his emotional life and are integral to, rather than reflective of, his constructions of identity and play of different personae. Nonetheless, the 1929 paintings bear out the later accounts in the *Secret Life* and elsewhere that he was that summer, when he met Gala, in a state of extreme nervous tension approaching madness. He suffered fits of uncontrollable laughter, exacerbated by imagining an owl on the head of a respectable bourgeois, topped with a piece of excrement (like the figure standing on the balcony here). The surrealists visiting him that summer at Cadaques, including Magritte and his dealer Goemans, the poet Eluard and Gala (then his wife), were intrigued by his "case."

Many paintings of 1929 depict an encounter between an older bearded man and a youth. Here, the "father figure" is horribly grinning, and calcified – his head is white as though turned to stone, while his torso is worn and hollow, like fraying bone. The idea of the figure turned to stone was familiar to Dalí from de

Chirico, and also from one of his seminal influences, Max Ernst's *Pieta or Revolution by Night* (Tate Gallery, London), where Ernst the Son is a statue in his Father's arms. Dalí characteristically pushes the idea to an extreme, incorporating not only petrifaction but its opposite, putrefaction. Leaning on the man's back is a youth whose posture suggests that of a child being carried piggy-back – an innocent intimacy, though elsewhere a similar gesture implies hiding his head in shame. They are watched by the older youth half-hidden behind a shutter.

The illuminated pebble with the parrot's head is one of the vivid visual images Dalí "saw" that summer which he believed to be the return of childhood fantasies or representations, among them parrot heads, a small deer, parasols. The pebbles and ornamented, cavitied fragments have the contours and details of the soft and wavy style of art nouveau, which Dalí was soon to champion in Paris. In "De la beauté terrifiante et comestible, de l'architecture Modern'style," he praises the Barcelona buildings of one of the greatest of the art nouveau architects, Gaudí, their defiance of the normal geometry of architecture, resembling rather a soft substance suddenly congealed like a frozen wave.[1] Art nouveau "smashes all creations of measure, order, balance, good taste to exalt dream and fantasy and suggest we devour our own desires."[2]

What of the "sound of the sea" in the title? Perhaps this is the first appearance of an idea Dalí had for part of the soundtrack of his film script *Babaou* (1932): passing along a high wall Babaou hears rhythmical noise growing in intensity, deafening and terrifying, like "monstrous and weary breathing."[3] It turns out to be produced by huge waves crashing on the beach. The deep breathing has a sinister association with the mysterious activities of the parental bedroom, thickening the sense in this painting of a child's perturbation and sexual anxiety.

[1] "De la beauté…," *Minotaure* 3–4, Paris 1933, p. 69.
[2] Salvador Dalí, *Unspeakable Confessions, op. cit.*, p. 146.
[3] Salvador Dalí, *Babaou*, Barcelona 1978, p. 82.

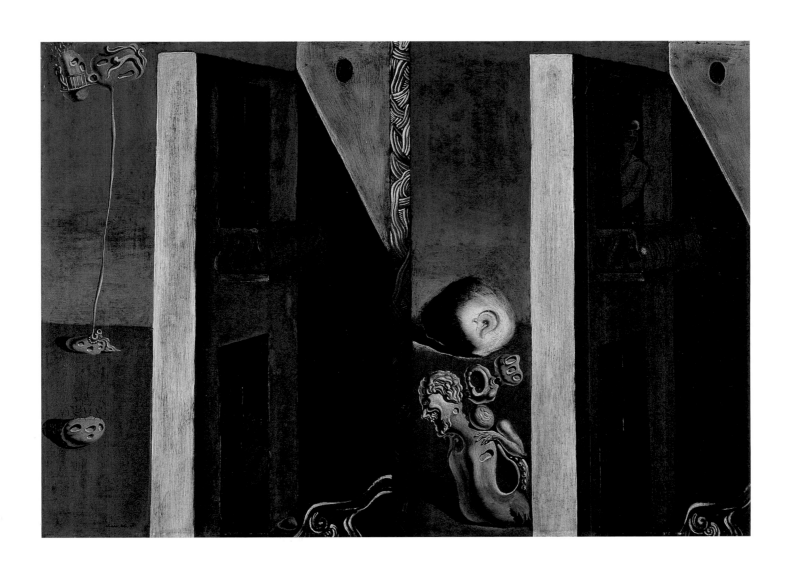

6

The Invisible Man, 1929–32
Oil on canvas, 55⅛ × 31½ in.
Museo Nacional Centro de Arte Reina Sofia, Madrid

This ambitious painting was begun in the winter of 1929, and Dalí appears to have worked on it sporadically over a long period.[1] It is one of the first in which he systematically explores the paranoiac double image. Dalí worked on it fanatically during an extended "honeymoon," when he and Gala had retired from Paris to a hotel at Carry-le-Rouet, at the same time as writing his book *La Femme visible* (fig. 6.1), the frontispiece of which was a photograph of Gala "whose gaze pierces walls."

If much in his autobiographical writings must be treated with caution, there's no doubt about the enduring impact of Gala on his life. She liberated him of repressed fears and violent anxieties, opening the way to the piercing self-analysis and intellectual exuberance not only in painting but texts like *La Femme visible*. The amanuensis who corrected his wild orthography, she "gathered together the mass of disorganized and unintelligible scribblings that I had made throughout the whole summer at Cadaques, and with her unflinching scrupulousness she had succeeded in giving these a 'syntactic form' that was more or less communicable. These formed fairly well-developed notes which on Gala's

Fig. 6.1
Frontispiece to
Salvador Dalí
La Femme visible
1930, Paris,
Editions
Surréalistes

advice I took up again and recast into a theoretical and poetic work which was to appear under the title *The Visible Woman*. It was my first book, and the 'visible woman' was Gala."[2]

The first text in *La Femme visible*, "L'âne pourri," introduces the "mechanism of paranoia," from which the "image with multiple figurations is born."[3] This is Dalí's first explanation of his paranoiac-critical method, although he does not use the full term until 1933, in his "Interpretation paranoïaque-critique de l'image obsédante de l'Angélus de Millet."[4] (fig. 21.1) "It is by a frankly paranoiac process that it has been possible to obtain a double image: that is to say the representation of one object which, without the least figuration or anatomical distortion is at the same time the representation of a totally different object."[5]

Dalí's concept of paranoia, while introduced under the banner of Surrealism, was nonetheless crucially different, in his view, from surrealist automatism, in that it was an active rather than passive activity. He found that he and Jacques Lacan, with whom he made contact after the publication of "L'âne pourri," and whose own thesis on a case of paranoia had been published in 1932,[6] were in close agreement about the paranoiac condition. This involved the systematic misreading of the world according to an over-riding obsessional idea. Lacan described paranoiac psychosis as the "coherent structure of an immediate and noumenal apprehension of oneself and the world."[7] Objects in the visual field were imprinted with meaning of a purely personal significance. The obsession, or what Lacan called the "identification itérative de l'objet," tended to a repetitive projection of the same events and the same personages, sometimes with doublings of the subject. The "delirium of interpretation" could produce a chain of images linked according to the individual's obsessive idea, which could then be imposed on the audience: "Paranoia makes use of the external world to validate an obsessional idea, with the disturbing peculiarity of making the reality of this idea valid for others."[8] The systematic and coherent paranoiac (mis)interpretation of external reality was for Dalí evidence of the over-riding power of thought, and he was to continue to explore its reality in delusional readings of the external world in multiple ways.

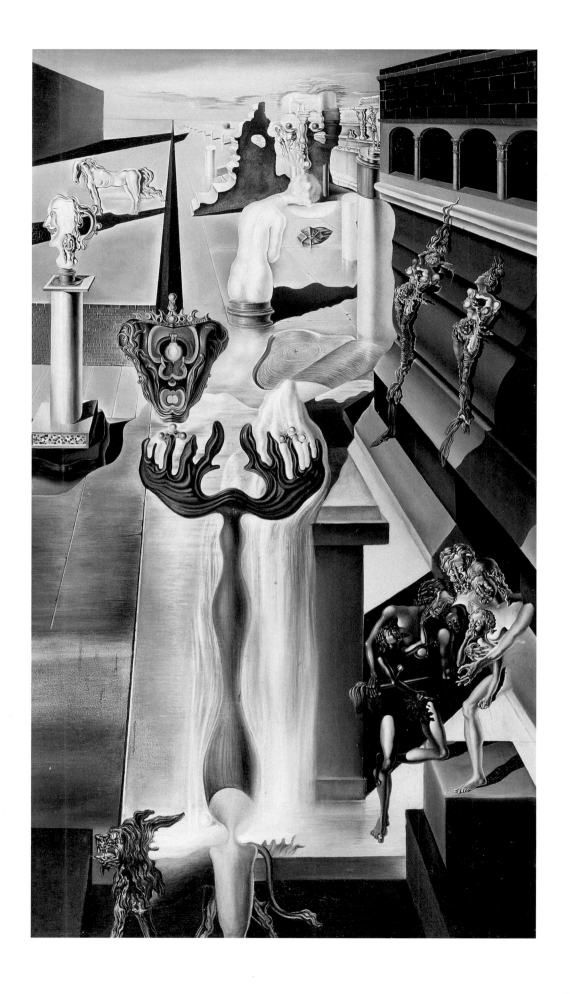

The Invisible Man represents both a landscape and a seated man. It contains numerous motifs familiar from other works of the period, scattered in this landscape of ruins in which the figure of a man extends from the golden clouds in the sky, which also read as his hair, through to the foreground. Parts of this landscape were based on a plate from a book with large colored illustrations which as a child "had affected me in an extraordinary way and even today remain very clearly in my memory";[9] among them was "a landscape of Egyptian ruins (this recollection gave me extra material for my painting *The Invisible Man*."[10] A rigorously constructed single-point perspective controls the lines of the walls, arcades and the giant paved platform, as well as the distant line of columns. The vanishing point is to the left of the horizon, at the very tip of the lowest and deeply shaded step. This also reads as a sharply pointed prong, jutting from a symmetrical "reliquary" shaped like a pelvic bone. The abrupt vertical line both emphasizes the sharp recession and flattens the landscape. The adaptation of the double-image figure of the man to span the whole landscape produces a kind of anamorphic perspective, as his bulk increases towards the front of the picture; his hands, visible in the "negative" patterns of the art nouveau fountain, and the feet similarly profiled by the lion's mane and formed of the fountain's water are inflated "anamorphically" to conform to the perspective but are thus out of scale with the head and shoulders. As the preparatory drawing shows even more clearly, Dalí carefully divided the horizon line to create a precise symmetry between the distance from the left edge of the picture to the vanishing point and the arcaded building to the right; the left side of the man's head touches the horizon at its exact center. The rational and abstract passion for measurement conflicts with the "concrete irrationality" of the paranoiac-critical image.

Visible in the top left of the landscape is the multiple image of the *Invisible Sleeping Woman, Horse, Lion* (fig. 20) discussed above, though the lion has become detached to the front of the canvas. Other motifs include the woman's head/jug, ubiquitous in paintings of this period, and an interesting example of the way Dalí introduces and then simultaneously interprets Freudian symbols: in this case, the idea that a "container" stands for the female. Implanted in the head, however, is a moustached long-haired woman, an example of the gender instability that often accompanied his William Tell iconography. In the lower right-hand part of the canvas is the disturbing "family group." A closely related drawing, reproduced in the "Great Masturbator" section of *La Femme visible* shows them gathered round a butterfly net, another thinly veiled sexual symbol. The two women with streaming hair and rose-bellies belong to the theme of Gradiva, another of Dalí's adopted icons and names for his muse, Gala. The lifted foot signifies her as the "Gradiva" of a short story by Wilhelm Jensen analyzed by Freud in "Delusions and desires in Jensen's Gradiva."[11] A young archaeologist became fixated by an antique relief of a woman walking, which he names Gradiva or "splendid in walking." He imagines he sees the woman resurrected in the ruins in Pompeii, and eventually recognizes that this is his childhood sweetheart Zoe Bertgang, whose German name translates as "gradiva." The real Gradiva/Zoe cures him of his obsession, as Dalí believed Gala had liberated him from his fears and anxieties.

1 When exhibited at the Pierre Colle Gallery in 1931, it was dated 1929–32, indicating that he considered it still unfinished. According to Reynolds Morse, in his notes to Eleanor Morse's English translation of *The Tragic Myth of Millet's Angelus* (Salvador Dalí Museum 1986), the painting remained unfinished. It was still in Dalí's possession when he died.

2 Salvador Dalí, *The Secret Life, op. cit.,* p. 250.

3 Salvador Dalí, "L'âne pourri," *La Femme visible,* Editions surréalistes, Paris 1930, p. 17.

4 *Minotaure,* no. 1, Paris 1933, p. 65.

5 *La Femme visible, op. cit.,* p. 15.

6 Jacques Lacan, *De la Psychose paranoiaque dans les rapports avec la personnalité,* Paris 1932.

7 Jacques Lacan, "Le Problème du style et la conception psychiatrique des formes paranoïaque de l'experience," *Minotaure,* no. 1, Paris 1933.

8 *La Femme visible, op. cit.,* p. 12.

9 *The Tragic Myth of Millet's Angelus* (1962) English trans. Eleanor Morse, Salvador Dalí Museum, St Petersburg, Florida 1986 p. 83.

10 ibid., p. 85.

11 Sigmund Freud, "Delusions and Dreams in Jensen's 'Gradiva'" (1907) *Pelican Freud Library*, vol. 14, *Art and Literature* 1987.

7

Spectre du Soir (*Evening Specter*), 1930
Oil on canvas, 18¹⁄₁₆ × 21⁵⁄₈ in.
San Diego Museum of Art,
Gift of Mr. and Mrs. Irving T. Snyder

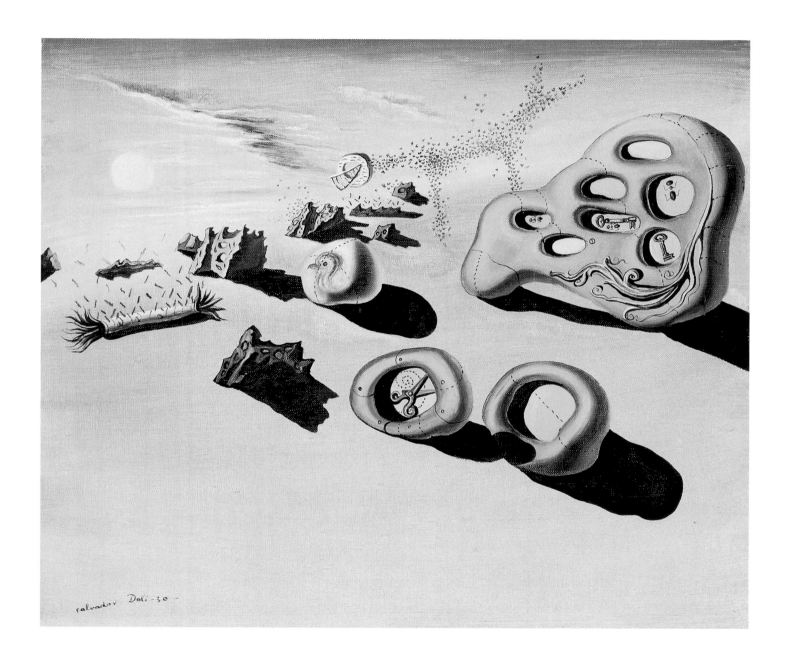

8

Solitude, 1931
Oil on canvas, 13⅞ × 10¾ in.
Wadsworth Atheneum, purchased through
the gift of Henry and Walter Keney Fund

The lonely figure of a young man among the rocks by the sea is the subject of several paintings in 1931. His face is always hidden, and often he is turned away with his back to the viewer. This pose, of the face hidden in shame or sorrow was a feature of the more dramatic symbolic narratives of the paintings of the previous two years, where the young man is often shown with an older "father" figure. The only immediately strange element here is the head whose curling hair, like the head of the *Woman Sleeping in a Landscape* (pp. 194–95) of the same year, metamorphoses into sea shells. The spiral of the shells belonged in Dalí's morphological lexicon to the same family as the curves of art nouveau. There was also a metaphorical link between the shell of the crustacean worn like armor outside its flesh and the head in human anatomy, which unlike the rest of the body, which wears its flesh outside its bones, conceals the soft brain beneath the cranium. Hair, for Dalí, was a disturbing and mysterious growth.

Once the apparent simplicity of the scene has been troubled by this initial metaphorical intrusion, other features take on heightened significance. The twin rocks against which the youth buries his head stand out as a pair, a couple, fissured down the center and split also in their color. That on the left has the golden-orange hue which Dalí often used to portray the rocks near his home in the late afternoon sun. The other is pallid and grey but not in shadow. It is closer to the bluish tonality of the youth's flesh, but nonetheless is a cold sheer surface. Both rocks, whose coupling gives them an anthropomorphic character, stonily resist him. Another painting of this group confirms in its title the idea of a sympathy between the human figure and the rocks: *Solitude – Anthropomorphic Echo.* In *Solitude,* however, the anthropomorphic rocks are faceless and irresponsive, and there is a sense of exclusion. To what personal memory or sensation this might relate is impossible to say – Dalí had cherished his solitude and independence before the arrival of Gala, and also felt bitterly his banishment from his father's house. The mood of the picture is powerful and cannot be pinned to specific causes.

Julien Green, the novelist and one of Dalí's first collectors, described his absorption on seeing two of Dalí's paintings on his first visit to the studio: "I lost myself in the contemplation of this marvelous world where the mind is drawn to the most distant dreams of childhood. Strange impression this extraordinary universe gives, but possible; it seems in some way to spread silence, it develops in silence like a plant in the light." But the silence of solitude may also be the utter loneliness of an untenanted universe, an empty sky.

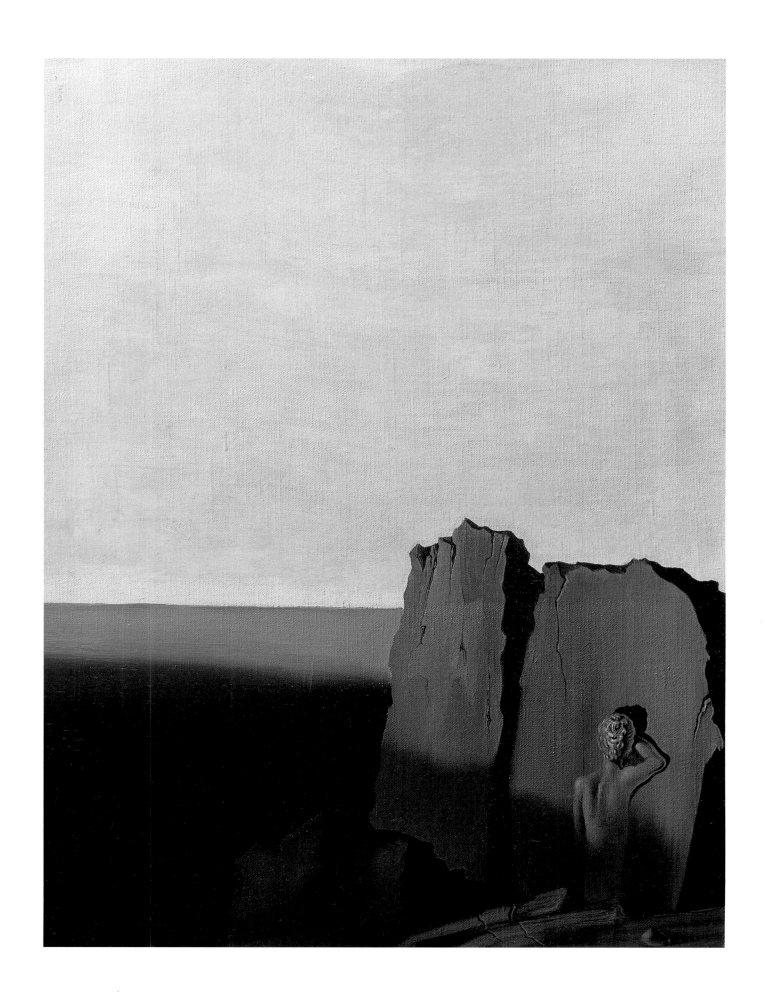

9

Fantasies Diurnes (*Diurnal Fantasies*), 1931
Oil on canvas, 32 × 39½ in.
Salvador Dalí Museum, St. Petersburg, Florida

Of all Dalí's "anamorphic" images, this comes closest to the famous blur in Holbein's *The Ambassadors* (fig. 30), which resolves itself into a skull only when seen from an oblique angle. The central form in Dalí's painting of a horizontal boulder with cavities, lying in a bleak seaside landscape, littered with truncated classical remains so worn that they resemble deeply grained rocks, echoes the shape of one of the skulls drawn in a letter to Paul Eluard, probably dating from the same period as this painting. This elongated, flattened cranium is identified in the letter as "the prettiest and most atmospheric of all *atmospheric-skulls*" (fig. 13).

The strong blue tonalities of this painting enhance the "atmospheric" quality, but Dalí meant more by this term than the mood produced by the blue of distances. The lowering black of the sky presses down on the earth and the bone-stone with physical force: "We know today," Dalí wrote, "that form is always the product of an inquisitorial process of matter – the specific reaction of matter when subjected to the terrible coercion of space choking it on all sides, pressing and squeezing it out, producing the swellings that burst from its life to the exact limits of the rigorous contours of its own originality of reaction."[1] The drawings of skulls and the compressed boulder-skull of the painting, from this perspective, take on an uncanny quality, for rather than behaving with the rigidity and brittleness of dead bones – by contrast, one might imagine, to the fragile goat skull in the foreground of the painting – they bend, twist or expand as though elastic and still able to respond with an internal reaction to the pressure of space. These symbols of mortality thus resist and react as though still alive, or in a second stage of death throes.

Stoking Dalí's meditation on matter, form and death, are ideas related to Freud's *Beyond the Pleasure Principle*, a key text for him. Dalí embraced the notion of the "death drive" as the "urge inherent in organic life to restore an earlier state of things,"[2] and elaborated on his own fantasy of a return to the womb, which can be understood as a return to origins. But what also appealed to Dalí in Freud's "metapsychological" ideas in this text was not only its extreme speculative nature but the consistent use of biology and reference to the distant origins of life-forms in mono-cellular organisms. This evidence of Freud's "organicism," his belief that there were not only parallels between his ideas about human psychology and its sources of energy and the physics of Fechner and Helmholtz, but that this physical energy was actually the same and that "the whole complex of human reactions and relations could be reduced to some as yet undiscovered physico-chemical reactions"[3] was a powerful attraction for Dalí, who constantly sought parallels between physics and biology, and aesthetics and psychoanalysis. In fact the origin of his most apparently irrational and fantastic visual images often lies in a morphological synthesis between diverse systems.

Dalí's interest in anamorphosis lay in its associative morphological potential, and rather than working with it as a specific visual technique to produce soluble puzzle-pictures he exaggerated the deformations according to irrational and imaginative trains of thought. However, on the second page of the letter to Paul Eluard, there is an example of almost classic anamorphosis (fig. 14): in the lower right hand corner a number of fleeting lines which become progressively more elongated make up a face which is clearly seen if the page is viewed obliquely. The hair of this personage (possibly Eluard himself) also forms the lips that multiply over the surface, thus combining the double image with anamorphosis.

Dalí's paintings become ever more complex as he filters his ideas through given mythical structures – the threatening or vengeful father (William Tell, Oedipus, Saturn) and through psychoanalysis. Hidden in one of the concavities of the stone are the repeated words "William Tell," which links this painting with one of his major themes, the myth of William Tell, which he interpreted as an Oedipal castration myth. Almost dead center of the painting is a tiny self-portrait mask, encased in a red seal, like a tiny globule of blood in the bleached scene.

[1] *The Secret Life, op. cit.*, p. 2.
[2] Sigmund Freud, *Beyond the Pleasure Principle*, trans. James Strachey New York/London 1961, p. 30.
[3] ibid., *Gregory Zilboorg*, "Introduction," p. x.

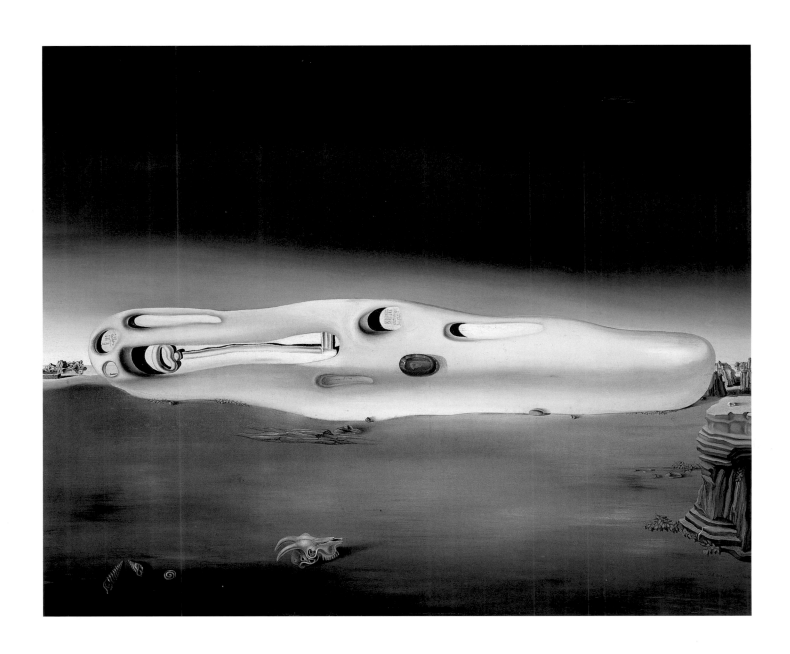

10

The Sign of Anguish, 1932–36
Oil on panel, 8¾ × 6½ in.
Scottish National Gallery of Modern Art, Edinburgh,
bequeathed by Gabrielle Keiller, 1995

After this painting was reproduced in *Minotaure* no. 5,
May 1934, (fig. 10.1) Dalí made a few changes and signed
and dated it on the back 1936. The changes are not sub-
stantial but include, as Elizabeth Cowling points out,
the elimination of a "limb" from the cypress tree in the
background, and the addition of another leafy branch
across the nude woman's shoulder.[1] Whether or not Dalí
intended to sharpen an allusion to the myth of Daphne,
who was transformed into a bush, is unclear, but the
transfer of a "limb" from the phallic cypress to the
female bush may have significance in the context of
certain of Dalí's characteristic paradigms, for example
hard and soft, swollen and deflated.

The "optical insecurity" in this painting is fed from
several sources, but comes primarily from the severe dis-
junction between the right and left hand sides, building

and landscape, whose perspectives do not match. The
figure of the woman placed at the center may mask
of the edge between the two, but her torso is cut off
such a way that a sensation of vertigo is produced by
apparent distance from the ground. She seems to be
the object of the kind of erotic reverie that Dalí often
described with the most minute attention to detail.

The cypress tree is associated by Dalí not only with
his familiar landscapes but also with one of his chosen
icons, Arnold Böcklin's *Isle of the Dead* (fig. 10.2), and
he initiates the long masturbatory fantasy in "Reverie"
with a meditation on the "frontality" of this painting.[2]

The woman's body, however, is very oddly painted –
while parts have normal musculature and flesh color,
others seem unnaturally swollen, inflated and pallid.
The proximity to the drooping, empty cloth or garments
hanging from the sill and draped over the branch sug-
gests an obvious sexual symbolism, but there may also
be a reference to Dalí's idea of a sexuality divided
between "phantom" and "specter." In the same issue
of *Minotaure* where the painting was reproduced, he

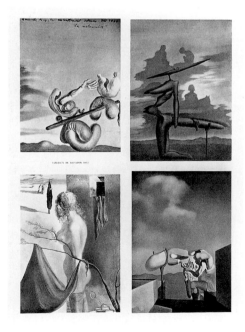

Fig. 10.1
Salvador Dalí
Signal d'angoisse (*Sign of Anguish*)
before alterations,
reproduced in *Minotaure,* no. 5, 1934.

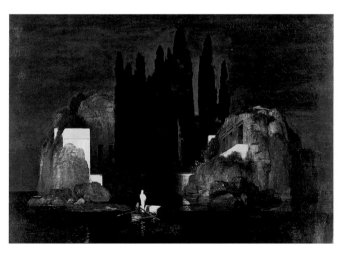

Fig. 10.2
Arnold Böcklin,
The Isle of the Dead, 1880
Kunstmuseum, Basel

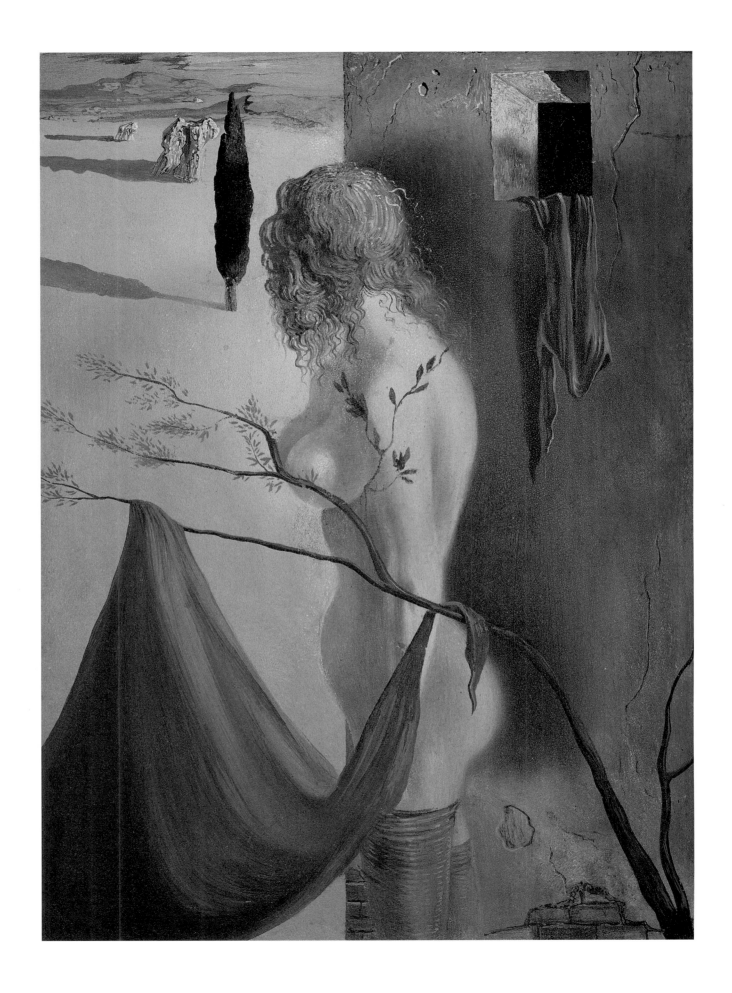

published "Les nouvelles couleurs du sex appeal spectral" (fig. 10.3). A fantastic meditation on the "virtual" volume of phantoms and the shrouds enveloping them invites the analogy of fat and flesh, which he calls "anthropomorphic anguish."[3] The terrifying fat of the flesh is that which "envelops, hides, protects, transfigures, incites, tempts, gives a deceptive idea of volume." Dalí then contrasts "Mae West's round and salivary muscles, terribly glutinous with biological after-thoughts" (as in the repellent swollen breasts of the painting) with a new form of "spectral sex appeal." The anatomy of spectral woman can be disassembled, taken apart and exhibited separately, according to her will: "The 'dismantle-able body' is the aspiration and the [algide] verification of feminine exhibitionism, which…permits each piece to be isolated and separately consumable." (The following issue of *Minotaure* contained Bellmer's photographs of his dismantled doll, "Poupée. Variations sur le montage d'une mineure articulée.") It is not hard to find here a deep anxiety about female sexuality, articulated between the poles of an engulfing mammary exuberance (Mae West) and an ambiguous cannibalist urge which he relates to the praying mantis.

Fig. 10.3
Salvador Dalí
"Les nouvelles couleurs du sex appeal spectral"
(The new colors of spectral sex appeal),
Minotaure, no. 5, 1934.

1 Elizabeth Cowling, *Surrealism and After: The Gabrielle Keiller Collection*, Scottish National Gallery of Modern Art, Edinburgh 1997, p. 87.
2 Salvador Dalí, "Les nouvelles couleurs du sex appeal spectral," *Minotaure*, no. 5, Paris May 1934, p. 20. Dalí's article is immediately followed by Roger Caillois, "La Mante religieuse: de la biologie à la psychanalyse."
3 ibid.

Detail, cat. 11

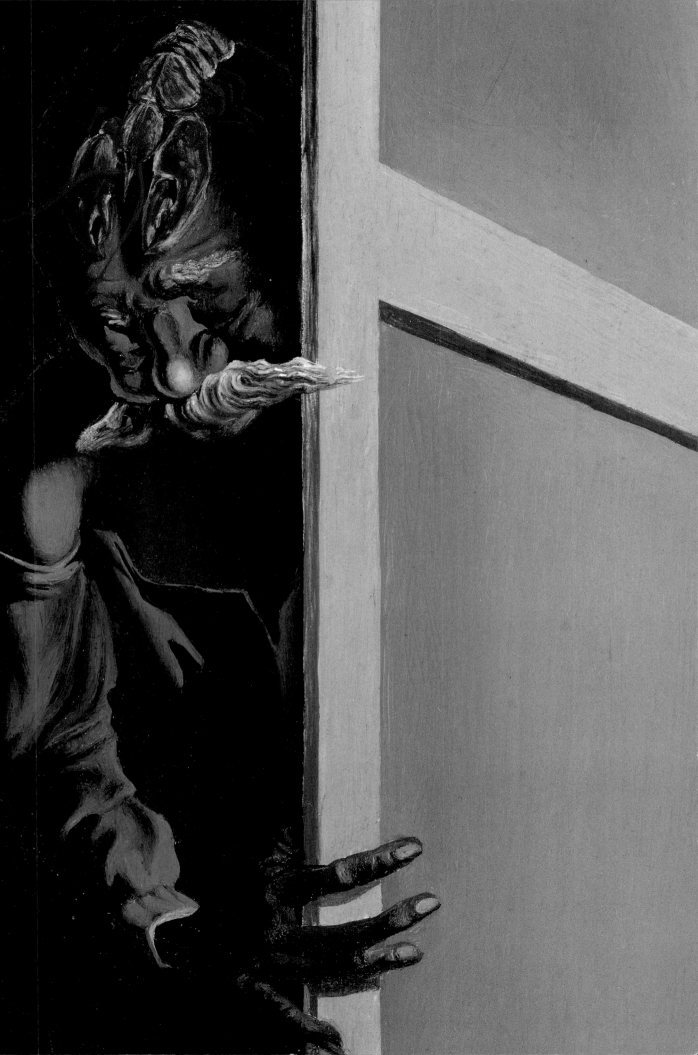

11

Gala and the Angelus of Millet Preceding the Imminent Arrival of the Conical Anamorphoses, 1933
Oil on panel, 9¼ × 7⅝ in.
National Gallery of Canada, Ottawa
*Shown only in Hartford and Washington

This tiny, luminous and mysterious painting disturbs the normal relations between size and scale. An impression of monumentality is achieved by the contrast between the two male figures and a minute, precise and photographic Gala and the "picture within a picture," the reproduction of a replica of Millet's *Angelus*. This effect is enhanced by the large clean architectural forms of the door and room, and the eerie black void within which the lighted room appears as windowless box. There is nothing here to help establish a "real" scale, for the human figures are disproportionate with each other, and are like visions or emotionally enlarged childhood memories.

This is the only painting among the series exploring what Dalí called the "Tragic Myth of Millet's Angelus" in which the original painting is represented more or less as it actually exists. In June 1932, Dalí experienced a vivid apparition of the *Angelus*, which profoundly disturbed him. The image was identical to the reproductions he knew, and which he had been familiar with since his childhood when it had hung in the schoolroom, but it nonetheless appeared "absolutely modified and charged with such a latent intentionality that [it] suddenly became for me the most troubling of pictorial works, the most enigmatic, the most dense, the richest in unconscious thoughts that had ever existed."[1] (fig. 21.1) Following a series of encounters with phenomena he related to the two figures in the *Angelus*, Dalí unraveled the systematic associations that structured the delirious ideas aroused by the image. The erotic and fatal meaning of this unique, insipid, menacing and crepuscular image for him emerges in the course of his book *The Tragic Myth of Millet's Angelus* as "the maternal variant of the grandiose, atrocious myth of Saturn, of Abraham, of the Eternal Father with Jesus Christ, and of William Tell himself – all devouring their own sons."[2] The aggressive "praying mantis" posture of the female, the sexual symbolism of the wheelbarrow, parallels with dolmens and pebbles inform the imagery of paintings on the theme, in which the drama is further complicated by the shifting relationships between the "couples":

husband–wife, mother–son.[3] However, here, the picture of the Angelus is intact – or if anything, the menacing pose of the female is lessened by the slight exaggeration of the distance between the figures.

The two male figures do not belong to the iconography of the "Tragic Myth," and Gala is dressed in the identical multi-colored coat she wears in *The Sugar Sphinx*. The Sphinx, as Dalí suggests in *The Tragic Myth*, is separate from the forms of the diminishing male figure and the devouring female as they are depicted in his "Angelus" paintings. Facing the smiling Gala is Lenin, while peering round the door is a figure Dalí identified as Maxim Gorky, a lobster on his head, wearing the luxurious moustache and with the downturned visage of the man elsewhere described as "the average bureaucrat." These are figures belonging if anything to the William Tell theme: the threatening father in the huge painting *The Enigma of William Tell* (Moderne Museet, Stockholm) has the features of Lenin, although here he is shown vulnerable, with a bald and slightly anamorphic head, and an arm uncannily metamorphosing into a crystalline substance. This is a kind of parallel to the crustacean on Gorky's head. The "conical anamorphoses" may be the phallic distortions associated with William Tell, imaginable as the lobster's flesh, and intrinsic here in the distended scale of the male figures. These are no more menacing, however, than the plaster busts along the mantelpiece; it is as though the threatening figures of childhood remembered as immense and atrocious have become inefficacious. The strange geometrical object on the table between Gala and Lenin suggests both a mathematical model half-remembered from childhood and a perspective construction which may deflect the "conical anamorphoses." Gala, associated, if ambiguously, with the Angelus, triumphs. Dalí's enigmatic comment on this painting, which he added when correcting the proofs to *The Tragic Myth* in 1978, suggests that the intrusion of the Angelus on his William Tell myth places it in a different light: "The Angelus, antidote for a lobster."

1 *Tragic Myth, op. cit.,* p. 3.
2 ibid., p. 135.
3 See Fiona Bradley, "Strategies of Encounter in Dalí's *La Gare de Perpignan*," unpublished.

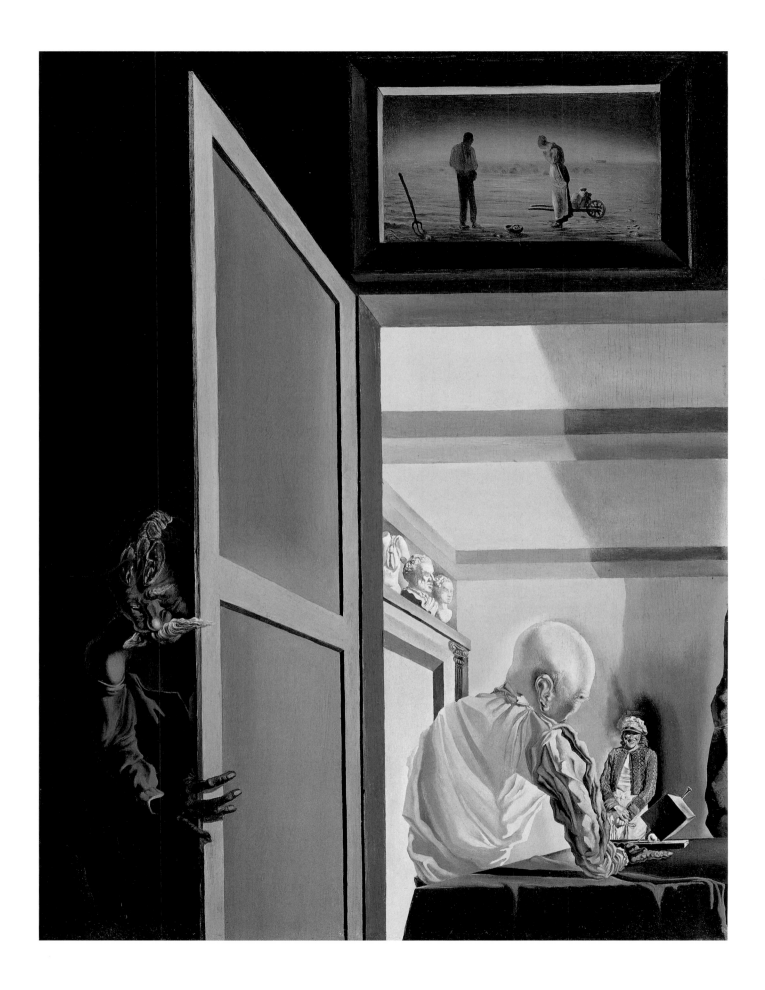

12

The Phantom Cart, 1933
Oil on panel, 6½ × 8 in.
Yale University Art Gallery, gift of Thomas F. Howard

Dalí painted several versions of this double image, in which the silhouettes of two buildings read also as the occupants of a covered cart approaching a little town. The golden light and blue hills of this version make it the most atmospheric. The setting is the Ampurdan plain, in which his home town, Figueres, lies. This stretches from the foothills of the Pyrenees to the sea, where there are the remains of major Phoenician and Roman cities: hence the fragment of the encrusted amphora in the foreground, memory of their ruins and sunken ships. The amphora catches the glow of the setting sun, anticipating the twilight that caused a nostalgia in Dalí both for past ages and his own childhood.

The town with its towers is typical of those that dot the Ampurdan plain; the bell-tower of one such church prompted another recurring double image of girl/bell (cat. 19).

Dalí's paranoiac-critical method, underpinning the idea of the double image, was a kind of "reasoning madness," a systematic misinterpretation of the surrounding world according to an over-riding obsession. It was valued by the surrealists as a remarkable "critical tool." From their point of view it would help to undermine empirical reality, and to revalue "abnormal" mental states by simulating their inventive powers. But the visual instability provoked by the experience of misreading a given object or configuration could be a source of pleasure as well as disquiet. Dalí was intrigued by the special pleasure produced by the slow metamorphosis of shapes in clouds or a moving skyline. "All the images capable of being suggested by the complexity of their innumerable irregularities appear successively and by turn as you change your position. This was so objectifiable that the fishermen of the region had since time immemorial baptized each of these imposing conglomerations – the camel, the eagle, the anvil, the monk, the dead woman, the lion's head. But as we moved forward with the characteristic slowness of a row-boat (the sole agreeable means of navigation) all these images became transfigured, and I had no need to remark upon this, for the fishermen themselves called it to my attention."

"Look, Señor Salvador, now instead of a camel, one would say, it has become a rooster."[1] The uninterrupted "becoming" of the features of a landscape to the observer in the slowly moving rowing boat appeared to Dalí to reveal the meaning of Heraclitus's enigmatic phrase "Nature likes to conceal herself."

As from a rowing boat, a slow journey by cart would produce a constant metamorphosis and shifting of associations in the scene; in this painting Dalí may be recalling the trip by cart that he and his family took every summer to their house on the coast at Cadaques. He may even be deliberately linking it with another famous exercise in memory, Proust's description in *A la recherche du temps perdu* of watching, during an evening drive, the two bell-towers of Martinville appearing slowly to change places and then meet the tower of the more distant village of Vieuxvicq, which was accompanied for Proust by the conviction that there was something hidden behind this movement. The three towers first appeared like three birds settled on the plain:

> *I saw them for the last time from far away, and they were now no more than three flowers painted on the sky above the low line of the fields. They also reminded me of the three girls of a legend, abandoned in a solitude where darkness was already falling; and while we moved further away at a gallop, I saw them timidly finding their path and, after a few awkward stumblings of their noble silhouettes, draw close together and slide behind one another, to leave against the pink sky a single black form, charming and resigned, and vanish in the night.*[2]

Dalí, like Proust, followed his nostalgic reveries to uncover the hidden source of attraction or disturbance in an object or image. Here, there is a kind of double distancing, as the cart with the figures moves away from the viewer towards the far towers.

[1] *The Secret Life, op. cit.*, p. 304.
[2] Marcel Proust, "Du côté de chez Swann," *A la recherche du temps perdu*, Paris 1954, p. 184.

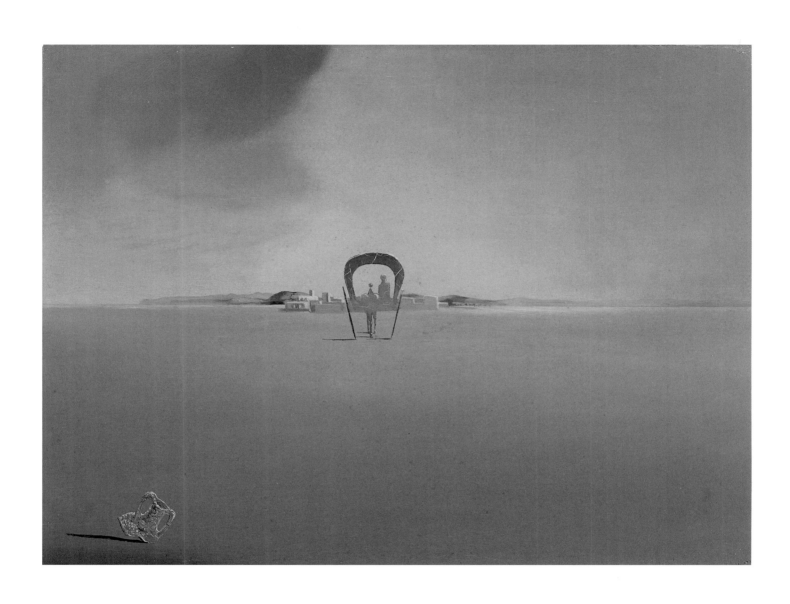

13

Myself at the Age of Ten when I was the Grasshopper Child – (Castration Complex), 1933
Oil on panel, 8⅝ × 6⅜ in.
Salvador Dalí Museum, St. Petersburg, Florida

Fig. 13.1
J. F. Niceron
Anamorphosis of a chair
Thaumaturgus Opticus, Paris 1646, pl. 23

"Castration complex" is not strictly part of the title; in the catalogue for the exhibition at the Pierre Colle Gallery in 1933 when the painting was first shown, Dalí scattered some explanatory phrases in brackets after the titles. So *William Tell is dead* was an "hallucinatory foreboding," *Gradiva finds again the Anthropomorphic Ruins* was a "retrospective fantasy"; and *The Atavisms of Dusk* an "obsessive phenomenon"; *Oeuf sur le plat*, however, was "sans le plat." Apart from "castration complex," therefore, which carries the full weight of Freudian theory, they belong to Dalí's personal terminology of states of mental and visual excitation.

Dalí's autobiographical writings give a full account of his "grasshopper complex," and the grasshopper is ubiquitous in earlier paintings, for example in *The Great Masturbator* (fig. 18), where it is fastened to the mouth of Dalí's portrait mask. But despite the title there is no grasshopper in this painting, which shows the boy Dalí in his sailor suit kneeling beneath a table, which zooms into the distance. Dalí has here borrowed from an illustration of a similarly simple straight-sided chair in perspective from Niceron's *Thaumaturgus Opticus* (fig. 13.1), dramatically extended, a device already used in his illustration for René Char's *Artine* (fig. 13.2). The child's limbs are caricatural, the muscles exaggeratedly reduced or amplified, and the buttocks visually parallel the apparently anamorphic head. Its elongated form resembles the head of a sculpture in Dalí's possession of an "aerodynamic woman" (fig. 21.2). This shape, however, which is stony and featureless, is also that of the fish which triggered Dalí's horror of grasshoppers. He tells in *The Secret Life* how as a small boy he loved grasshoppers, catching them to study the color of their wings, but then suddenly developed such a phobia that "the fright which grasshoppers cause me has not diminished since my adolescence."[1] The utter horror they then aroused in him was inexplicable until much later when his father reminded him of an incident when he was about seven or eight when he caught a little fish, stared at it and threw it violently away crying "It's got the same face as a grasshopper's."[2] The implication of the fatal incident as he tells it first in the 1929 text "Liberation of the Fingers," at a time when having read Freud's

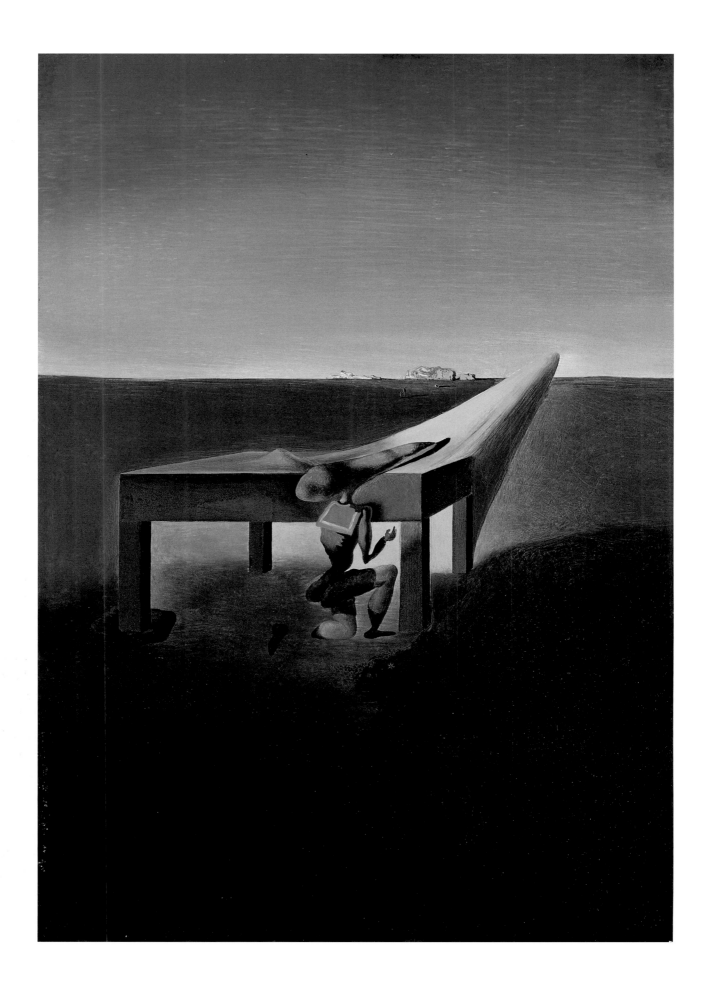

Interpretation of Dreams he was obsessed with self-analysis, is that the fish symbolized castration, a terrible floating phallus. Dalí here and in the painting's suffix is thus referring to Freud's Oedipal scenario; in Dalí's mythography sexual guilt is usually shown through one of his "Father figure" myths like William Tell, as violence against the son by the father, though this could equally be interpreted as repressed wish of the castration of the father, inverted into auto-punition. However, the repulsion grasshoppers aroused in him seems to exceed the Oedipal threat; he attributes two specific causes — the insect's sudden spring from motionless stillness, and the sliminess of the crushed body of the insect. These aspects of the horror open up other areas of psychic anxiety. The stillness/violent leap are like an uncanny enaction of death, while the glutinous substance of the dead insects casually killed by his playmates relates to what Dalí called the "simulacra of terror": excrement, blood and putrefaction. Both Freud's idea in *Beyond the Pleasure Principle* that life is attracted to death, the organic to an original state of inorganicity, and Kolnai's elaboration of the idea of defense against the attraction of the repellent were important to Dalí.[3] The obsessional repetition of the horrifying element, like the repeated presence of the grasshoppers, relates to this pull between existence and annihilation. In the painting *Myself…* the hard stone or perhaps bone of the boy's naked skull is like a defense against its own dissolution in the form of the fish/grasshopper. The phallic blur of the table's perspectival extension in a golden substance neither flesh nor wood is as it were sucked into the distance, as if penetrating space. To label the painting as Dalí does "castration complex" is thus perhaps to simplify its visual complexity.

[1] *The Secret Life, op. cit.*, p. 128.
[2] "Liberation of the fingers," *op. cit.*
[3] On Kolnai and Dalí's concept of repulsion see David Lomas, "The Metamorphosis of Narcissus," *op. cit.*

14.

Enfant Sauterelle (Grasshopper Child), 1933
Etching and drypoint, 14⅛ × 11⅞ in.
Wadsworth Atheneum, Hartford, gift of David Austin

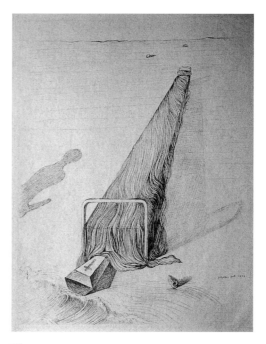

Fig. 13.2
Salvador Dalí
Frontispiece to René Char, *Artine*, 1930

15

Paranoiac-astral Image, 1934
Oil on panel, 6⅛ × 8⅝ in.
Wadsworth Atheneum, Hartford, the Ella Gallup
Sumner and Mary Catlin Sumner Collection Fund

The even placing of the four "figures" on the vast
bleached expanse of sand suggests both a balance and
a pairing that has been carefully measured. The fact
that the man casts a shadow unlike the other three
objects has already been discussed (p. 19) in terms of
the temporal disjunctions in the painting. As well as
seeming to inhabit a different time-space from the rest
of the picture, a piece of soft cloth trails from his hat,
suggesting a speedy materialization. The slightly diag-
onal placing of the fragment of an amphora in the
foreground and the woman in the background sets the
four objects into an oblique circle, which evokes a clock
face or sundial. In the boat are seated a woman, perhaps
Gala, facing a boy in a sailor suit, Dalí himself as a child.
The painting encapsulates the experience of memory,
the irrational resurgence of childhood experiences or
sensations; nostalgia for the past is both personal and
individual, and also inscribed within the deep history
of the mediterranean coast, allegorized by the amphora.
The bleached and empty beach, though, is like the
dead surface of a star, the fate of the earth in the far
distant future. The poignancy and futility of human
memory are suspended within the immensity of the
idea of space–time.

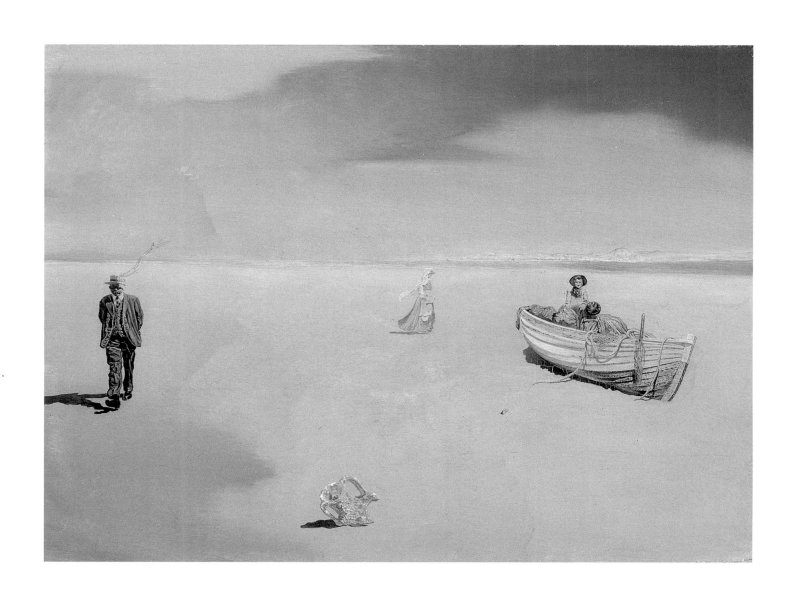

16

Cardinal, Cardinal!, 1934
Tempera and oil on panel, 6¼ × 8¾ in.
Munson-Williams-Proctor Institute, Utica, New York

This strange and intriguing painting is in some ways more enigmatic than the more obviously irrational phantasms of critical paranoia. Coming after the extraordinary, sustained paranoiac interpretations, both visual and written, of Millet's *Angelus* and the cannibalist transformations and osmoses of the *Chants de Maldoror* etchings, *Cardinal, Cardinal!* seems personal and somewhat tentative.

There is a subtle but nonetheless clear disjunction of mood and style between the left foreground scene, and image of Gala on the right. The juxtaposition is similar to a montage, such as Dalí's frontispiece to *L'Amour et la mémoire* (1931; fig. 16.1) which combined a photograph of Gala seated on a wall with one of Dalí himself in the guise of William Tell's son. In *Cardinal, Cardinal!* Gala is evidently painted from a photograph, as was Dalí's frequent habit, but superimposed like a

Fig. 16.1
Salvador Dalí
Frontispiece to *L'Amour et la mémoire*
Paris, 1931

double exposure over golden sunlit sands which shine through her body. She holds up a stained rag, as if she had caught a fish; this has multiple reverberations with the William Tell paintings and the castration theme, for the father often holds an invisible object within a bloody cloth. Here, the cloth falls open and is empty, and Gala smiles reassuringly.

The gloomy group of men, by contrast, with bowed and hidden faces, gather in the shade of a ruin round a bedside cabinet. They are streakily painted and in places the dark wall shows through their transparent bodies. The man in the center with the white shirt conceals his head in his hand in the gesture familiar from earlier paintings like *Le Jeu lugubre* (fig. 29.1), and could represent Dalí himself. The jug he holds towards the cupboard is mottled like the amphora of *Paranoiac-astral Image*, but in the context is evidently a memory of the jugs that appeared as dream symbols in the 1929 pictures. The two objects, jug and cupboard, are containers and stand, Freud had proposed in *The Interpretation of Dreams*, as symbols for women and female sexuality. But unlike the ubiquitous jug-women of earlier paintings such as *Illumined Pleasures*, where Dalí not only interprets the jug symbol according to Freud's *Interpretation of Dreams*, making manifest its latent meaning, but also depicts it distorted and with a congealed and unearthly clarity to replicate a dreamed image, here both jug and cupboard are earthy and realistic. Other works of the period, however, use furniture symbolism more explicitly, sometimes making it anthropomorphic.

The title of another painting of 1934, *Skull with its Lyric Appendage leaning on a Bedside Table which should have the Exact Temperature of a Cardinal's Nest* (cat. 18), is a clue to the "Cardinal" of the title – the North American bird with the brilliant red plumage whose likeness to a cardinal's robes gave it its name. The cupboard–nest analogy thickens the womb symbolism, while red is the color of fire and passion and also, for Dalí, of the "intra-uterine paradise."

The symbols in this painting are masked or absorbed into its generally realist appearance, which in turn is of two types – photographic and painterly. Overall, perhaps it refers to Gala's role, celebrated so often in his writings, in solving the painter's neurosis and sexual anxieties.

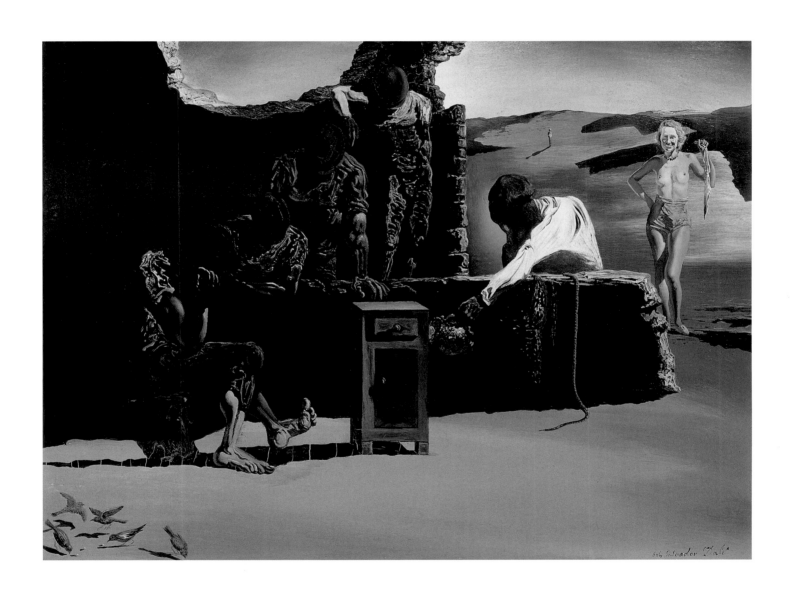

17

Atmospheric Skull Sodomizing a Grand Piano, 1934
Oil on panel, 5½ × 7 in.
Salvador Dalí Museum, St. Petersburg, Florida

The paintings *Atmospheric Skull Sodomizing a Grand Piano* and *Skull with its Lyric Appendage…* are linked as images of "concrete irrationality," through the constantly evolving process of association and metamorphosis. The first of these, *Atmospheric Skull,* was inspired Dalí says in *The Secret Life,* by a dream at Cadaques, in the summer of 1937 (sic). Both the skull and the grand piano, however, have long and complicated histories in earlier works. The grand piano figured famously in the film *An Andalusian Dog* where, stuffed with the carcass of a rotting donkey, it seemed to symbolize the decadence of a bourgeois culture. The rotting donkey had its own further set of associations for Dalí both with the sentimental comforts of the cultivated bourgeois (the *putrefact,* in the language he shared with Lorca) and with his own complex notion of putrefaction, one of the "three great simulacra," as he called them, involved in the mechanism of repulsion, the others being blood and excrement.

The skull as an image derives its uncanny mobility in the first instance from Holbein's *Ambassadors* (fig. 30), and its anamorphic distortion of the death's head. A group of drawings from a letter to Paul Eluard, discussed in relation to *Diurnal Fantasies,* (cat. 9; fig. 13) revealed Dalí's concept of the "atmospheric skull" which was uncannily animated through the "inquisitorial" pressure of space, which moulds everything, including

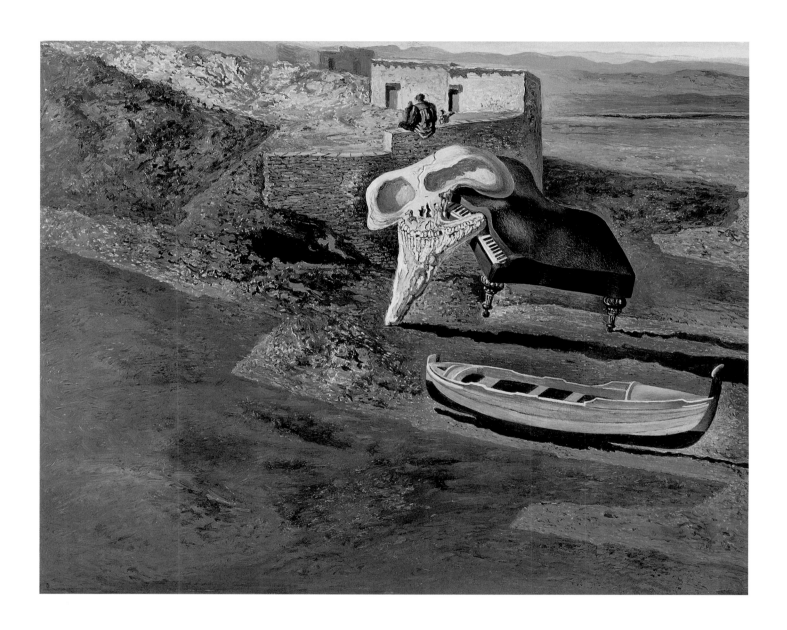

Skull with its Lyric Appendage Leaning on a Bedside Table which should have the exact Temperature of a Cardinal's Nest, 1934
Oil on panel, 9¼ × 7½ in.
Salvador Dalí Museum, St. Petersburg, Florida

bones. The skull here, unlike that in *Diurnal Fantasies,* is vertical, anthropomorphically rooted to the ground but with a single bony stump.

The whole surface of the painting in *Atmospheric Skull* is subject to the material disintegration of the surroundings: rocks and sand dissolve into an indeterminate mass of geological and mineral matter; the stark calcinareous skull stands out against the muddy collapse of the rest of the landscape as paradoxically the only active force within it. The crutch in *Skull with its Lyric Appendage,* which was to be such a prominent feature of later paintings like *Sleep,* and which he later explained in terms of the support his work would give to the embattled and decadent culture of a disappearing aristocratic order in Europe, here simply seems to prop up the elongation of the teeth-keys, and to undermine the idea of the heavenly elevation of the grand piano, and its cultural pretensions to a superior order of artistic activity.

In the background to these images of the grand piano is Dalí's acceptance at this period of the surrealist rejection of music. "May night descend upon the orchestra," as Breton wrote in *Surrealism and Painting:* this prejudice against music seems to derive from a clash between a perceived vagueness and abstraction in musical expression and the desire for the specific and the concrete image in Surrealism.

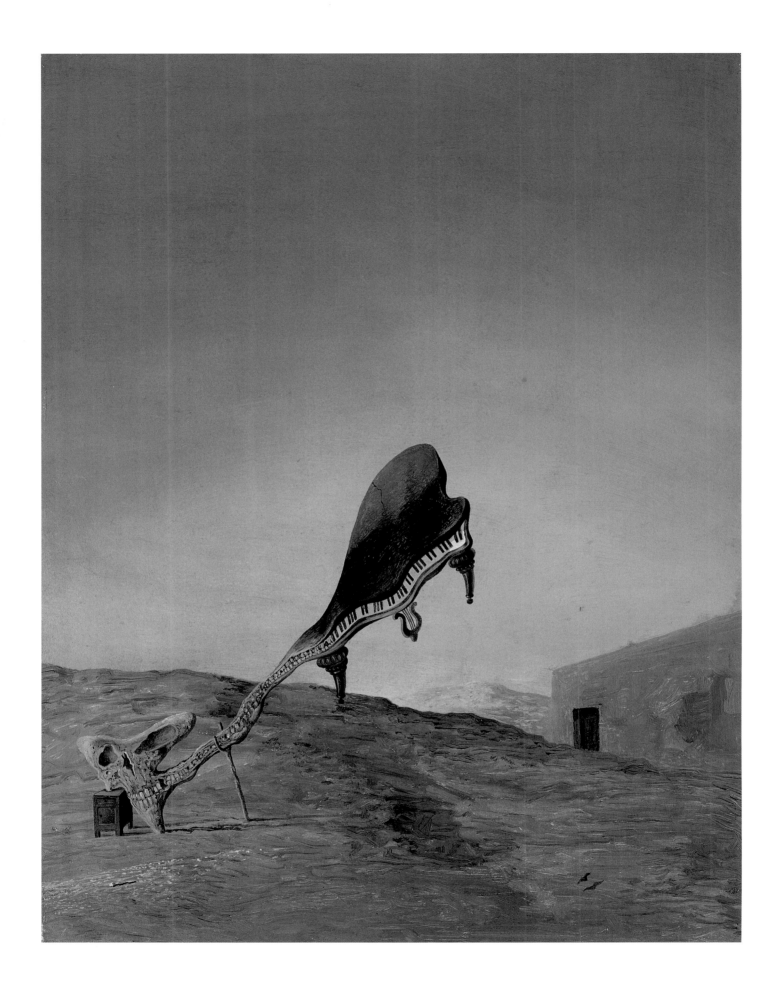

19

Morphological Echo, 1934–36
Oil on canvas, 25½ × 21¼ in.
Salvador Dalí Museum, St. Petersburg, Florida

As the title suggests, rhymes are set up in this painting
between shapes and structures, hinting, in places, at the
mechanism of the paranoiac double image. The bell
suspended in the niche echoes the form of the girl with
the elongated shadow running with raised arms and
skipping rope. The raised arms of the girl form a hoop,
which increases the resemblance to the shadow-girl
bowling a hoop in de Chirico's *Mystery and Melancholy
of a Street* (Museum of Modern Art, New York). In
Morphological Echo the angle of the running girl is
repeated in the worn and leaning granite rock with
the hole in it, as well as in the pole emerging from the
tower in the foreground. Her shadow, though is thin
and insect-like, raising an association with the "spectral"
praying mantis.

 The tower-arch in the foreground casts no shadow,
and moreover its perspective lines meet outside the
picture-frame, possibly at the presumed source of light
low to the right of the painting. The dark, erect tower
is placed firmly in the center of the picture, so that the
eye has to pass either side of it rather than being drawn
to a centrally positioned vanishing point, and this exac-
erbates the spectator's sensation of looking on as though
from the wings of a stage at a partially obscured scene,
with the heavy shadows of night descending and creep-
ing up from below. In the de Chirico there are no
human presences, only their shadows; Dalí includes a
figure, but her identity is sucked into the inanimate
and menacing features of the landscape. She is, as it
were, the visible core of a scene whose features other-
wise appear as façades, like Freud's notion of the façade
of the manifest dream, that is, what is remembered on
waking, which conceals latent meanings.

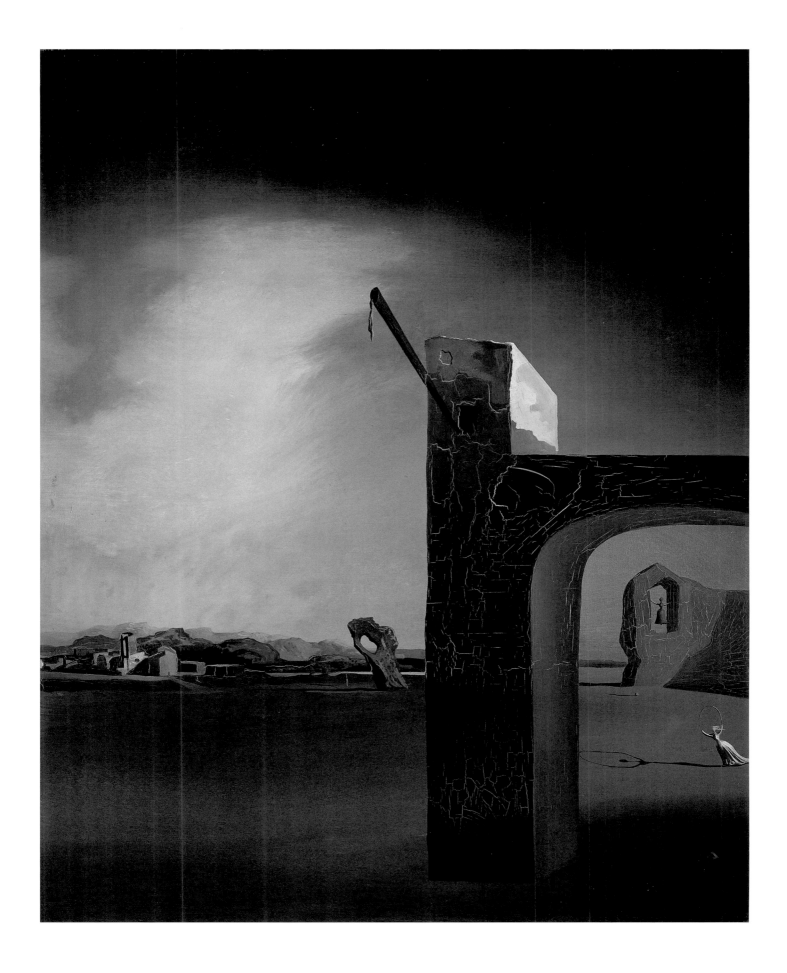

Three Young Surrealist Women Holding
in their Arms the Skins of an Orchestra, 1936
Oil on canvas, 21¼ × 25⅝ in.
Salvador Dalí Museum, St. Petersburg, Florida

There is a striking variation in the overall tonality and coloring of Dalí's landscapes during the 1930s, and this is often linked to the atmosphere of a particular time of day. The strong golden ochers and blues of the land and sky, complementary colors which strengthen each other and reach a lurid intensity in some works, signal heat and the late afternoon sun, while the greenish tones of other paintings represent twilight and an aura of nostalgia. By contrast, *Three Young Surrealist Women* is painted in the lightest and most delicate tones, with a gentle gradation from the pale blue of the sky to the silvery white of the sand. The dark rocks stand out sharply against the sand, as if one is looking at them against the light, but the figures are modeled out of the same tones of white, grey and cream as the beach. The woman on the left, however, is more strongly and heavily modeled, and the harsh and serrated shadows across her body echo and sometimes become part of the rock behind her, as though Dalí were here planning a double image.

The heads of the young women are composed of flowers, although that on the left is more of a twiggy bush. The substitution of the heads of young women with flowers, often roses, was a fairly frequent motif at this moment, and may relate to the roses, sometimes bleeding, that appear in place of the womb in *The Invisible Man* (cat. 6) and *The Bleeding Roses* (1930). This has a specific reference to the hysterectomy Gala was forced to undergo and which filled Dalí with panic; it could be that eventually this symbol for the womb was displaced to the head, a substitution or confusion of the lower for the upper parts of the body that Dalí often enacted, in the process purging the roses of their painful associations, and restoring to the petals the carnal and sensual quality that make them traditionally the emblem of love. On the occasion of the International Surrealist Exhibition in London in June 1936, Dalí had dressed a young woman in a mask of roses and a long evening dress. In *The Dream*, a woman places a hand on a man's shoulder, her head composed of massed coral-like flowers.

The presence of the tuba here may be due to the long-established dialogue between Dalí and Magritte which reached a level of more direct rivalry as both artists sought the patronage of the wealthy English poet and collector, Edward James. Magritte had added a tuba to his repertoire of objects in 1928 in *The Acrobat's Ideas*, for instance, where it dangles like an additional limb from a network of smooth but fragmented bodies. His flaming tuba, *The Discovery of Fire* (1934/5), harks back perhaps to the blazing giraffe ejected from a window in Dalí and Buñuel's film *The Golden Age*, and Dalí too returned to this idea of an object in flames later in the thirties. Here, the tuba, by contrast to the other instruments, retains its solid shape but appears to be blackened or charred. The profile of the melting piano could be related to Dalí's ubiquitous dissolving self-portrait masks. The soft musical instruments have, as in other paintings of the period, an obvious sexual symbolism, signifying fears of impotence. But the idea of the malleable morphology, of an object anamorphically distorted for pictorial reasons then as it were taking on that new shape and this in turn being subject to distortion appealed to Dalí. Moreover, the soft instruments may have a parallel with the soft watches of *Persistence of Memory*, through an irrational link between musical time and space-time.

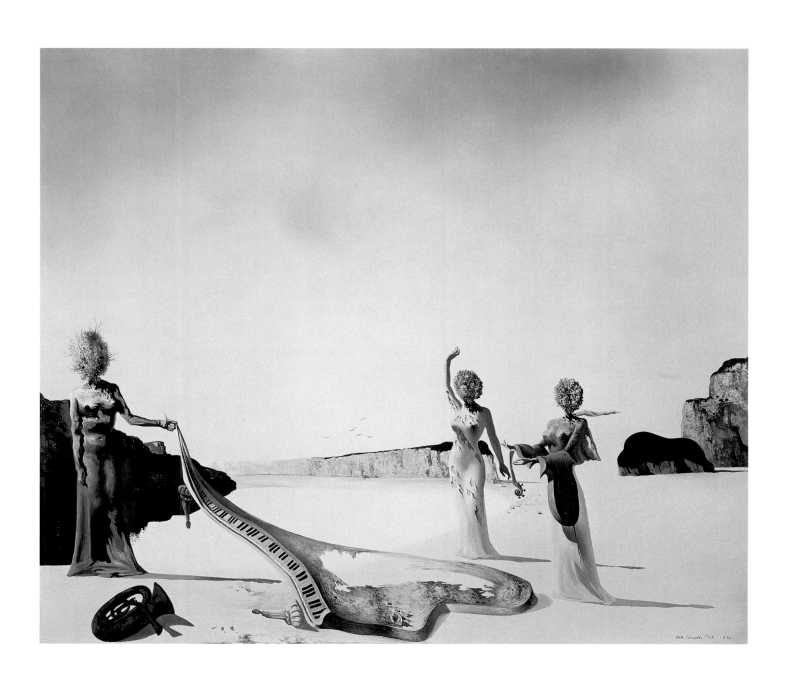

The Great Paranoiac, 1936

Oil on panel, 24⅜ × 24⅜ in.

Museum Boijmans Van Beuningen, Rotterdam

Although Dalí had been experimenting with t[]noiac double image since *The Invisible Man* (c[]was only in the mid 1930s that he began regul[]orchestrate whole canvases of multiple figurations with such fluid technical assurance. In a landscape of beach and rocks a mass of figures forms a large head whose lightly defined shoulders in the foreground are distinguished by more intense reddish-orange hues. Otherwise, the canvas is almost monochrome, which suggest that Dalí needed to restrict the complexity of the painting in order to achieve the graphic double-reading, but also that he was looking on several levels at the example of Leonardo da Vinci. Freud's psychoanalytical study of Leonardo had long been important to Dalí, and he had reproduced the *Virgin with St Anne,* where Freud had discovered the hidden image of the vulture, in his earliest publication on his interpretation of Millet's *Angelus* (fig. 21.1).[1] He was also familiar with Leonardo's ideas of sounding different surfaces for visual invention, such as "walls and varicolored stone, [which act] like the sound of bells, in whose pealing you can find every name and word that you can imagine."[2] In the chromatically unified but nonetheless varied substance from which *The Great Paranoiac* is forged, Dalí could almost be illustrating Leonardo's instruction to "look into the stains of walls, or ashes of a fire, or clouds, or mud, or like places, in which, if you consider them well, you may find really marvelous ideas."[3] At more or less the same time that he was working on this painting, Dalí was making sketches of horses and battle scenes based on Leonardo's drawings for his *Battle of Anghiari,* which

Fig. 21.1

Salvador Dalí, page from "Interpretation Paranoïaque-critique de l'image obsédante de 'L'Angelus' de Millet," *Minotaure,* no. 1, 1933. Dalí's commentary on the reproduction of Leonardo's *Virgin and Child with St Anne*" reads, "The ensemble constituted by the child's mouth and the tale of the famous invisible maternal vulture that Freud interpreted in Leonardo's painting coincides intentionally with the head of the child in Millet's *Harvesters.*"

were to produce the double image *Spain*, and he was also probably looking to Leonardo's unfinished *Adoration of the Kings*, with its brownish lay-in and crowded scenes of figures and horses.

The Great Paranoiac, though, is built entirely of figures, none of whose faces is visible. Most are men, wearing caps, possibly based on the fisherman of Port Lligat, though the capped man also recalls the Lenin of *The Enigma of William Tell*. A naked female body forms the nose, and the forehead is a hard light patch of white stone. Dalí's treatment of ground in his paintings, of the earth, stone and sand, moves between two distinct poles: either it is licked smooth, undifferentiated and flat, or it is rough, almost convulsed and like molten lava. Often, as in the fiery landscape of *Metamorphosis of Narcissus*, or in *The Specter of Sex Appeal*, this creates a parallel with the emotional and sexual tension in the painting. Here, the contrast is between cold, sandy or brown excremental tones and the red and golden foreground.

Dalí placed such importance on the paranoiac-critical method that he planned to make it the basis of a movement in its own right. He drew up plans for a magazine that he called "*Paranoyaquinesis (mouvement paranoyaque),*" of which he would be sole editor. Of the various rubrics he toyed with, one read "morphologie – esthetique – gestalteorie – surrealism…," but the project was not realized.

Fig. 21.2
Photograph from Salvador Dalí,
The Tragic Myth of Millet's Angelus.
The sculpture of an "aerodynamic woman"
can be seen beside Dalí on a table.

1 "Interprétation Paranoiaque–critique de l'image obsédante de 'L'Angelus' de Millet," *Minotaure*, no. 1, Paris 1933, p. 65.
2 *The Notebooks of Leonardo da Vinci*, selected and edited by Irma A. Richter, Oxford 1998, p. 182.
3 ibid.

Detail, cat. 21

22

Paranoia, 1935–36
Oil on canvas, 15 × 18⅛ in.
Salvador Dalí Museum, St. Petersburg, Florida

There were nine muses in classical antiquity, born of Zeus, the father of the gods and of the goddess Mnomosyne, memory. To this offspring of the marriage of the ego and the id, Dalí adds his personal muse, "Paranoia." The muse of Paranoia watches over the images born of the mental state that Dalí understood according to ideas drawn from theories of Freud, Lacan and psychologists like Serieux and Capgras as an active form of interpreting images, objects or events in the world according to a personal and irrational obsession. Dalí insisted that his method was, unlike the surrealist notion of automatism, of the unconscious recording of inner images, an active and systematic form of thought. Dalí's double images are born of this process of reading a given configuration according to internal and irrational compulsion; it is only partly for Dalí, an associative process – links may subsequently be discovered, according to a system of analysis, but may remain arbitrary. But the process of representation must retain cognizance of the original image in order for the double reading to operate. The process, then, as Freud commented to Dalí, is a conscious one, even if the initial irrational visual perception was not. The determined and concentrated gaze which re-interpreted phenomena in the light of an entirely internally motivated desire has parallels with Leonardo's advice to use stained and mossy walls as a spur to the imagination, and here Dalí deliberately pays homage to Leonardo.

> *Do not despise my opinion, when I remind you that it should not be hard for you to stop sometimes and look into the stains of walls, or ashes or a fire, or clouds, or mud or like places, in which, if you consider them well, you may find really marvelous ideas. The mind of the painter is stimulated to new discoveries, the composition of battles of animals and men, various compositions of landscapes and monstrous things, such as devils and similar things, which may bring you honor, because by indistinct things the mind is stimulated to new inventions.*[1]

Representing "Paranoia" in the form of a bust set on a shallow pedestal, (her name inscribed with his usual orthographic awkwardness), Dalí constructs her face according to the "active" paranoiac mechanism. It is made up of a Leonardo-like battle scene, with the brightly lit buttocks of the horses forming her eyes, and the twisted figure before them her nose and mouth, creating from a distance the mirage of an inclined classical face. The setting is highly artificial – a deep stage with the ghostly seascape of Cadaques like a stage set enclosing it. The world this modern muse inhabits is like a film, black and white, and she appears as a moonlit Hollywood sex goddess.

[1] *The Notebooks of Leonardo da Vinci*, selected and edited by Irma A. Richter, Oxford 1998, p. 182.

23

City of Drawers, 1936

India ink on paper, 12¼ × 16½ in.

Private Collection

*Shown only in Hartford and Washington

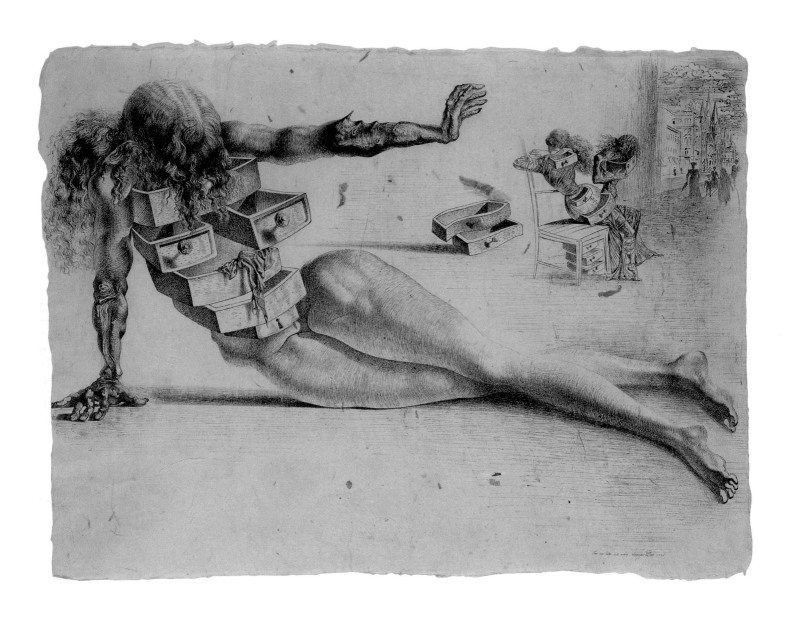

24

Venus de Milo with Drawers
Executed in plaster, 1936; cast in bronze, 1964;
artist's proof, 0/5
Painted bronze and pompoms, height 37¾ in.
Private Collection, courtesy Beadleston Gallery,
New York

Dalí's original version, an altered plaster copy of the
antique statue of Venus in the Louvre, belongs within
the expansive field of the surrealist object. This was first
envisaged by André Breton in 1924, in "Introduction to
the discourse on the paucity of reality," where Breton
had imagined launching into the everyday world of
utilitarian objects things that had their origins in dreams,
and had no obvious function but to perturb the idea
of the so-called "real." The fabrication of such dream
objects – Breton's example was a book with pages of
heavy black cloth whose back was the statue of a wooden
gnome with a white beard – might "help to demolish
these concrete trophies which are so odious, to throw
further discredit on those creatures and things of
'reason.'"[1] This sentiment had a powerful impact on
Dalí, and he was often to quote this passage from
Breton's "Discourse." Dalí played a prominent role in
launching the surrealist object as a major collective proj-
ect in 1931, with a text that introduced the idea of the
"symbolically functioning object."[2] Many of the surreal-
ists, whether artists or poets, constructed objects of
intricate design from found materials whose primary
"symbolic function" was geared to erotic fantasy and the
emergence of unconscious desires. These objects were,
however, often highly elaborate and esoteric, and by the
mid-thirties objects of simpler fabrication, or simply
chosen or found, became more popular. The intention
was not to create a new formal category but to expand
Surrealism into the world of objects in the broadest
definition. The threshold between art and the everyday
object, between natural and sculptural forms was blurred.
The Surrealist Exhibition of Objects at the Charles Ratton
gallery in Paris in 1936 included "natural objects, inter-
preted natural objects, found objects, Oceanian and
American objects and mathematical objects" as well as
"surrealist objects." Among the latter Dalí showed his
Aphrodisiac Jacket, and Gala Dalí *The Staircase of Love
and Psyche*. Gala's object incorporated a winged Cupid,
which suggests that the classical iconography of the

goddess of love was on their minds. At the International Surrealist Exhibition in London, which opened shortly after the Ratton exhibition in June 1936 Roland Penrose showed his *Captain Cook's Last Voyage*, a construction based on a found plaster cast of a classical female torso. It was in this context that Dalí adapted the plaster *Venus de Milo*.

Furniture symbolizing the body had already appeared in Dalí's painting: in *Cardinal, Cardinal!* (cat. 16) for instance, the bedside cabinet with drawers could signify the female body. But by 1936 the symbol had melded with the human body, which now appears in its own right with the addition of drawers. There are numerous examples at this period of drawers embedded in a figure: in the cover for Dalí's London exhibition at the Reid and Lefevre Gallery (coinciding with the International Surrealist Exhibition), a female figure sprouts drawers in her chest and leg; on the cover of the catalogue of the Levy Gallery exhibition in New York of December 1936 a drawer is depicted protruding from a head, while Dalí's cover for the surrealist review *Minotaure* (no. 8, June 1936) presents the bull-headed demi-god with a drawer in his rib-cage. A new metaphor is evidently in play here; that of the hidden recesses, the locked

compartments of man's inner mental life. In the *Second Surrealist Manifesto* Breton uses a similar image:

> These products of psychic activity, as far removed as possible from the desire to make sense, as free as possible of any ideas of responsibility which are always prone to act as brakes... – these products which automatic writing and the description of dreams represent offer the advantage...of proposing a key capable of opening indefinitely that box of many bottoms called man, a key that dissuades him from turning back, for reasons of self-preservation, when in the darkness he bumps into doors, locked from the outside, of the "beyond," of reality, of reason, of genius, and of love.[3]

In carving out drawers in the most famous of female nudes Dalí here brings together the two symbolic ideas, of the woman-container and of the mysterious depths of the human psyche. Moreover, in choosing a mass-produced copy to "interpret" he turns the *Venus de Milo* into a readymade, thereby confusing the distinctions normally operating between art and industry. She is a new manufactured object, realization of a personal fantasy, and with the promise of intervention, of interaction that had characterized the "symbolically functioning" erotic object.[4]

[1] André Breton, "Introduction to the discourse on the paucity of reality," trans. Bravig Imbs, in F. Rosemont, *What is Surrealism?*, Pluto Press, London 1978, p. 26.

[2] Salvador Dalí, "Objets surréalistes," *Le Surréalisme au service de la révolution*, no. 3 December 1931, p. 16.

[3] André Breton, "Second Manifesto of Surrealism," *Manifestoes of Surrealism* (1930), trans. Richard Seaver and Helen R. Lane, University of Michigan 1969, pp. 162–63.

[4] Robert Descharnes states that Dalí designed the drawers but that his friend Marcel Duchamp, inventor of the "readymade," "made the sculpture," but disappointingly there seem to be no evidence of Duchamp's involvement in this project.

Soft Construction with Boiled Beans –
Premonition of Civil War, 1936
Oil on canvas, 39½ × 39½ in.
Philadelphia Museum of Art
the Louise and Walter Arensberg Collection
*Shown only in Hartford and Washington

This must be one of the most powerful images of self-destructive frenzy ever painted, as a body rends itself apart. It is an allegory of Civil War, although there has been controversy about its title, critics claiming that Dalí alleged after the event that it was a painting prophetic of the Spanish Civil War, and had renamed it with opportunism for his exhibition at the Julien Levy Gallery in December after the Civil War broke out in Spain in July 1936. The story is a little more complicated than that. It was painted in the first half of 1936, and first shown in London in June 1936 under the title "Soft construction with boiled apricots," (certainly an understandable mistake by the translator, confusing "abricots" with "haricots" in Dalí's appalling orthography). But in October 1936 it was reproduced in *Minotaure* with the title *Spain: Premonition of Civil War*. At the

Julien Levy exhibition in December 1936 this was reduced to a subtitle: *Soft Construction with Boiled Beans 1936. (Premonition of Civil War)*.

The renaming thus takes place just after the long-feared and anticipated war in Spain began. To assert that Dalí claimed falsely to have premonition is as futile as saying that he knew exactly when it would happen. Such a foreboding is not surprising, because Spain had been in a highly volatile state since the second Spanish Republic had come to power in 1931, and there had been continuous right-wing and Catholic reaction against their reforms. More fruitful would be an investigation of the way he transforms earlier cannibalist and violent themes such as the *Chants de Maldoror* and *Angelus* works in this painting. In Dalí's treatment of the *Angelus* theme, which he took as the maternal variant of the myth of the vengeful father, with mother/wife devouring son/husband, and the *Maldoror* etchings human figures may become monumental in scale and horribly mutilated and metamorphosed (Fig. 25.1). However, the single self-destructive figure is unusual; countries are often allegorized as a woman – Dalí's 1938 painting *Spain* is a case in point. While a clear distinction between the

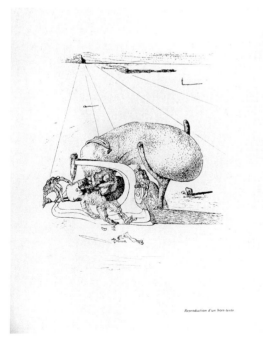

Fig. 25.1
Salvador Dalí, illustration to Lautréamont
Les Chants de Maldoror, 1934 (reproduced in
Minotaure, no. 5, 1934).

iconography of his personal mythology and political allegory is difficult, there is no denying the aptness of this painting in terms of the latter.

The animus against Dalí in relation to the Spanish Civil War is largely conditioned by his subsequent acceptance of Franco and monarchism. However, there is no real reason to doubt reports of his enthusiastic support of the Republic and of early POUM and Anarchist successes in the Civil War. The opportunism of which he is always accused is more properly attached to his later reconciliation with the Franco regime, once it had gained power. Deeply timid and fearful of revolution and violence, he was primarily interested in being allowed to return to Spain. The powerful description in *The Secret Life*, written in the USA in 1940–41, long after its conclusion, of the Civil War as an atavistic and mortal struggle to reach the granite of Spanish tradition is by then already conditioned by the victory of the forces supporting catholicism and traditional Spain.

Nothing in the painting supports an ideological bias of this kind. That it is specifically Spain that is in question, though, and not a generalized reference to civil war is clear from the setting of the Ampurdan Plain and the tiny figure of the "Ampurdan Chemist" behind the monster's hand. It is a single figure, its limbs horribly rearranged in an elegant rhomboid, seen from a low and grounded viewpoint. The feeble beans scattered about are an echo of Dalí's old William Tell theme, of the vengeful father diverted from his cannibalist practices by the offer of other food. Here they are evidently inefficacious. The body is already decomposing and part turned to bone, tongueless and eyeless, its closest parallel Goya's engravings of *The Disasters of War*.

26

Untitled Composition with Soda Siphon, 1937
Pen and ink, and gouache on paper, 17 × 21¼ in.
Scottish National Gallery of Modern Art, Edinburgh,
bequeathed by Gabrielle Keiller, 1995

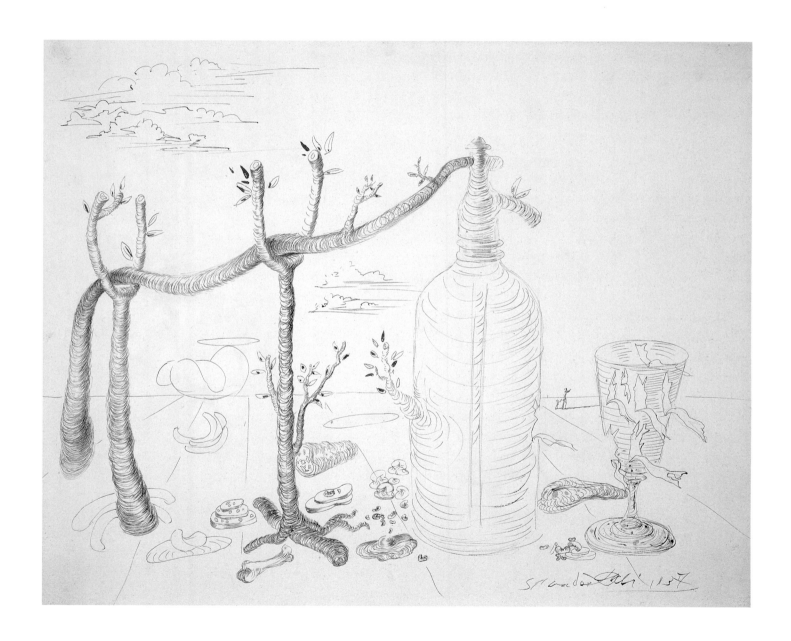

27

Impressions of Africa, 1938
Oil on canvas, 36 × 46¼ in.
Museum Boijmans Van Beuningen, Rotterdam

Dalí painted *Impressions of Africa* in Rome, where he and Gala temporarily took refuge after fleeing the Civil War in Spain. This was a moment of crisis for Dalí, one sign of which was a new interest in tradition, and especially sixteenth- and seventeenth-century painting. *Impressions of Africa* is an unusual painting, in that it combines a very life-like self-portrait with passages containing some of his most consummate, but minute, double images.

He referred the title to an excursion to Sicily, where he found "mingled reminiscences of Catalonia and of Africa,"[1] although he also often referred to the "African" elements in Spanish culture, remnants of the long Moorish occupation. He must also, however, have intended the allusion to Raymond Roussel's play *Impressions d'Afrique*. Roussel's "method," which he only revealed in *Comment j'ai ecrit certains de mes livres* (1935), was to compose "using homonyms or near-homonyms, two phrases with meanings as different as possible, and to use these phrases as pillars of the story."[2] One such example was *mou à raille* and *mou à rail*, together with *baleine à ilôt* and *baleine à ilote*; "the couplings of the words gave me the statue of the slave made of whalebone corsets, running on rails of calves' lights…"[3] The bizarre episodes and objects thus produced by the free and illogical use of language fascinated the surrealists. Duchamp, who attended a performance in 1912 seems to have penetrated the method and adapted verbal puns for his own purposes, as in the title of his Large Glass, *La mariée mise à nu par ces célibataires, même (m'aime)* (fig. 15). The utterly unconventional character of Roussel's inventions, frequently including automata, their arbitrary and often humorous character, were seen by the surrealists as a rupture with traditional modes of representation and a denial of reality. The "conscious" in Roussel was, as Breton said, constantly struggling with the "imperious unconscious man."[4] Dalí found in Roussel a precursor of his own paranoiac method of irrational association. In 1933 he reviewed Roussel's *Nouvelles Impressions d'Afrique* in *Le Surréalisme au Service de la Révolution*, in a tone of

the highest appreciation for its obsessional and irrational metaphorical inventions. "The comparisons derive from the most immediate, the most direct anecdotal, accidental resemblances thanks to which the compared elements which follow one another by the hundred introduce us to the most obscure, the most impenetrable conflicts ever produced."[5] To Dalí the book "appears like the dream journey of the new paranoiac phenomena."

The title of the painting thus has both literal reference to Africa, and an invocation of a literary ancestor to his own visual "double images." Threaded through the imagery are specific motifs drawn from *Impressions d'Afrique*, as Piet de Jonge has convincingly argued.[6]

Impressions of Africa was painted at the Rome house of Lord Berners, (a friend of Dalí's patron Edward James): "in the Roman forum," as Dalí put it. However, the baroque Rome of Bernini interested Dalí more than its classical antiquities, and the red cloth over the painter's knee could echo the dramatic crimson draperies of baroque painting. It could also, though, invoke the red cloth in which the emperor's son Rhejed was carried off by a giant black-plumaged bird in Roussel's *Impressions d'Afrique:* an incident that recalls the abduction of Zeus's favorite, Ganymede, by an eagle. This could even, therefore, be construed as a distant compliment to his patron James, with Dalí as a "surrealist Ganymede."[7]

Although subsidiary to the main paranoiac "action" of the painting, the self-portrait also uses the *chiaroscuro* characteristic of the baroque period to give emphasis to the artist's outstretched hand silhouetted against his shadowed head. Dalí's posture seated before his easel recalls his painting practice at the beginning of his surrealist period, when he would place his easel beside his bed so that it was the last thing he saw at night and the first thing when he awoke." I spent the whole day before my easel, my eyes staring fixedly, trying to "see," like a medium (very much so indeed), the images that would spring up in my imagination. Often I saw these images exactly situated in the painting. Then, at the point commanded by them, I would paint, paint with the hot taste in my mouth that panting hunting dogs must have at the moment when they fasten their teeth into the game killed that very instant by a well-aimed shot."[8] At the period Dalí is describing here, he was trying to link the images into his dreams, while the reference to the

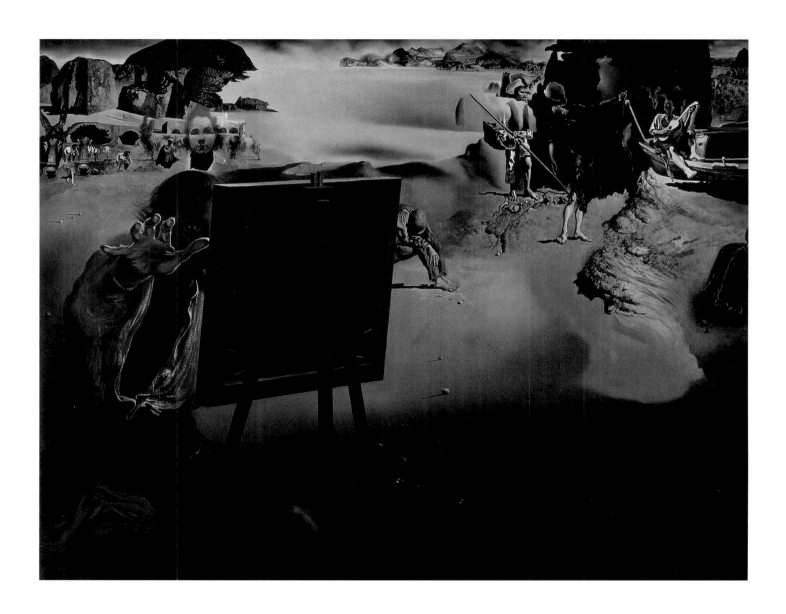

mediums evokes the surrealist idea of the unconscious recording of such images. However, Dalí's "gaze" in *Impressions of Africa* is disconcerting; one eye is hidden by the canvas, the other carefully framed by his thumb and forefinger – an effect preserved in the preparatory drawings, where the contour produced by the curved hand is continued by the eyebrow, so that the single eye is both isolated and enclosed (cat. 28). He looks out at something in the spectator's space, it seems, though only with one eye. By 1938, the gaze is to be imagined as linked not so much to the dreamer but to the paranoiac, who obsessively re-interprets what he sees. The split vision could be the double effect of "seeing" both what is in the mind's eye and what is there in "reality." His gaze is fixed on an object beyond, in our space. This could be the whole scene above his head, within which Gala's head appears – perhaps the only object before him "in reality." Dalí also draws on the device of one of his favorite artists, Velázquez, in *Las Meninas,* where the presence of the artist and his easel within the picture throws the rest of the scene into a mysterious relationship with the subject being represented.

Dalí represents Gala's face rising above his head in the manner in which spiritualist mediums represented their own visions spilling like ectoplasm from their foreheads. And this is the point at which the paranoiac critical images begin. The eyes in Gala's face, a little

faded and monochrome like a black and white photograph, are also the arcades of a building, and this initial double reading starts a chain reaction across the painting to the left. The arcade/eyes become a cave and then a black bushy tree. Framed in the tree is the figure of a monk, his arms outstretched with long white sleeves; this figure repeated at the far left then becomes the head of a donkey, its eyes formed by the same hand/sleeve configuration. Several of these figures and objects were borrowed from Roussel's *Impressions d'Afrique,* whose meticulous and obsessionally complete descriptions and irrational chains of association were endlessly intriguing for Dalí. The donkey-priest also recalls both Goya's satires in *Los Caprichos* engravings and the anti-clericalism in Dalí and Buñuel's own film *The Golden Age.* Double readings in this section of the canvas proliferate like Roussel's puns, in ever-increasing minuteness. Immediately above Gala's head is a partridge (killed, perhaps, by the "well-aimed shot"), as though suspended from the black rock and merging with the jagged edge of the bay – unmistakably that of their home at Port Lligat near Cadaques.

Across to the right of the canvas, figures with basket and guitar, who may be Port Lligat fishermen, or gypsies, melt into and double as the forms of the rocky beach. The violent conflict between revolution and tradition of the Civil War seemed to Dalí to be laying bare an

elemental and fanatical Spain: "that passion built of stone, massive with granitic and calcareous reality which is Spain."[9] Between them is a figure of uncertain gender, its head also a cavity in the rock behind, wearing what appears to be the remnants of a matador's costume, holding in its hand a limp red cloth. The gesture repeats that of the father in *Le Jeu lugubre*, (fig. 29.1) where the blood-stained object in the outstretched hand is clearly related to castration fears. Here, though, it seems more like the gesture of a bullfighter offering a trophy to the crowd. Dalí may even have been remembering the death of García Lorca, and the poet's great lament on the death of the bull-fighter, Ignacio Sánchez Mejías, to which he returned at the end of his life (see p. 64).

In the center of the painting, partially obscured by the right hand side of Dalí's canvas sits a dejected bare-footed man; his headgear is curious, and although it may be a helmet, it also resembles the cap worn by Lenin in the 1933 *Enigma of William Tell*. If so, it could be that this figure embodies for Dalí the revolutionary ideology, which had come into violent conflict with conservative forces on Spanish soil. Spain had become the battlefield of the competing philosophies and political ideologies of modern Europe, perhaps thus also fleetingly inscribed here.

1 *The Secret Life, op. cit.*, p. 363.
2 André Breton, "Raymond Roussel," *Anthologie de l'humour noir*, Paris 1940, p. 181.
3 Raymond Roussel, *Comment j'ai ecrit certains de mes livres*, Paris 1938, p. 9.
4 Breton, *op. cit.*
5 Salvador Dalí, "Notes-Communications," *Le Surréalisme au service de la Révolution*, no. 5, Paris 1933, p. 41.
6 Piet de Jonge, correspondence with the author 1999.
7 ibid.
8 *The Secret Life*, p. 220.
9 ibid. p. 360.

Detail, cat. 27

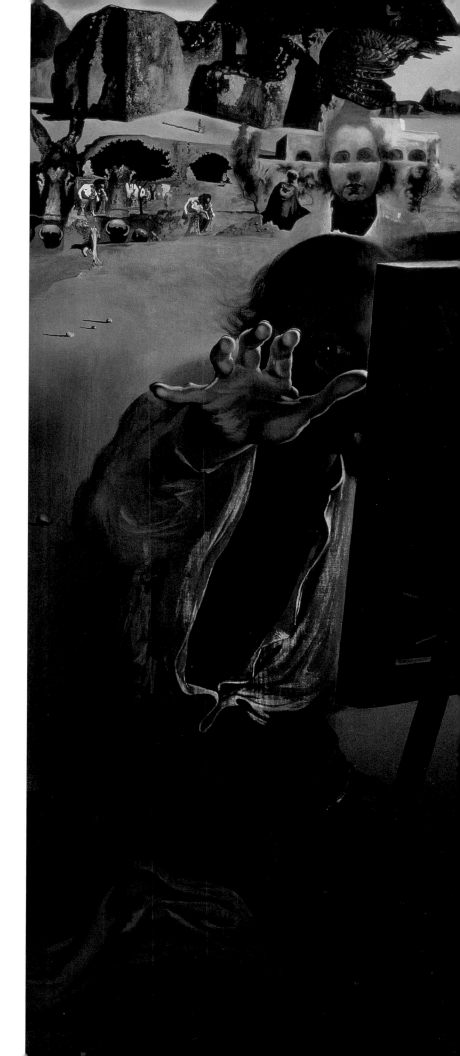

28

Study for Impressions of Africa, 1938
Pencil on paper, 20½ × 13 in.
Museum Boijmans Van Beuningen, Rotterdam

29

Study for Self-Portrait in Impressions of Africa, 1938
Pencil and India ink on paper, 24¾ × 18⅞ in.
Museum Boijmans Van Beuningen, Rotterdam

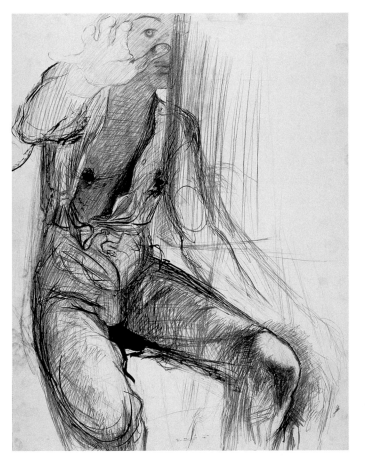

These two preparatory drawings for *Impressions of Africa* concentrate on the figure of Dalí himself and the gesture of the outstretched hand. Although many paintings over the previous ten years include motifs and figures which refer to Dalí's various personae: son, lover, victim, often coded through myth, there are very few actual self-portraits done, as these drawings appear to be, in front of the mirror. Dalí's powerful narcissism involved the construction of other identities, not only in his paintings but also before the mirror or the camera. At the moment of the break with his father in 1929, for instance, he has himself photographed as "William Tell's son," with a sea urchin in place of an apple on his head (fig. 16.1). In the paintings a young and sometimes androgynous man is occasionally represented in conjunction with a soft and melting "portrait mask," as in the center of *Le Jeu lugubre* (fig. 29.1), or in the tiny red seal in *Diurnal Fantasies* (cat. 9); all refer to Dalí himself, but as it were divided and dispersed. The self is thus rarely represented as single and coherent entity, but is dramatized and filtered through masquerade, myth and imagination.

Despite their apparent naturalism these two self-portrait drawings partake of masquerade. They are identical in gesture – in each case the thumb just touches the inner edge of the canvas, so that this and the tips of the fingers protrude illusionistically into the spectator's space. But they are strongly contrasted as representations of the artist. The flamboyant exhibitionism in one recalls the love of adornment dating from his student days in Madrid and carried to a peak when he prepared himself to meet his new surrealist friends visiting him at Cadaques: with pearl necklace, tousled hair, sun-darkened skin, palette in hand, his best silk shirt cut and torn to expose his nipple: a "composite of beggarly painter and exotic Arab which I was trying to make myself into."[1]

The other drawing shows a soberly clad Dalí familiar from photographs of him in Paris in the 1930s. The manner of the drawing underlines this contrast: Dalí depicts himself neatly and conventionally dressed with jacket and tie, and the drawing skillfully uses the delicate resources of tonal contrast, shade and light, to create the illusion of depth. The vigorous and more linear character of the other drawing responds to the semi-naked and much more strongly sexualized body of the artist; the head and hand are given less emphasis. In the final painting, the two different self-representations are merged, but although Dalí retains the loose, open shirt, the sexual body is not so strongly marked as in the second drawing.

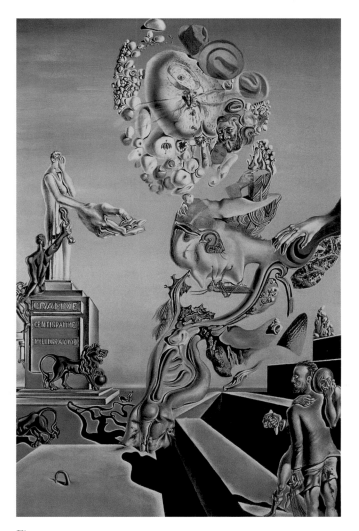

Fig. 29.1
Salvador Dalí
Le Jeu lugubre (*Lugubrious Game*), 1929
Private collection

[1] *The Secret Life*, p. 228.

30

Transparent Simulacrum of the Feigned Image, 1938
Oil on canvas, 28½ × 36¼ in.
Albright-Knox Art Gallery, Buffalo, New York
bequest of A. Conger Goodyear, 1966

In 1938 Dalí painted a series of triumphant double images which were exhibited at the Julien Levy Gallery in New York in 1939 with great popular success. The catalogue quoted André Breton's 1934 acknowledgement of Dalí's importance for Surrealism: "Dalí has endowed surrealism with an instrument of primary importance, in particular the paranoiac-critical method, which has immediately shown itself capable of being applied equally to painting, poetry, the cinema." However, 1939 also marked the definitive break with Surrealism; Breton in "Recent tendencies of surrealist painting" had dismissed his recent work as little more than "crossword puzzles."[1] There is no doubt that the balance between optical tricks for their own sake and their integration with the fuller meanings of Dalí's unrepressed self-analysis and imaginative constructions of his persona was a delicate one.

This painting is one of the most lucid and classically constructed of the related double-images. Its basic play is between the pictorial genres of landscape and still life. The rocks of Cap Creus near Port Lligat encircle a bay which is also a shallow dish containing fruit. The sandy beach stretches inland and is cut off by shadows to form a table. A white cloth in the foreground takes the shape of a bird, lying spread-eagled on the table-beach but also echoing a distant bird on the far horizon. Gala's head floats into the canvas from the right. It is worth remembering that the group of double-images of which this forms a part, like the Tate Gallery's *Beach with Telephone*, was painted when Dalí was cut off from his beloved Catalan coast, having departed Spain during the Civil War, and the intensity of these images has a strong element of nostalgia.

[1] André Breton, "Des tendances les plus récentes de la peinture surréaliste," *Minotaure* no. 12/13, Paris 1939, p. 17; see also next entry.

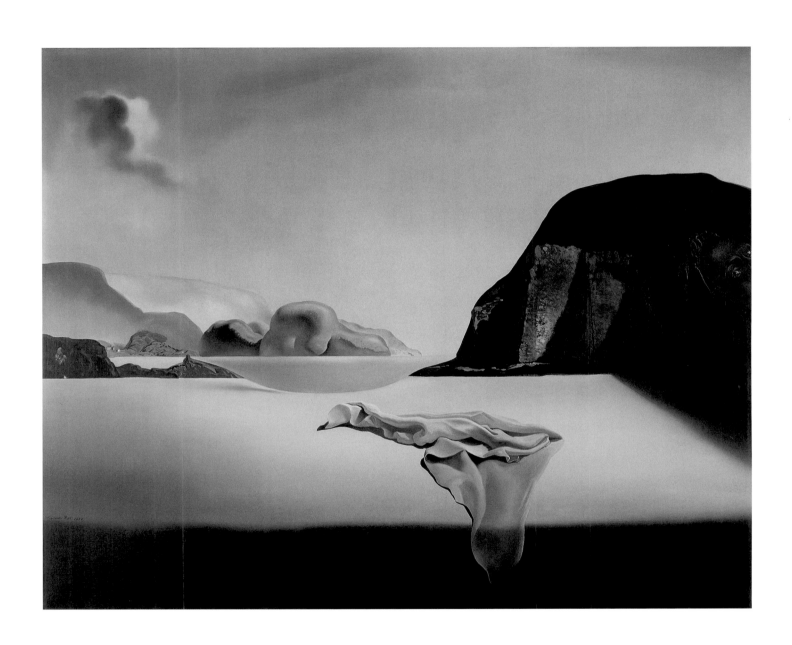

Apparition of Face and Fruit Dish on a Beach, 1938
Oil on canvas, 45 × 56⅝ in.
Wadsworth Atheneum, Hartford, the Ella Gallup
Sumner and Mary Catlin Sumner Collection Fund

Mastery of the technique of double and multiple figuration encouraged Dalí to produce a series of large canvases with dazzlingly complex imagery. They included the Wadsworth Atheneum picture, a closely related work entitled *Invisible Afghan with the Apparition on the Beach of the Face of García Lorca in the form of a Fruit Dish with Three Figs*, and *The Endless Enigma* (fig. 22). When the latter was exhibited at the Julien Levy Gallery in March 1939 six accompanying drawings were reproduced to guide viewers to the six alternative and complete readings of the whole painting (fig. 31.1). In all of them a landscape is partially composed of such elements as a dog and a bowl of fruit which also reads as the forehead of a hallucinatory face. Dalí probably also intended this face in *Apparition of Face and Fruit Dish*, as in the related *Invisible Afghan*, to be the poet Federico García Lorca, as Ian Gibson assumes.[1] Lorca had been murdered by the Fascists in September 1936 shortly after Franco's Nationalists invaded Republican Spain in July. Lorca was Dalí's closest friend during his student days and subsequent involvement in the Catalan avant-garde, and his "Ode to Salvador Dalí" had recently been translated into French. His death haunted Dalí.

There is still some confusion over Dalí's political attitudes in the late thirties; although he had troubled the surrealists with his interest in Hitler, this he convinced them was of a "paranoiac" and not a political character, and he had remained associated with the movement. It was only in February 1939 that a final rupture with Breton was precipitated when Dalí expressed racist views. Breton's survey of recent surrealist art in *Minotaure* in 1939 relegated Dalí firmly to the past, and made a wounding attack on the very method that had previously given Dalí so prominent a position within Surrealism: "His determination to rarefy his paranoiac method still further has reduced him to concocting entertainments on the level of *crossword puzzles*."[2] There is no very logical reason why the greater conviction and complexity of Dalí's double images of the late 1930s should thereby have suddenly lost their status as a surrealist "tool"; the change in attitude is more plausibly the consequence of Dalí's double offense, firstly of expressing politically unacceptable views which date from the victory of the Fascists over Republican Spain, and secondly of becoming the most famous surrealist through sensational publicity at a time when Surrealism was attempting to exclude the public in order to retain its serious and coherent identity.

Apparition of Face and Fruit Dish, like its companion pictures, melds a landscape with a broadly rectangular plane in the foreground that functions like the table in a still life, here marked with the undulating edges of a loose white cloth. Thus the whole spatial frame of the painting is doubled, to read as both the restricted arena of a still life and the more expansive space of a landscape. The dog's eyes are a tunnel through the rocks, and its collar is an aqueduct; below its muzzle is a cavalry scene recalling Leonardo da Vinci, whose advice to "see" battles in a stained wall was a instance, often recalled by Dalí, of the exercise of the imagination. The head in the dead center of the painting is composed of several discrete elements: one eye is the end of a pitcher, and the nose, mouth and chin are formed from a configuration that itself unites a fruit with the back of a seated figure.

Fig. 31.1
Page from the catalogue of the exhibition at Julien Levy
Gallery, New York, March 1939

1 Ian Gibson, *The Shameful Life of Salvador Dalí*, London 1997.
2 André Breton, *Surrealism and Painting*, trans. Simon Watson Taylor, New York 1972, p. 147.

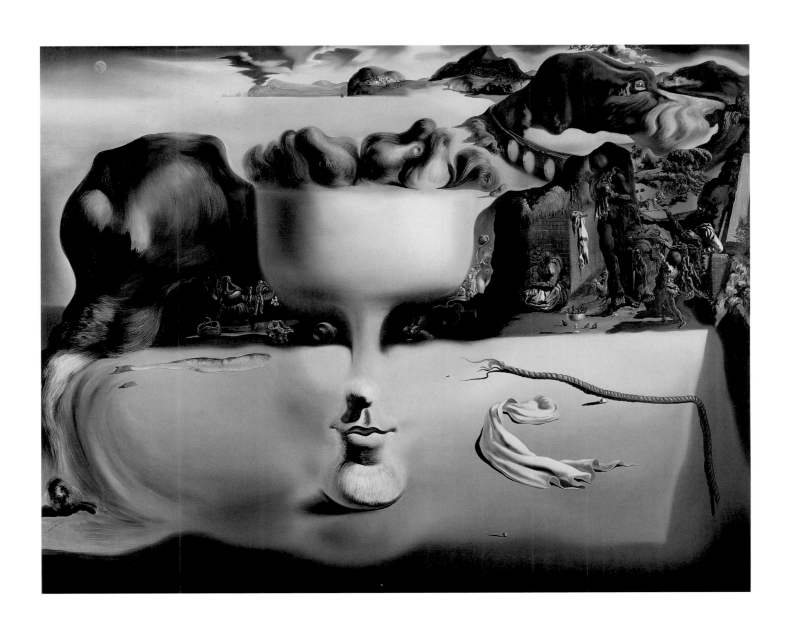

The Image Disappears, 1938
Oil on canvas, 20 × 19 in.
Fundació Gala–Salvador Dalí, Figueres
*Shown only in Washington and Edinburgh

Study for The Image Disappears, 1938
Ink on paper, 25⅞ × 20¼ in.
Fundació Gala–Salvador Dalí, Figueres
*Shown only in Washington and Edinburgh

The Image Disappears was shown at Dalí's 1939 exhibition at the Julien Levy Gallery in New York. Among the varied and virtuoso works on show were *Palladio's Corridor of Dramatic Disguise*, in which Dalí plays on the exaggerated perspective recession of Palladio's theater set at Vicenza, and his most complex double image, *The Endless Enigma* (fig. 22) which has no less than six alternative readings. Dalí's introduction to the catalogue, "Dalí, Dalí!," traces the "paranoiac phenomenon (delirium of systematic interpretation)" from the "hallucinating contours" of paintings on the irregular walls of caves, through historical predecessors such as the Greek playwright Aristophanes, who, like Hamlet, saw objects in cloud shapes, to Leonardo, Piero di Cosimo, Arcimboldo, Palladio.

Vermeer's painting was a long standing passion dating back at least to his student days. The immaculate precision of Vermeer's technique had a profound effect on Dalí's painting in the mid 1920s and off and on throughout his career. *The Lace Maker*, of which Dalí once made a careful copy, appears fleetingly in *An Andalusian Dog*. It may also have been the mysterious sense of a concealed meaning in Vermeer's paintings, an unspoken emblematic or symbolic stratum beyond the quiet interiors with figures that intrigued him so much. It is possible that *The Image Disappears* and the related studies and drawings were the beginnings of an extended "paranoiac" interpretation of Vermeer along the lines of his *Tragic Myth of Millet's Angelus*. Such an interpretation would not be an attempt to "psychoanalyze" Vermeer, however, but to uncover a hidden meaning projected into the image through his own unconscious associations. Dalí's copy of a book on Vermeer with plates is covered with pencil notes, suggesting that Dalí had plans to produce double images from other paintings, like *Street in Delft*.

Dalí reads into the figure of the girl reading a letter the head of a man in profile, his eye formed by the girl's head, his nose by her upper arm, his moustache by her hands and letter. The dark line of his long hair is the curtain drawn back in Vermeer's painting to let light

into the room. The man's head may, as Antonio Pitxot suggests, be identified as Velázquez.

Although Vermeer's *Young Woman Reading a Letter at an Open Window* (Gemäldegalerie Dresden) seems to have been the primary image which Dalí has here subjected to his paranoiac-critical method, he had supplemented his interrogation of Vermeer with elements from other paintings. The map on the rear wall, for example, appears in several works by Vermeer, including *Woman in Blue Reading a Letter* (Rijksmuseum, Amsterdam); the swelling form of this woman also resembles Dalí's figure. The curtain, too, is adapted from various sources to produce the sweep of the hair. Dalí's method when working on his double images was to switch frequently between the alternative depictions, concerned lest one should predominate too far. Here the chequered floor and the map served to retain the balance.

34
Study for Apparition of a Figure of Vermeer
in the Face of Abraham Lincoln, 1939
Watercolor on paper, 12¾ × 19⅛ in.
Fundació Gala–Salvador Dalí, Figueres

These drawings are quite closely related to *The Image Disappears* and its study (cat. 32, 33). A similar figure of a girl in profile with bent head based on Vermeer's *Interior with Girl Reading* doubles as the face of Abraham Lincoln. While the nose, mouth and eye are clearly distinguishable in cat. 34, the face is less fully realized in cat. 35, although Dalí here appears to be working up an additional double image in the area of the girl's head. Unlike *The Image Disappears*, the head of Lincoln is depicted from the front rather than the side.

The reference to Lincoln remains obscure; the assassinated President does not figure for obvious reasons in his pantheon of oppressive father-figures. However, Dalí would have been familiar with Marcel Duchamp's notes on the "Wilson–Lincoln" effect, in the Green Box, *The Bride Stripped Bare by her Bachelors, Even*, published in 1934. Here Duchamp described "the perspective and the geometrical drawing of 2 figures which will be indicated…by the Wilson–Lincoln system (i.e. like the portraits which seen from the left show Wilson seen from the right show Lincoln)." Dalí probably knew the kind of popular picture to which Duchamp referred, which made use of surfaces folded like a concertina with, for example, the portraits of the two presidents drawn on alternate sides of the folds. Although not exactly like Dalí's double images, the idea of the single object that could switch from one picture to another adds to the area of shared interest between the two. In 1942 Duchamp made his *Genre Allegory, [George Washington]*, a length of gauze soaked in iodine shaped to form the USA on its side, and reading also as profile portrait of Washington.

Duchamp and Dalí shared a passion for optical illusions, double readings and finding ways to produce three-dimensional effects from a two-dimensional surface. Among their many speculations and experiments in this domain, it is curious that both artists refer to the "moiré" effect – that is, the way a certain kind of finely banded silk can look as if it has real depth – an effect not unlike a simple form of the later hologram. Duchamp talks in his "Infrathin" notes about the iridescence of shot silk (reading as two different colors) as well as the moiré which appears to have two surfaces. Both of these are

35

Apparition of a Figure of Vermeer in the Face of Abraham Lincoln, c. 1939
Pencil on paper, 24⅞ × 19 in.
Fundació Gala–Salvador Dalí, Figueres

examples of the liminal, the minute change or interface between states or objects which constituted the infrathin. Different though the tone may be, Dalí makes an identical comparison in his *Unspeakable Confessions*. Talking about the *Slave Market with the Apparition of the Invisible Bust of Voltaire* (see p. 141) he wrote that when he painted invisible figures, "I force the imagining of a new reality – new and coherent time and space. With my moiréed canvases, the microscopic texture of which contains three-dimensional images, I free the real from its terrifying vertigo by creating the gooseflesh of space–time which 'at will' can be or not be."[1]

[1] *Unspeakable Confessions, op. cit.*, pp. 239–40.

Within the illustration:

DEL MONTE LODGE
PEBBLE BEACH, CALIFORNIA

36
Sketch: Skeleton, Zoomorphic Figure
and Female Figure
Pencil and ink on paper, 10½ × 7¼ in.
Fundació Gala–Salvador Dalí, Figueres

37
Double Image with Skeletons, c. 1940
Charcoal on canvas, 3 × 13¼ in.
Fundació Gala–Salvador Dalí, Figueres

Disappearing Bust of Voltaire, 1941

Oil on canvas, 18¼ × 21¾ in.

Salvador Dalí Museum, St. Petersburg, Florida

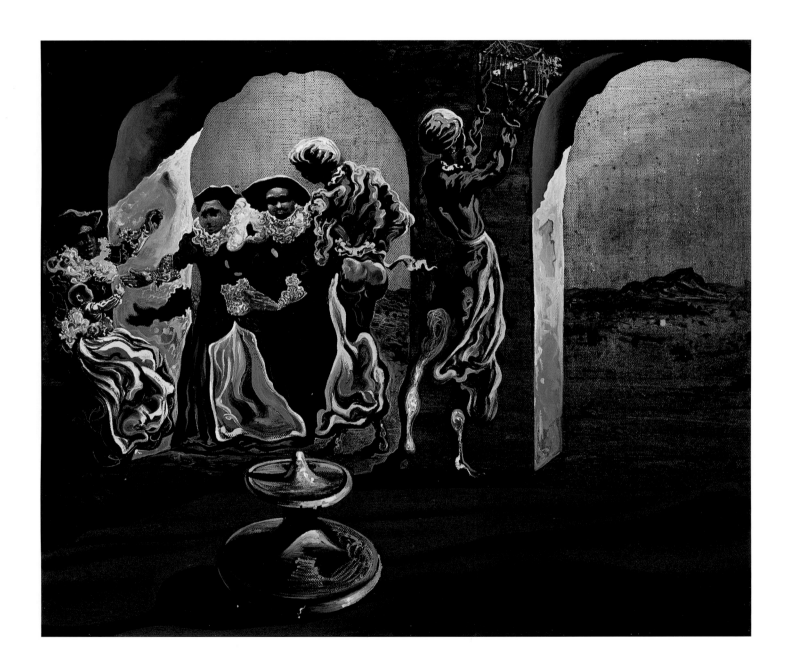

This is a version of one of the most successful and "hallucinatory" of Dalí's double images: the *Slave Market with the Apparition of the Invisible Bust of Voltaire*. From a group of figures in an arcaded, partly ruined building, looking onto plains and mountains, emerges the head of Voltaire, which Dalí has based on a bust by the eighteenth-century French sculptor Houdon. His features are constructed with the figures of two women in seventeenth-century dress, their faces forming his eyes, hooded by their black hats, and his nose and chin are their white lacy ruffs and sleeves. These are more loosely painted than in Dalí's first version of the subject, and give the impression of wrinkled skin. The hairy outline of the dome of Voltaire's head is also that of a crumbling arch framing a silvery sky, here left as bare canvas.

In *Disappearing Bust of Voltaire* Dalí eliminates most of the elaborate *mise-en-scène* of the first version, which included a landscape/still life with distant hills that also form pears on a fruit dish, and a complex multi-figured scene at which an internal spectator, Gala, gazes. The only hint of the still life is the red-draped table in the foreground with the vestigial but prominent pedestal stand. Of the slave market Dalí retains two exotic, half-naked turbanned figures, exaggeratedly sexual beside the black-robed women. The slave market may mingle memories of the orientalist taste in nineteenth-century painting with incidents from the experiences of the hero of Voltaire's satire, *Candide* – who may be the baby on the lap of a seated figure to the right. The face of this figure, although it appears to be a woman, oddly resembles that of the seventeenth-century Spanish painter Velázquez.

In the sequence of drawings related to the *Disappearing Bust of Voltaire* Dalí explores various alternative configurations of double images. Common to all of them is a building pierced by large archways. In one group the openings of the more or less symmetrical but partially ruined structure become the profile of a man's head, lying on its back – to the left his forehead, his nose the cavity above the central arch. In one of these drawings (cat. 39) the streakily drawn shadow on the inner side of the archway doubles as the long lashes of a face we recognize as that of Dalí's self-portrait mask. The opening to the far right of the building in cat. 41, through which a more distant arcade begins to suggest eyes, is developed in two drawings which newly configure the motif (cat. 42, 43) clearly to read as a skull.

Dalí wrote in the introduction to his 1939 exhibition at Julien Levy's Gallery: "It was in 1929 that I first drew the attention of my surrealist friends to the importance of the paranoiac phenomenon and especially to those images of Arcimboldo and Bracelli composed of heteroclite objects, and to the romantic detritus that expands and flowers into those compositions of double figuration almost entirely filled with the death's head theme." In cat. 43 a woman bends over reaching towards the fruit, and her hand forms a nucleus with the bowl and the skull, as a *memento mori*.

There is no skull in the final painting, but Houdon's bust of the rationalist philosopher Voltaire is a deathly presence, bleached of color. The ink and gouache drawing on pink card (cat. 44) is close to the version of the painting shown here.

39

Study for Slave Market with Disappearing
Bust of Voltaire, c. 1940
Pencil and ink on paper, 10 × 13 in.
Fundació Gala–Salvador Dalí, Figueres

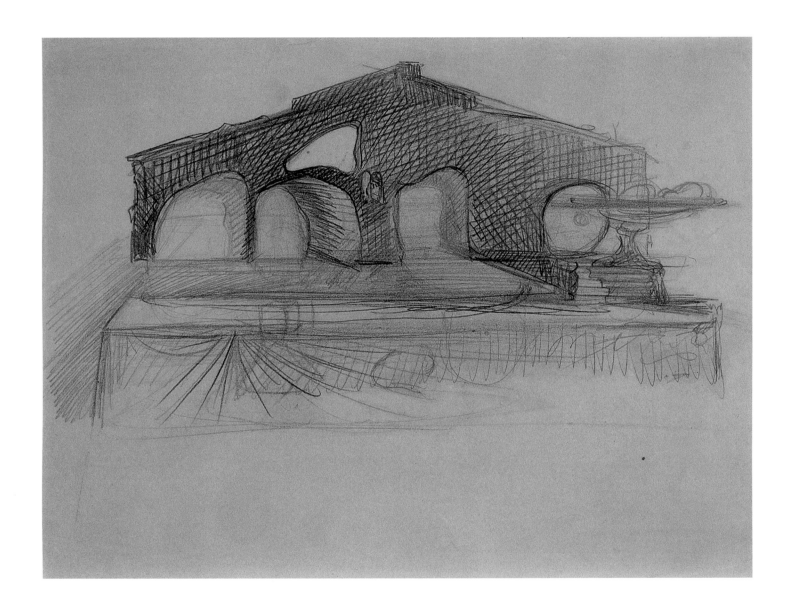

40

Study for Slave Market with Disappearing
Bust of Voltaire, c. 1940
Pencil and ink on paper, 5⅛ × 9⅞ in.
Fundació Gala–Salvador Dalí, Figueres

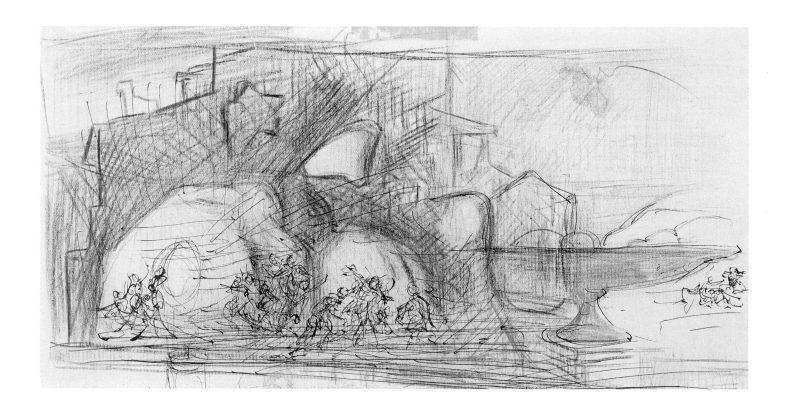

41
Study for Slave Market with Disappearing
Bust of Voltaire, c. 1940
Pencil on paper, 10 × 12⅞ in.
Fundació Gala–Salvador Dalí, Figueres

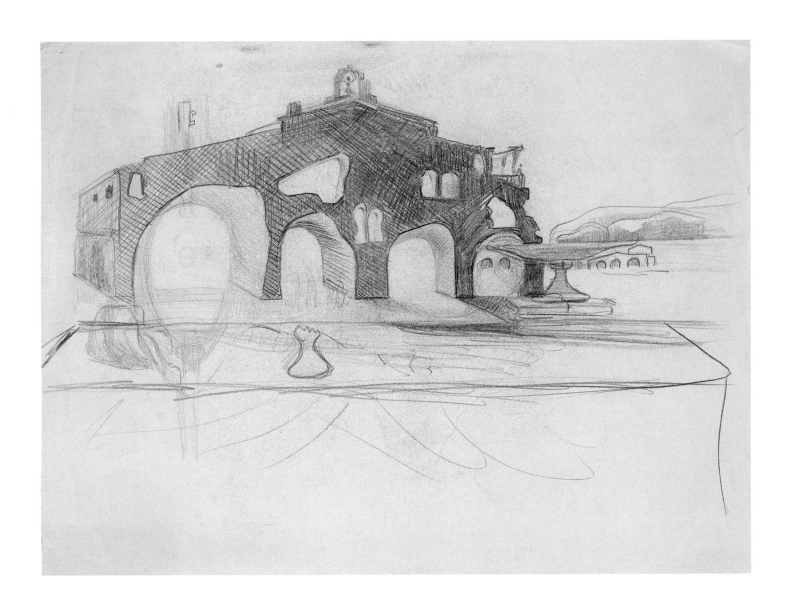

42
Study for Slave Market with Disappearing
Bust of Voltaire, 1941
Pencil on paper, 20 × 26 in.
Fundació Gala–Salvador Dalí, Figueres

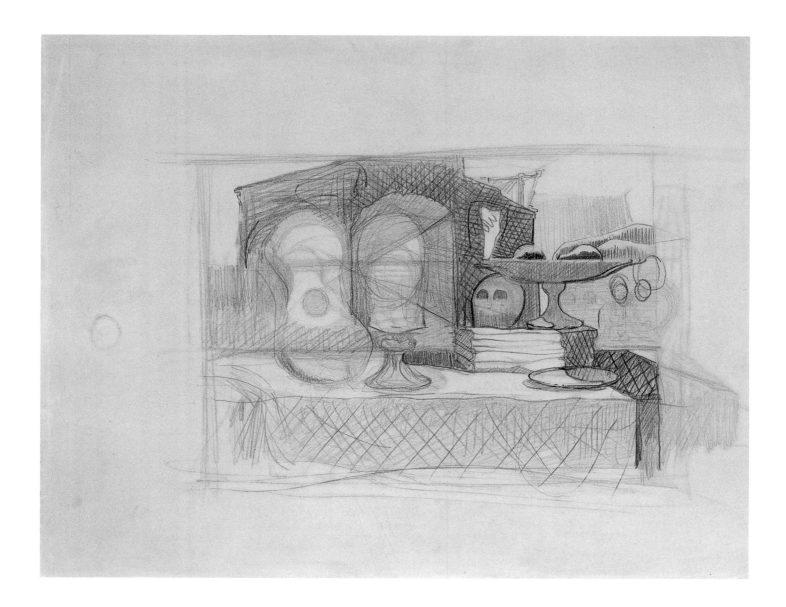

Study for Slave Market with Disappearing
Bust of Voltaire, 1941

43

Study for Slave Market with Disappearing
Bust of Voltaire, c. 1940
Pencil on paper, 10 × 12⅞ in.
Fundació Gala–Salvador Dalí, Figueres

44

Study for Slave Market with Disappearing
Bust of Voltaire, 1941
Gouache, conté crayon and Chinese ink on
pink cardboard, 20 × 26 in.
Fundació Gala–Salvador Dalí, Figueres

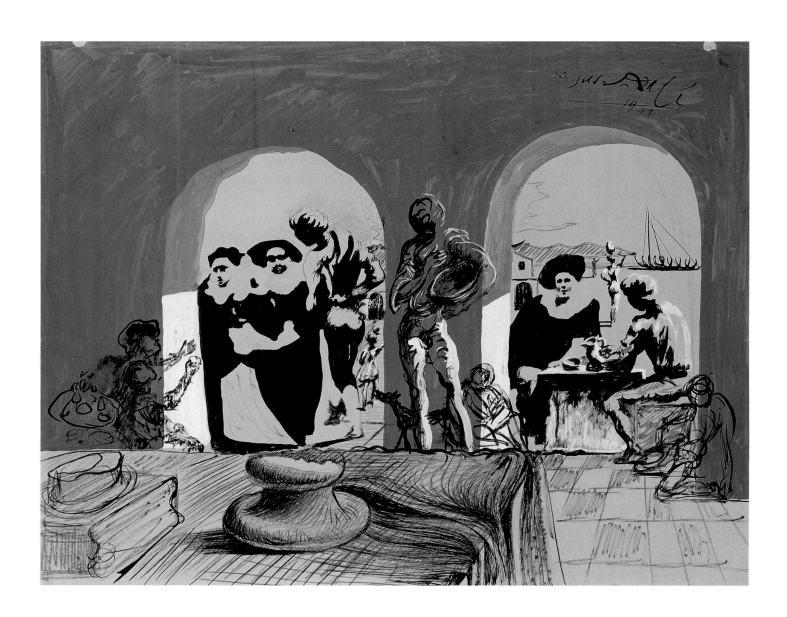

45

The Face of War (*Drawing for Moontide*), 1941
Pencil, watercolor and Chinese ink on paper, 7 × 5 in.
Fundació Gala–Salvador Dalí, Figueres

Detail, cat. 46

46

One Second Before Awakening from a Dream provoked by the Flight of a Bee Around a Pomegranate, 1944
Oil on canvas, 20 × 16 in.
Fundación Colección Thyssen-Bornemisza, Madrid
*Shown only in Hartford and Washington

The phenomenon of experiencing a complex and apparently extended dream, which in reality is only momentary, is brilliantly captured here. The sleeping figure of Gala on the rocks at Port Lligat is assailed by a rush of ferocious images, and Dalí produces the maximum effect of momentary surprise and horror.[1] Whether or not the dream actually happened, it has visual antecedents. Dalí here refers to a famous drawing by J.-J. Grandville: *Premier Rêve: crime et expiation,* of a nightmare in which a criminal imagines committing a murder and is pursued by an enormous eye, which at the last moment metamorphoses into a fish with its jaws open to devour him. This was reproduced in *Documents* (fig. 46.1), to illustrate the same dictionary entry on "Eye" in which Bataille discusses *An Andalusian Dog.* Another striking photograph of a huge fish about to swallow a smaller one appears a little later in *Documents,* this time to illustrate the entry on "space," an anti-philosophical diatribe on the absurdity of trying to match the grandiose concept of space with our limited experience of it. Here the string of images appears to spring outwards, with the red snapper projected from the pomegranate spewing the tigers out into space, towards the viewer. Spatially there is no logic to the forms, which are outside the perspective of the peaceful beach scene. The dream experience of contradictions in time and space is exacerbated by the mirage of Bernini's elephant-monument striding across the horizon.

The associative chain also runs in reverse, for the gun whose bayonet's prick anticipates the bee's sting suggested the hunting of tigers, while their fanged jaws prompt the gaping mouth of the fish. It is Dalí who experiences the dream rather than Gala, for she too is part of it, floating slightly above the rock. But despite the blatant sexual symbolism of the associations: the pomegranate (which for instance figured in Masson's surrealist paintings as both female sex and wound), the fish with its former fearful sexual connotations for Dalí, the tiger's "vagina dentata" jaws, the phallic gun, we are very far from the lingering dream analyses and persistent enigmas of his earlier work. At the base of the painting a shadow in the form of a heart is cast by the "real" pomegranate, as a faint talisman of protection against the eruption of the aggressive nightmare.

" Derniers dessins de J.-J. Grandville : Premier Rêve. — Crime et Expiation "
Magazin Pittoresque, 1847, p. 212.

Fig. 46.1
"Last Drawings by J. J. Grandville:
First Dream – Crime and Expiation,"
reproduced in *Documents,* no. 4, 1929.

[1] The painting was exhibited with the above title, rather than the slightly tamer version "Dream caused by the flight of a pomegranate round a bee, one second before awakening," in 1947 at the Bignou Gallery in New York.

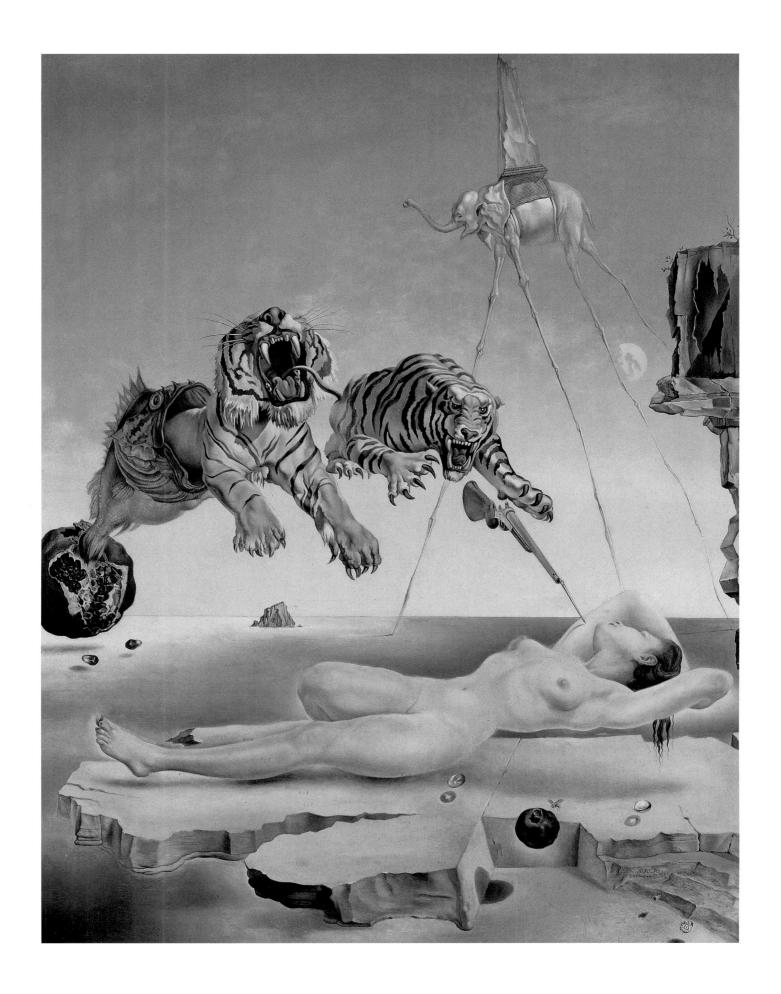

Fig. 47.1
Stills from Alfred Hitchcock's film,
Spellbound, 1945

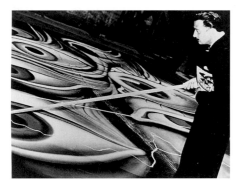

Fig. 47.2
Dalí painting the scenery for the dream
sequence of *Spellbound*

47

The Eye, 1945
Oil on board, 23 × 33 in.
Private Collection

One of five oil paintings (and numerous sketches) that
Dalí made for the dream sequences of Alfred Hitchcock's
film *Spellbound, The Eye* remained in Hitchcock's col-
lection until his death. *Spellbound,* with screenplay by
Ben Hecht after the novel by Francis Beeding, *The House
of Dr Edwards,* was the first Hollywood film to take
psychoanalysis seriously as its subject. Described as a
psychological thriller, Hitchcock's brilliant device in
Spellbound (fig. 47.1) was to set the case of a deluded
paranoid amnesiac within a murder mystery, so that
the solution to the patient's illness and to the murder
coincide. The dreams are not interludes but puzzles to
be interpreted, and Hitchcock "wanted absolutely to
break with the tradition of cinema dreams which are
usually misty and confused, with a shaking screen," and
instead "obtain very visual dreams with sharp, clear
features." Dalí described the project in the *Dalí News,*
his one-man newspaper:

> *I haven't yet had the occasion to see this film, but here is
> the story of my intervention: my movie agent and excel-
> lent friend Fe-Fe (Felix Ferry) ordered a nightmare
> from me by telephone. It was for the film "Spellbound".
> Its director, Hitchcock, told me the story of the film
> with an impressive passion. After which I accepted.
> (Hitchcock is one of the rare personages I have met
> recently who has some mystery.) I got along wonderfully
> with Hitchcock, and set to work, but Fe-Fe telephoned
> me: "They adore all that you are doing at the Selznick
> studios, but I want to caution you, for the moment they
> want to use you only in small drops."*[1]

Dalí's involvement did not go according to his plans,
and became a bizarre clash with Hollywood experts in
special effects. For one nightmare sequence Dalí planned
fifteen heavy and lavishly sculpted pianos to hang from
a ballroom ceiling, with the dancers, who would be
"diminishing silhouettes in a very accelerated perspec-
tive." To his stupefaction when he arrived at the studios
there were neither grand pianos nor silhouettes, but
some tiny pianos in miniature and about forty live

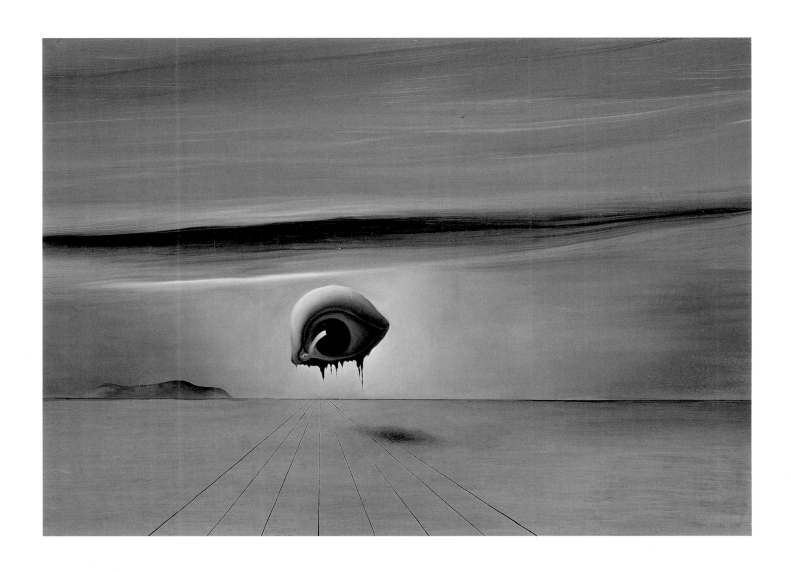

dwarfs who "according to the experts would give per-
fectly the effect of perspective that I desired. I thought
I was dreaming."[2] The scene was scrapped, and Dalí's
intervention was limited to a painted dream landscape
and the "eye" sequence. In this, a dream transition takes
place as a real eye turns into a painted eye. The interior
of a gambling club is festooned with giant hangings
covered with huge painted eyes, which a man is cutting
with a pair of giant scissors. Although obviously recall-
ing the scene in *An Andalusian Dog* of the cutting of a
real eye, the fact that this is a disturbed and fantastic
dream is made clear. The symbols of the nightmare are
carefully uncovered and interpreted by the psychoanalyst.
Fantastic and exaggerated, the dream sequences of
Spellbound are "bracketed out" from the main action of
the film, which is geared to restoring the hero to sanity
and "reality"; by contrast *An Andalusian Dog* perturbed
the relationship between dream, desire and reality,
using cinematic techniques to sustain the ambiguity in
unprecedented and subsequently unmatched ways.

In this painting the eye is depicted with the pains-
taking realism of *The Basket of Bread* of the same year.
Glutinous and as though torn, it hovers like Odilon
Redon's floating organ in *The Eye is a Strange Balloon*,
a "cannibal delicacy."[3] The deeply converging lines to
the horizon do not just create an accelerated perspective,
but seem in relation to the disembodied eye to mimic the
diagrams of the early perspective theorists. Lines were
often drawn, in pyramid or cone-shapes, from the eye of
the spectator to the viewed object. Here, however, the
effect is reversed so that the receding perspective is also
"sight lines" from the eye back towards the viewer. The
eye itself, moreover, with its heavy upper lid resembles
Mario Bettino's anamorphic projection (fig. 7), as well
as the vengeful eye in Grandville's dream (fig. 46.1).

[1] *Dalí News: Monarch of the Dailies*, New York, Tuesday,
 November 20, 1945, p. 2. (A newspaper entirely devoted to Dalí,
 published on the occasion of his Bignou Gallery exhibition).
[2] ibid.
[3] Georges Bataille, "Oeil," *Documents* no. 4, September
 1929, p. 216.

48

Dalí Anatomicus, 1948

Philippe Halsman photograph

Gelatin silver print, 10½ × 13½ in.

Museum of Fine Arts, St. Petersburg, Florida.

National Endowment for the Arts and Fine Arts

Council of Florida Photography Purchase Grant, 1977

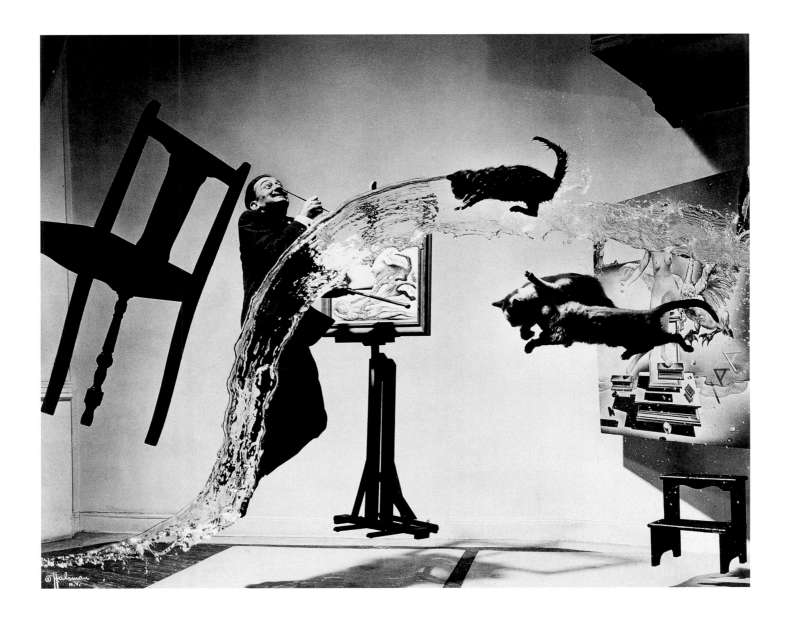

49

Future Martyr of Supersonic Waves, 1949–50
Pencil on paper, 5½ × 10¾ in.
Salvador Dalí Museum, St. Petersburg, Florida

Detail, cat. 50

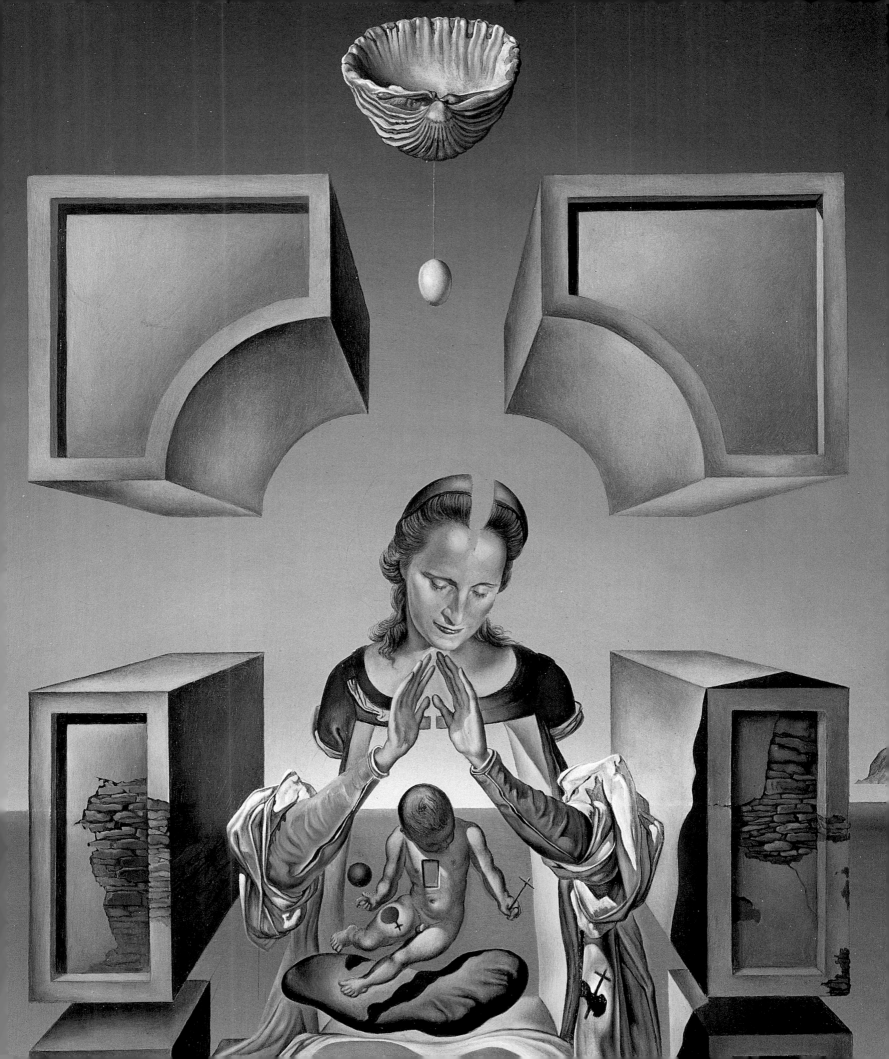

50

Madonna of Port Lligat, 1949
Oil on canvas, 19½ × 15⅟₁₆ in.
Patrick and Beatrice Haggerty Museum of Art
Marquette University, Milwaukee, Wisconsin
gift of Mr. And Mrs. Ira Haupt

Gala is not simply the model for the Madonna here: her identity as Dalí's muse, companion and twin is integral to the subject of the painting.

Dalí has loosely based his Madonna and Child on Piero della Francesca's Brera altarpiece resiting them in the bay at Port Lligat; he split and opened out the architectural surround so that it appears to hover in space. Dalí inverts the shell with suspended egg that hangs above Piero's Virgin, so that it echoes that which gave birth to Venus. Both Gala–Madonna and Child have openings carved through their bodies as though they were also architecture. The Madonna's cleft head evokes the magical births of classical mythology and also Dalí's earlier poem *Metamorphosis of Narcissus*:

> *When that head slits*
> *when that head splits*
> *when the head bursts*
> *it will be the flower,*
> *the new Narcissus,*
> *Gala –*
> *my narcissus.*

The Madonna and Child is iconographically linked by Dalí to an Annunciation couched in terms of classical mythology: his *Leda Atomica*. In this painting completed shortly before the *Madonna of Port Lligat*, Leda is the naked Gala, embracing the swan who is the god Zeus in disguise. The egg from which the fruit of this union was born, the immortal-mortal pair of twins Castor and Pollux, and Helen and Clytemnestra, floats broken at her feet. The idea of an impregnation or immaculate conception, symbolized by the egg, which united earthly and supernatural, rational and irrational, was also a metaphor for his own inspiration through Gala. As Fiona Bradley writes:

> *Mary becomes the Virgin Mother through an action of a male (re)creator. In a sense, she is God's muse, and is close to those incarnations of the surrealist muse (Gala being the supreme example) who owe their pictorial and literary identity to the activity of their men. The muse is the object of desire, of love, and God is, famously, love itself. His transformation of Mary is the result of love: "God so loved the world that he gave [her] his only son". God uses Mary as a channel through which to create. That which he creates through her mediation is, as so often with Dalí and Gala, the image of himself.*[1]

The child here is both secular and heavenly king, with orb, and the cross that foretells his fate. Rather than fragmenting his forms into particles as in *Raphaelesque Head Exploded* (cat. 51) Dalí suspends architecture, figures and objects before the landscape as though they occupy a different dimension. The high horizon line apparently marking the sea is in fact detached from the rocky outcrops of the bay, as though a distinction is being made between actual landscape of sky and sea and a more abstract idea of space – "heaven" above and a watery amniotic fluid below. The sea urchin's hollow shell was for Dalí like the Renaissance cupola that re-creates the dome of heaven, and the spiral shell was a symbol of infinity.

[1] Fiona Bradley, "Gala Dalí: The Eternal Feminine," in *Dalí: A Mythology, op. cit.,* p. 69.

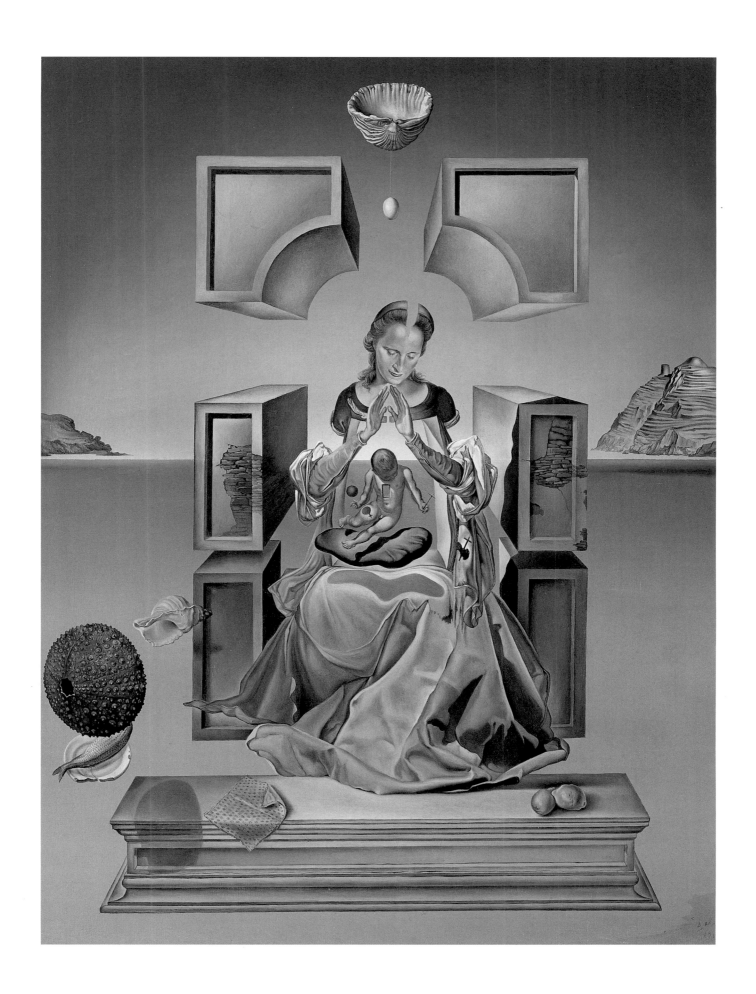

51

Raphaelesque Head Exploded, 1951
Oil on canvas, 17 × 13 in.
Private Collection, on loan to the Scottish
National Gallery of Modern Art, Edinburgh

A vista of the Pantheon in Rome forms the interior of
the head of a Raphaelesque madonna, revealed as it were
by the disintegration of the head into atomic particles.
This is not a double image of the kind Dalí had pro-
duced in the late thirties, although the way in which the
head is read visually in terms of the shattered elements
has something in common with the head in *Paranoia*.
It is rather an instance of the morphological analogies
that he developed; the interior structure of the dome
with its opening is elsewhere compared to the shell of
the sea urchin. The explosion is both related to the atom
bomb, and to the discoveries of molecular chemistry.
The mass of particles still more or less conform to and
circulate within the contours of the head, but also have
more irrational associations. The solid-looking cones
and log-like shapes appear in a watercolor drawing of a
cupola-head and torso entitled *The Wheelbarrows,* as the
long handles of the wheelbarrows. In the *Tragic Myth
of Millet's Angelus* Dalí had interpreted the wheelbarrow
as a rustic erotic symbol, and the handle-shape freed of
the barrow itself becomes a detached phallic symbol.

For Dalí recent scientific explanations of the physical
make-up of the universe, and their literally explosive con-
sequences exacerbated rather than explained its mystery.
That the whole universe "seems filled with this delirious
and unknown substance" was in his view as much a
problem for metaphysics as for physics. In his *Mystical
Manifesto,* written the year he painted *Raphaelesque
Head,* he wrote: "Thus we observe that each quarter
hour and second matter is in a constant and accelerated
process of dematerialization, of disintegration, escaping
the hand of scientists and showing us the spirituality of
all substance, for the physical light of Dalí's paranoiac-
critical activity too is at one and the same time 'wave
and corpuscle.'"[1]

[1] "Manifeste Mystique," Paris 1951, in *Salvador Dalí,* Paris,
 Centre Pompidou 1979–80, pp. 372–74.

52

Eucharistic Still Life, 1952
Oil on canvas, 21½ × 34¼ in.
Salvador Dalí Museum, St. Petersburg, Florida

Dalí ended *The Secret Life* with the words "At this moment I do not yet have faith, and I fear I shall die without heaven." Although Dalí's apparent embrace of the Church definitively alienated him from the Surrealists, the mystical and religious subject matter of his post-war painting is nonetheless ambiguous and potentially iconoclastic. He expresses his metaphysical doubt through a range of pictorial and optical ideas that pit order against uncertainty.

In terms of Christian iconography this still life of bread and fishes refers both to Jesus feeding the multitude, when seven loaves and a few fishes miraculously became sufficient for all, and to the sacrament of the last supper. Over and above the sacramental quality that many still life paintings of bread and wine possess – those by Chardin for example – this has two particular precedents: Spanish still life painting of the Golden Age, especially Zurbarán, and de Chirico. The vertical position of the fish, which makes no concession to any perspectival recession, could be based on such still lives as those of Sanchez Cotán or Alejandro de Loarte, in which vegetables, fruit, game or fish are suspended parallel to the picture plane on strings.[1] De Chirico had featured fish in his portraits of the poet Guillaume Apollinaire, although the immediate source for Dalí was *The Sacred Fish* of 1919.

But the most striking aspects of Dalí's painting are the geometrical composition, and the symmetrical separation of the fish and bread, so different from the usual heaped and affectedly careless disposition of a still life. To an extent this also brings de Chirico to mind, with his references to geometry and inclusion of measuring instruments in his interiors and still lives. However, while de Chirico's spaces have an internal collage-like disjunction, here Dalí constructs the whole composition according to geometrical figures, symmetrical and asymmetrical. The rectangle of the table is cut by the vertical edges of the canvas, and thus involves no perspectival foreshortening; but the white cloth is arranged diagonally so that its further edges give the effect of recession. Despite the illusion of the white cloth falling perpendicularly at the near edge of the table, in fact its edges continue dead straight to touch the bottom of the canvas at its center point: were the further edges continued to the top of the picture, they would also meet and create a parallelogram. But beside this notional diamond shape, the cloth as represented is a pentagon, a shape of special significance to Dalí. A second pentagon is formed by the rigid edge of the central flat fish. Although these are irregular pentagons, they evidently relate to the studies of Matila Ghyka on proportion and harmony in life and in design.[2] In his *Practical Handbook of Geometrical Composition*, for instance, Ghyka describes the asymmetrical ratio of the Golden Section, which controls the pentagon. Ghyka also talks about pentagonal symmetry in the morphology of living organisms, and the logarithmic spiral in the growth of flowers and leaves, drawing on the work of D'Arcy Thompson, whose *On Growth and Form* was another of Dalí's valued sources.[3] All this is not to claim that Dalí calculated his measurements precisely according to Ghyka's mathematical models, but rather to suggest that both the composition and the objects in this still life are informed by ideas about the significance of morphology ("The youngest, the most modern science").[4] However, this is no simple application of "the geometry of life"; for one thing, while the central fish is undeniably pentagonal, the loaves, which also resemble the Catalan tripartite bread, are more like *informe* versions of irregular solids, the unpredictable nature of baking introducing a formal mystery into the highly controlled setting. The contrast, too, between the crusty exteriors and the slimy fish with their internal skeletons is also characteristic of Dalí's long standing fascination with the mechanism of repugnance. Moreover, the division of the canvas into light and dark, with the flying fish and one loaf brightly lit and casting shadows, while those to the right appear to float in the gloom hints at a metaphysical dimension.

At an exhibition at the Bignou Gallery in New York in 1945 Dalí showed the second version of his *Basket of Bread*. Bread, he explained "has always been one of the oldest and fetishistic and obsessive subjects in my work… This typically realist picture is the one that has satisfied my imagination the most. Here is a painting about which there is nothing to explain: The total enigma!"[5] *Eucharistic Still Life* matches the enigma of the realism of the bread with the optical enigma of the metaphysical Eucharist.

1 See *Spanish Still Life from Velázquez to Goya*, National Gallery, London, 1995.
2 The following are among the works in Dalí's library by Ghyka: *Practical Handbook of Geometrical Composition and Design*, London 1952; *The Geometry of Art and Life*, New York 1946, with a dedication to Dalí "Au pays du rêve / au nombre des rêve / Salvador Dalí"; *Esthetiques des proportions dans la nature et dans les arts*, Paris, 1927; *Essai sur le rhythme*, Paris 1938 (with dedication to Dalí and Gala in Hollywood, 1946). Dalí drew over many of Ghyka's diagrams, his additions ranging from elaborating the rectangles to erotic sketches.
3 The notes to *50 Secrets of Magic Craftsmanship* include long quotations from *On Growth and Form*.
4 *50 Secrets of Magic Craftsmanship*, op. cit., p. 177.
5 *Recent Paintings by Salvador Dalí*, Bignou Gallery, New York November 20 – December 29, 1945 (cat. no. 2).

53

Crucifixion (Corpus Hypercubicus), 1953–54
Oil on canvas, 76½ × 48¾ in.
The Metropolitan Museum of Art, New York
gift of the Chester Dale Collection, 1955
*Shown only in Hartford and Washington

In the early 1950s Dalí fully realized his revolt against modernism, and his championship of tradition with large-scale works which merge Christian iconography with his personal mythology. The tradition to which he aligned himself at this moment was above all that of the Spanish mystical painters like Zurbarán, or Valdés Leal. *Corpus Hypercubicus* was preceded by *Christ of St. John of the Cross* (1951). Far from rejecting modern science, however, as his "Mystical Manifesto" of 1951 emphasizes, Dalí claimed that his mystical paroxysm was based on "the progress of the particular sciences of our era, especially on the metaphysical spirituality of the substantiality of quantum physics…" The idea that matter was in a constant process of disintegration both recalled Heraclitus and affirmed for Dalí "the spirituality of all substances." Other paintings of this period graphically depict dematerialization (cat. 51), and his religious iconography was in no sense accompanied by a morality, which would inhibit erotic imagery.

Although Dalí rejected the "materialist and anti-mystical painting of Grünewald," the body of his Christ is clearly that of a specific model. Unlike the Phidias-inspired torso that he painted the same year, this seems a modern, not an ideal body. Dalí's diary for 1953 reveals his degree of nervous and physical identification with the painting, as well as the displacement to the Phidias torso: "I was not worthy to undertake the abdomen and the chest of my Corpus Hypercubicus. I practice on the right thigh. My stomach has to recover, my tongue must be very, very clean. Tomorrow I shall work on the testicles of the torso of Phidias, waiting for purification."[1]

Gala, wearing rich and vaguely ecclesiastical robes is positioned as contemplative mystic rather than mourner; however, her persona like that of Dalí himself had multiple significance in his mythology: lover, wife and mother–madonna. In *Perpignan Station*, for instance, the couple from Millet's *Angelus* are doubled as Dalí and Gala, who form a vertical axis, Dalí at the top and Gala at the bottom, superimposed over a huge, but only dimly visible, figure of Christ crucified.[2] Dalí's complex process

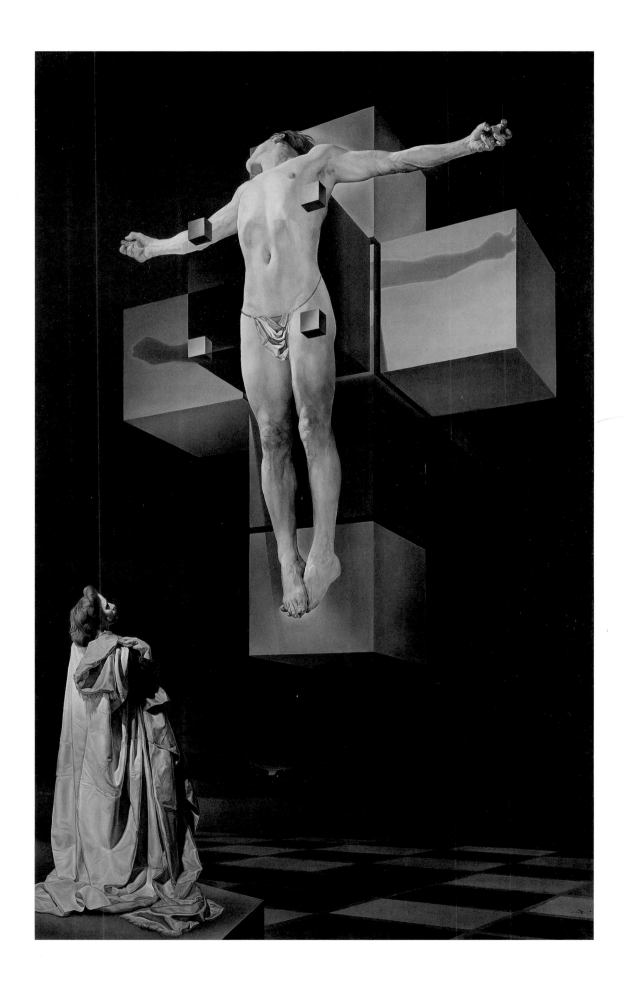

of identification with Christian myth reached a pinnacle with his opera-poem *Etre Dieu* (1974), in which the choir announces

> *But if you were God*
> *You would not be Dalí.*

The black and white squared floor, reminiscent of Vermeer, includes a two-dimensional cross. Christ's cross is "three-dimensional," the body suspended in space against the nearest protruding cube (fig. 8). However, as the title suggests, Dalí was thinking of an extra dimension, "beyond" or exceeding the cube. The idea of it in time as well as space may be implicit in the to–fro, convex–concave form of the individual cubes, which may be perceived alternately as being solid or hollow. Thus they become unstable and in constant perceptual flux. Dalí extended his idea of the "hypercube" in a mobile construction now in the Teatro Museo Gala–Salvador Dalí, a jointed three-dimensional cross of cubes which turns and twists in space.

Dalí was also interested in the ideas of Juan de Herrera, one of the architects of Philip II's vast castle-monastery, the Escorial, and author of *Tratado de la figura cúbica* (c. 1570–80). Herrera, actually master-draftsman and intellectual rather than architect, was responsible for the spare, stripped down style of the Escorial, whose only decoration, in finials for instance, was based on the simplest possible geometrical forms. While working on this painting Dalí notes in his dairy for August 19, 1953: "Some young researchers specializing in nuclear physics came to see me today. They left again, intoxicated, having promised to send me the cubic crystallization of salt photographed in space. I should like salt – symbol of incombustibility – to work like me and like Juan de Herrera on the question of the Corpus hypercubicus."[3]

Herrera's treatise was written, it appears, at the request of "Lullist friends," that is followers of the Catalan mystic, natural philosopher and alchemist Raymond Lull (another of Dalí's favorite authorities.) Herrera explained Lull's "Art," or his philosophy of natural science, by representing it, in Euclidian terms, in grid form on the six faces of a cube.

> *It is likely that Herrera thought of the Art as a kind of natural philosophy, a system of analogies for interpreting nature. And…it seems certain that it sustained his scientific endeavors by providing a system in which these were legitimate aspects of Catholic doctrine… Mathematics and the science of mechanics linked architecture to the sciences, whose principles were universal. The divine machine was designed on mathematical principles…[Herrera] further folded science into the all-encompassing structure of Lull's philosophy. It was a fragile construction, but, in contrast to Alberti's only nominally Christian philosophy, it was both classicizing and Catholic.*[4]

Dalí's passionate efforts to harmonize modern scientific thought with spiritual or metaphysical ideas has echoes of Lull and Herrera, and other natural philosophers or scientists whose world view had not yet suffered the split between knowledge and belief, science and religion that Dalí was so determined to mend.

[1] *Diary of a genius, op. cit.* p. 105.
[2] See Fiona Bradley, "Strategies of Encounter in Dalí's *La Gare de Perpignan*"(unpublished).
[3] Catherine Wilkinson Zerner, *Juan de Herrera*, New Haven and London 1993, p. 43. I am indebted to Dr. Valerie Fraser for ideas about Herrera and for bringing Zerner's book to my attention.
[4] *Diary of a genius, op. cit.* p. 102.

Detail, cat. 53

54

Skull of Zurbarán, 1956
Oil on canvas, 39½ × 39½ in.
Smithsonian Institution, Hirshhorn Museum and
Sculpture Garden, gift of Joseph H. Hirshhorn
Foundation, 1966

There may be a double significance to the "Zurbarán's
skull" of the title, referring both to the painter's own
cranium and to the skulls that he depicted. Francisco
de Zurbarán (1598–1664) was one of the masters of
Spanish Golden Age painting, and although Dalí refers
to him less frequently than to Vermeer, Raphael and
Velázquez, he was nonetheless one of Dalí's chosen
masters both in his pre-surrealist days and during the
post-war attempt to revitalize traditional painting.
Apart from his still lifes, which were probable models
for Dalí's two versions of *Basket of Bread*, Zurbarán
is best known for his portrayals of ascetic monks, and
in particular Saint Francis, whom he usually depicted
as a solitary hooded figure in prayer or meditation,
holding a skull.

Dalí's double image here combines a solemn church
interior with the skull, most obvious of memento mori,
typical of the Vanitas theme that was so frequently
treated in seventeenth-century Spain, where it was known
as *Desengaño del mundo*, (Disillusionment of the World).

The skull appears in the configuration of cubes,
themselves reminiscent of *Corpus Hypercubicus* (cat. 53);
the nasal cavity is formed by a slightly bowed arch,
within which the corner angle formed by three of the
cubes switches illusionistically from concave to convex,
while the white-robed figures of monks, gathered as
if in prayer, read also as the teeth.

Dalí's fascination with morphology prompted a
series of analogies between the brains of famous people
and diverse natural forms. He conceived an analogy
between Freud's cranium and the spiral of a snail shell,
"Raphael's skull is exactly the opposite of Freud's; it
is octagonal like a carved gem, and his brain is like
veins in the stone. The skull of Leonardo is like those
nuts that one crushes: that is to say, it looks more like a
real brain" (fig. 54.1).[1]

This imaginative fancy is in fact rooted not only in
the modern morphological theories of D'Arcy Thompson
but also in the ideas of a much older "natural science,"
where the secret of natural things (including man, ani-
mals, the stars) resides in their sympathies or affinities
with each other. The friction between embryonic mod-
ern science and medicine and the belief in magic is
evident in Della Porta's *Natural Magick* (a favorite text
of Dalí's): "I think that magick is nothing else but the
survey of the whole course of Nature. For, whilst we
consider the Heavens, the Stars, the Elements, how they
are moved and how they are changed, by this means
we find out the hidden secrecies of living creatures, of
plants, of metals, and of their generation and corrup-
tion."[2] If Leonardo's brain is like a nut (and this precise
analogy, between the human brain and a walnut, was
drawn by another natural scientist, Paracelsus) Zurbarán's
seems to Dalí morphologically to resemble a hard and
regular cubic structure. The simple austerity of the setting
may refer to the huge and undecorated façades of the
Spanish royal palace, the Escorial, built in the latter half
of the sixteenth century, and its architect Juan de Herrera,
author of *Discourse on Cubical Form* (see cat. 53).

Fig. 54.1
Salvador Dalí
"Morphology of Sigmund Freud's Cranium,"
from *The Secret Life of Salvador Dalí.*

[1] *Secret Life*, p. 24.
[2] J.P. Porta, *Natural Magick*, London 1658.

55

*Velázquez Painting the Infanta Margarita with
the Lights and Shadows of his own Glory*, 1958
Oil on canvas, 60¼ × 36¼ in.
Salvador Dalí Museum, St. Petersburg, Florida

Dalí's fascination both with the explosion of the atomic
bomb and with the great painters of the realist tradition
in oil painting, above all Vermeer and Velázquez, come
together in this painting. The splitting of the atom led
Dalí visually to imagine the disintegration of matter
in various ways; here, Velázquez's image of the Infanta
Margarita shatters into particles, some in jagged and
parallel formations suggesting magnetic and electrical
charges. The Infanta faces the viewer, her pink-striped
skirt expands towards the right hand edge of the paint-
ing, in an echo of anamorphic perspective. Like dark
slabs running diagonally across the painting are a series
of immensely tall canvases, on one of which, in the
center, the artist is in the process of painting the Infanta
Margarita. He is a composite of Dalí and Velázquez,
in whose likeness Dalí elsewhere represented himself.

Here too, on the painting within a painting, Dalí refers
to the anamorphic device of distorting the proportions
of the figure, by elongating the lower part of the Infanta.
The beams of light piercing the gallery are drawn in
the manner of the pyramids that perspective theorists
devised to illustrate the area of vision, and thus take on
a kind of paradoxical solidity by contrast with the de-
materialization of the Infanta.

Dalí was not the only twentieth-century artist to be
drawn to Velázquez and to rework his images according
to their own ideas. Picasso and the Mexican artist
Gironella, for different reasons, reproduce, embellish
and disfigure chosen paintings by Velázquez. So Dalí's
much-trumpeted return to tradition and to the example
of artists of the past can also be seen in the light of a
more widespread retrospection – either because of the
poverty of painting in the twentieth century, or in the
spirit of a post-modern need critically to work through
and assess the past, or to cannibalize it. Neither Picasso
nor Gironella is respectful or faithful to their original.
They do not copy, but re-invent, just as Dalí does here.

56

Ascension, 1958
Oil on canvas, 45¼ × 48½ cm.
Private Collection

The colossal foreshortening of the body in this image of
the Ascension was probably achieved with the help of
the glass floor Dalí installed near his studio at Port Lligat.
Models could be posed either above or below it, depend-
ing on the required view point. The presence of Gala
and the development of Dalí's iconography imply a dual
identification with the artist himself, whoever actually
posed for the figures of Christ. Gala too is often identified
with the mother of Christ, although here she is poised
above a dove representing the Holy Ghost.

Despite the transcendental thrust of the image and
the celestial orbs to which the body ascends, there is
an equal and opposite pull of descent and a powerful
materiality, with for example the prominence of the far
from idealized feet. It is tempting to recall the ideas of
Georges Bataille, for whom man's idealist impulses and
metaphysical yearnings were always accompanied and
countered by a corresponding recognition of his earth-
bound nature. The extraordinary spatial to–fro of the
corresponding but inverted positions of Gala and Christ–
Dalí also produce a dizzying sense of ascent and fall.
The clouds above have the materiality and fissures
of the Port Lligat rocks, while the nearest "globe" is
like the compact mass of a coral, or a microscopic sea-
organism (fig. 3), or the patterned shell of a sea urchin.
This creature which had long been of symbolic signifi-
cance for Dalí as well as his favorite food had also taken
on an architectonic significance: its interior seen through
a hole drilled in the top of the shell forms, Dalí wrote
in *50 Secrets of Magic Craftsmanship*, "the interior of
one of the most beautiful, natural cupolas..." Thus
Gala would be looking up into the cupola, whose interior
points skywards.

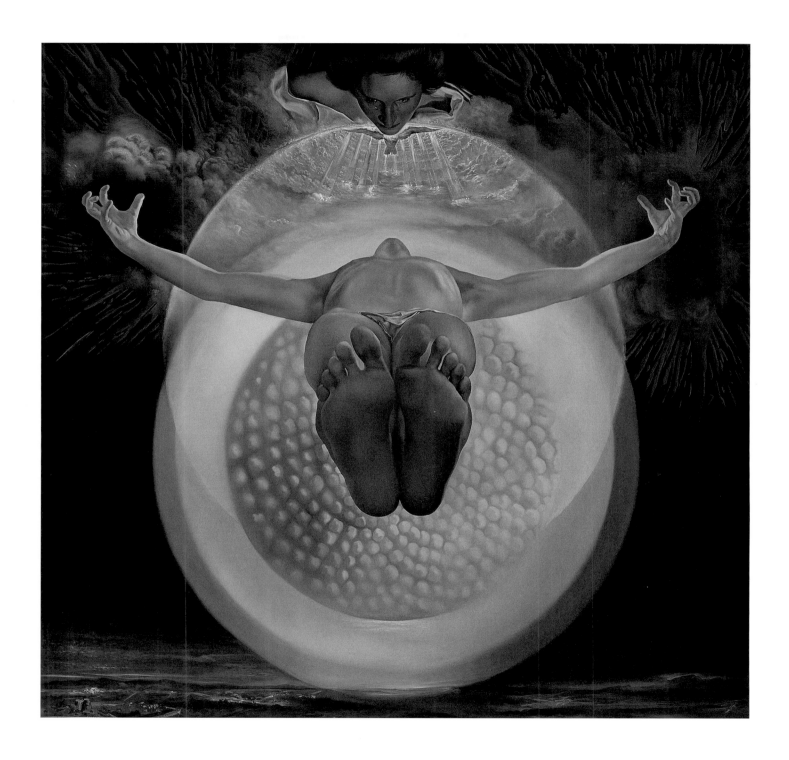

57

Portrait of my Dead Brother, 1963
Oil on canvas, 69 × 69 in.
Salvador Dalí Museum, St. Petersburg, Florida
*Shown only in Hartford and Washington

The idea of doubles and doubling is present at every level in this brilliant composite portrait of Dalí and his dead brother. Another Salvador had died at the age of 22 months, in August 1903, just nine months before the second Salvador's birth (not three years, as Dalí said). Naming a child after a deceased sibling was not uncommon; but combined with the fact that he and his brother resembled each other like "two drops of water" the absent double was a cause of confusion and morbid anxiety for Dalí. However much loved, he felt always a substitute for another, "When my father looked at me, he was seeing my double as much as myself… My soul twisted in rage and pain beneath the laser that constantly scrutinized it and then through it, tried to reach the other who was no more."[1] Dalí links his constant and conscious construction and reconstruction of his persona to the double who shared his identity and prevented coherent formation of a bodily self to be projected into the world. "For my schema, my corporeal image, my double started by being a dead boy. I had no corporeal image, fate having willed for me to be born without a body, or in an angelic one, with putrefaction images to boot."

To construct the head, Dalí transforms the idea of the dot-transmission of images into giant molecules, which turn out to be cherries. Some are paired as twins, and in the center four dark and four light cherries are arranged in a cube with their stalk-bonds forming a precise molecular structure, evidence of Dalí's continuing interest in molecular chemistry and the composition of matter.[2]

Embedded in the head and doubling as hair is a vulture, resembling that which Freud saw in the robe of Leonardo's Virgin in *The Virgin and Saint Anne,* and interpreted as the unconscious sign of the artist's repressed fantasies. Freud's analysis of the Leonardo was one of the models for Dalí's extended psychoanalytical study of Millet's *Angelus.* Uncovering the cause of the obsession this banal devotional image exercised on him was also to reveal the picture's hidden erotic and threatening meaning. The little group of distant sepia figures on the plain are an animated composite of Millet's *Angelus* and his *Le Vanneur,* which Dalí reproduced together with Leonardo's *Virgin and Saint Anne* in his "Interpretation Paranoiaque-critique de l'image obsédante de 'L'Angélus' de Millet" (fig. 21.1).

[1] *Unspeakable confessions, op. cit.,* p. 23.
[2] See also Bradley in *Dalí: a Mythology, op. cit.*

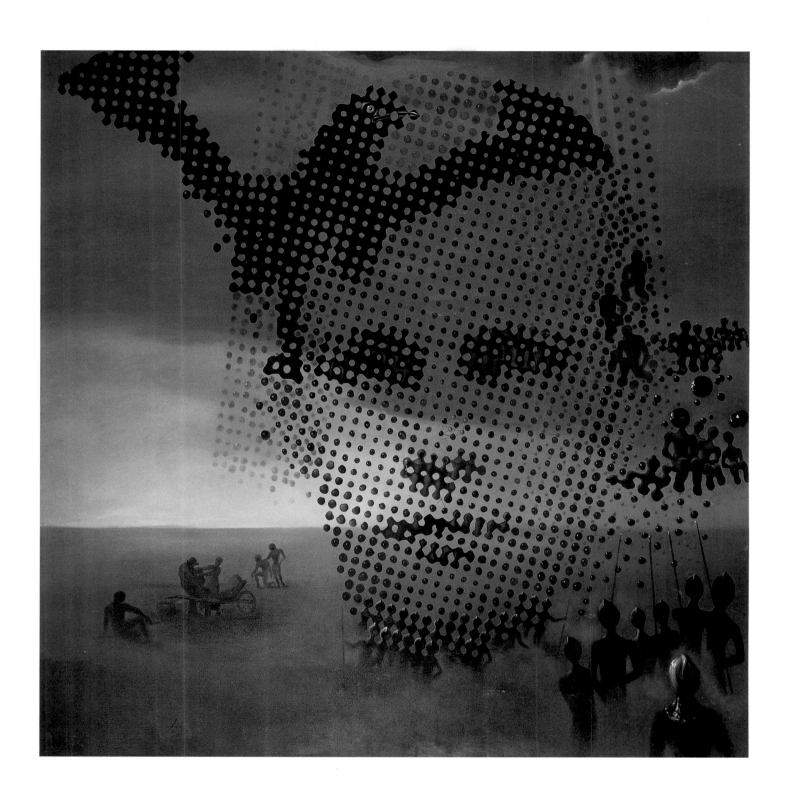

58

The Anatomy Lesson, 1965
Ink on paper, 13½ × 18¼ in.
Salvador Dalí Museum, St. Petersburg, Florida

59

The Sun and Dalí, 1965
Oil on canvas, 39¾ × 29¾ in.
Private Collection

Painted in the same year as the monumental canvases *Apotheosis of the Dollar* and *Perpignan Railway Station,* the loose technique and irregular application of the dots, which are partially Pointillist and partially stencil-like give this work an experimental feel. Possibly he was exploring ways of producing an optical effect of relief within the double image.

The elision of Dalí's head and the sun relates to Dalí's personal mythology of the family and his paranoiac critical interpretation of the couple in the *Angelus.* In *Perpignan Railway Station* he identifies himself in a complex set of pairings with both God the Father and God the Son, and the center of Christ's head is also the core of the sun sending out four beams of light. Dalí was perfectly aware of the pun in English sun/son. The double image, though only partially realized, is of Dalí's face with a cluster of buildings with a tower, outlined with dark dots against the white dots of the sky circumscribed by the rim of the sun. Thin streaks of paint define the edges of the buildings. Where they reach the ground at the lower left their depth is indicated not with a solid mass but with the hint of a thin sheet punctured with holes, which strengthens the idea that he was brooding on some form of stereoscopic or zoetropic machine to create a three-dimensional effect.

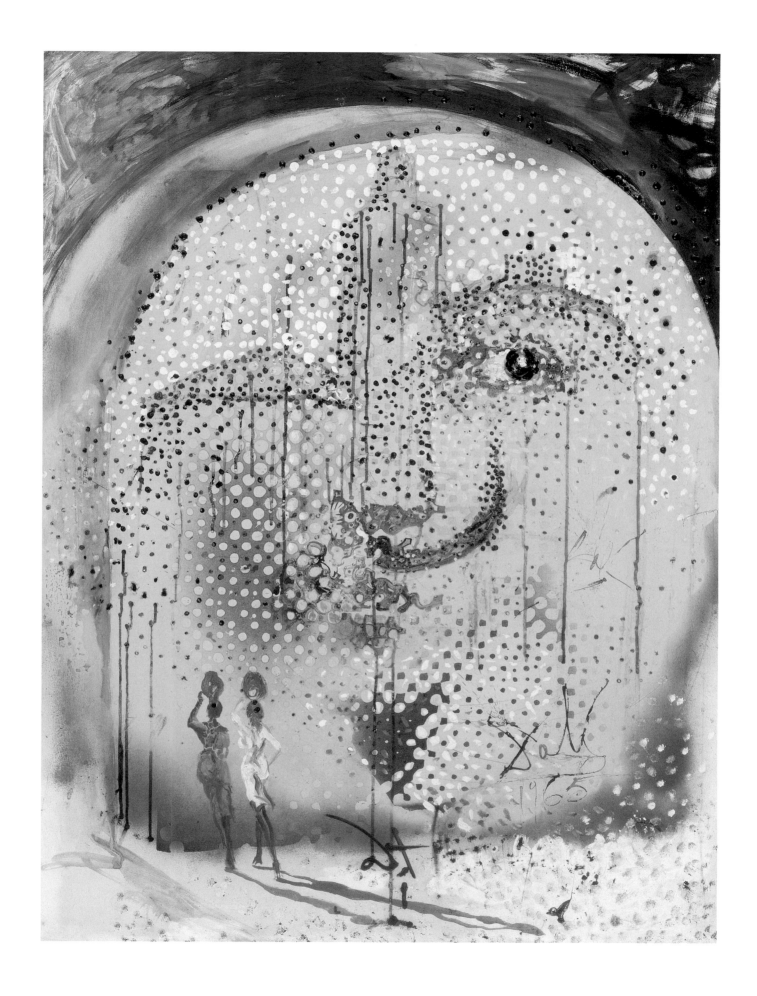

60

Dalí Painting Gala, 1973–74
White light hologram, 15 × 16 in.
Salvador Dalí Museum, St. Petersburg, Florida
*not illustrated, shown only
in Hartford and Washington

61

Nieuw Amsterdam, 1974
Bronze with oil overpainting and metal collage,
20½ × 19 × 10 in.
Salvador Dalí Museum, St. Petersburg, Florida

There are several examples within Dada and Surrealism
of the transformation (humorous, iconoclastic, enigmatic
or romantic) of readymade figurative sculpture;
Magritte's *The Future of Statues* (1937) is a readymade
plaster head of Napoleon with blue sky and clouds
painted over it. Dalí covered a bust of Joella Lloyd (1934)
with a painted sky and lurid brick walls, and there are
sporadic instances throughout his career of both meta-
morphoses and of "paranoiac-critical" readings of
three-dimensional found or chosen objects. This found
sculpture/double image is one of the most elaborate of
his over-paintings, and a rare example of Dalí respond-
ing to American history.

The nineteenth-century bronze bust of White Eagle,
a chief of the Ponca tribe of Plains Indians, is by
Charles Schreyvogel. White Eagle was one of the most
articulate opponents to the Washington government's
policy of forcible confinement of his people in the
1870s to reservations; a celebrated case of 1879 had
ruled that an Indian was a "person" with the same
rights as the whites. It is unlikely that Dalí had other
than opportunistic interest in the specific history behind
this heroic and romantic bust. He transforms the face
into an imaginary scene from a much earlier period of
the invasions: two Dutch merchants whose faces are the
eyes, their red cloaks the cheeks of White Eagle, toast,
with a coca cola bottle between them, the foundations of
American capitalism in the Dutch traders' purchase of
New York (Nieuw Amsterdam) in the seventeenth cen-
tury for a string of beads. The fruits in the basket-lips
refer to Thanksgiving. The painted face of the "red
man" is an awkward and rather grotesque summary of
the "Indian" stereotype.

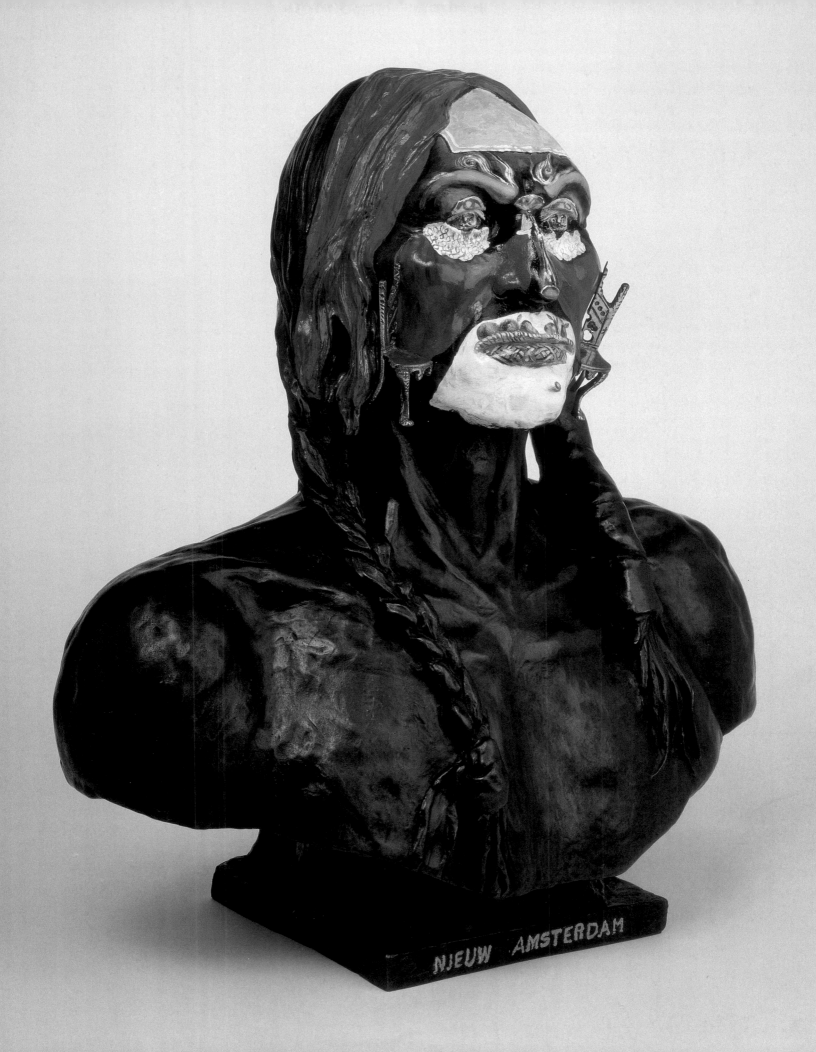

62, 63

Dalí's Hand Drawing back the Golden Fleece in the Form of a Cloud to Show Gala the Dawn, completely Nude, very, very far away Behind the Sun, 1977
Two stereoscopic panels, oil on canvas, each 23⅝ × 23⅝ in.
Fundació Gala–Salvador Dalí, Figueres

After the experiments with holography, at its then current state of development, had proved somewhat disappointing, Dalí pursued his quest for convincing illusion by turning to an older method for producing the three-dimensional effect of binocular vision: stereoscopy. Early in the 1970s he began to paint pairs of almost identical pictures; when viewed side by side, with the use of angled mirrors, or, ideally, through special lenses, the two images would merge and spring into relief.

The stereoscope first developed by Sir Charles Wheatstone, c. 1832, prepared two views of the same design as though from the slightly different perspective of right and left eyes, and projected them with the use of mirrors so that each eye would see the appropriate image in relief. With the invention of photography in 1839, Wheatstone recognized the possibility of producing much more realistic stereoscopic effects, and invited Talbot and Collen to prepare "Talbotypes of full-sized statues, buildings, and even portraits of living persons."[1] With the use of two cameras set up to mimic binocular sight, pairs of photographs were produced, but the viewing machine was very unwieldy, and it was another specialist in optics, Sir David Brewster, who invented a

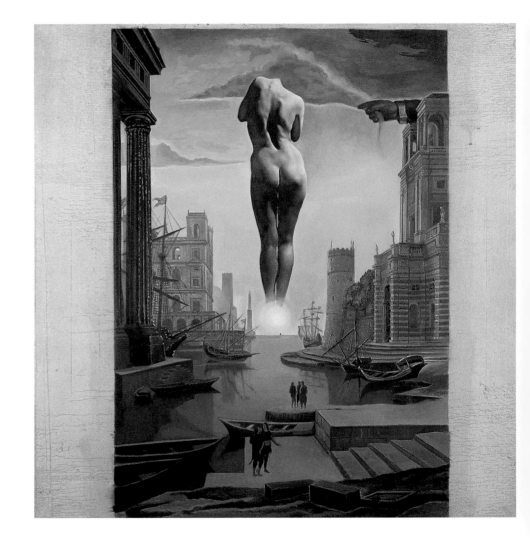

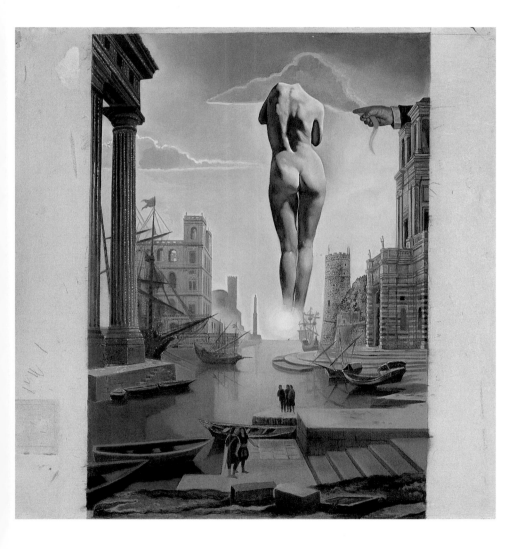

much handier stereoscopic viewer with two lenses, and a double-lensed camera, eventually made in France. From their launch at the Great Exhibition in 1851 the resulting "stereoscopic daguerreotypes" were immensely popular, taking their place among the most successful and magical of Victorian scientific toys. It is interesting that the stereoscopic device was invented simultaneously with rather than as a consequence of photography.

The "optical theater" his old teacher Señor Traite showed Dalí as a child was one such toy, with the added magic of color. Dalí now returned this device to the arena of oil paint, using his meticulous technique and possibly also with an impulse given by the neo-realist painters in the States whose work he admired.

Dalí's pairs of paintings vary considerably in scale: some, such as *The Chair*, are over two meters tall (making the image in this case over life-size). The original and its copy vary slightly in hue and tone, as well as view-points, to assist the stereoscopic effect. Here Dalí has taken a Claude Lorrain harbor scene, adding the allegorical nude to represent the "dawn" and thereby imposing an entirely different personal reading on the calm classical scene. The choice of the seafaring image, the reference in the title to the Golden Fleece in search of which Jason set off with his Argonauts, and the insistence on the sun rising rather than its setting seems an oblique reference to a life's voyage that Dalí is determined to present as a beginning rather than an end, the nude itself recalling Gala in her youth.

1 See Martin Kemp, *The Science of Art*, New Haven and London 1990, pp. 215ff.

64, 65
Gala's Christ, 1978
Two stereoscopic panels, oil on canvas,
each 39⅜ × 39⅜ in.
Private Collection

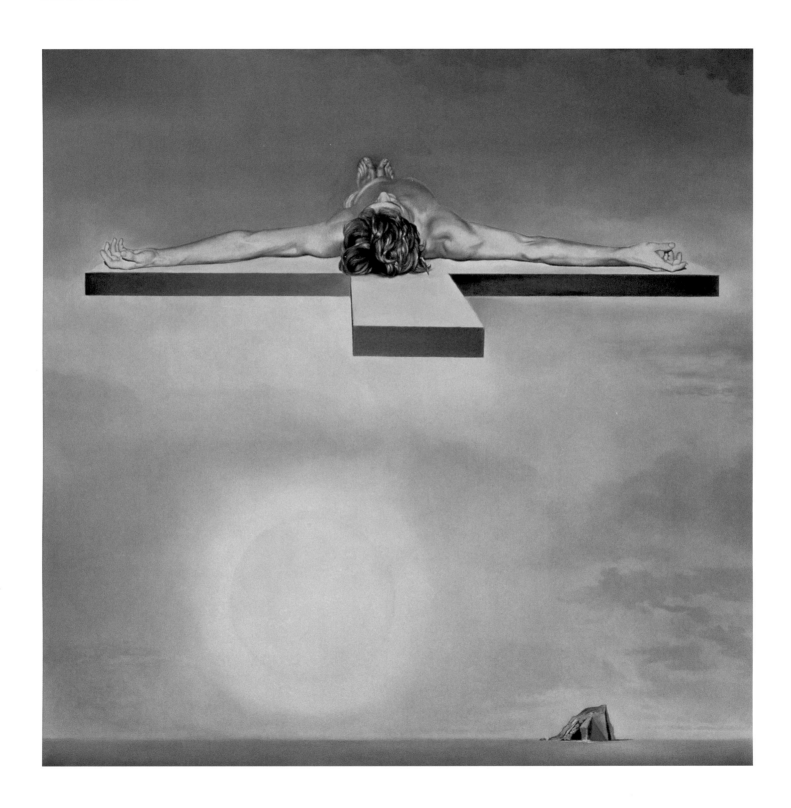

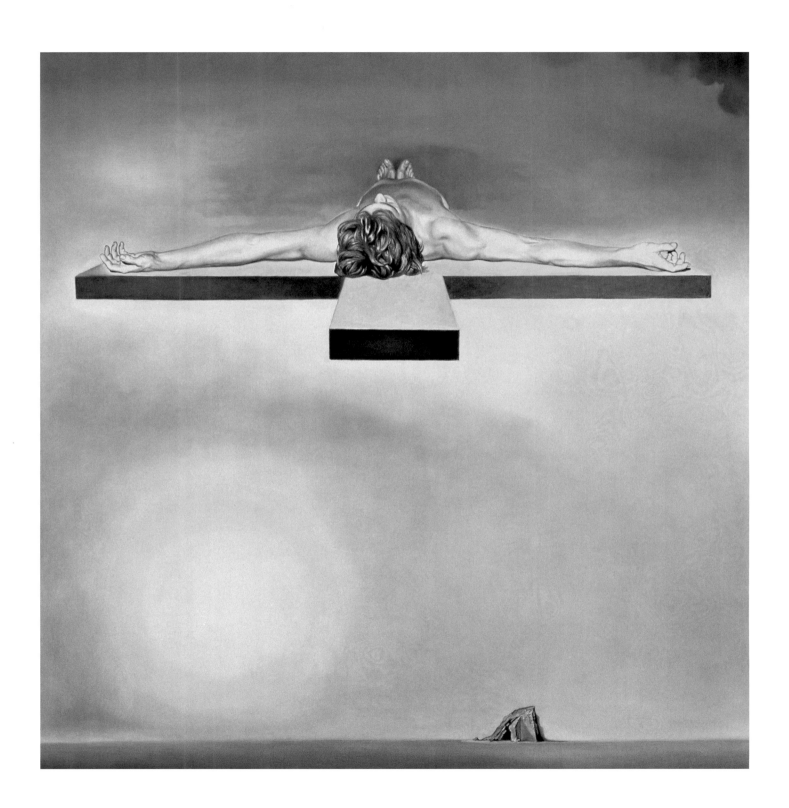

66, 67

Athens is Burning (The School of Athens
and *The Fire in the Borgo*), 1979–80
Two stereoscopic panels, oil on panel,
12⅝ × 17⅜ in. and 12⅝ × 17¼ in.
Fundació Gala–Salvador Dalí, Figueres

In taking two different paintings by Raphael
as his models for this stereoscopic work, Dalí
appears to be attempting a form of his
original double imagery, though there is no
evidence of any paranoiac-critical interpre-
tation of Raphael in train. It is rather an
experimental form of a superimposition in
which the classical harmony of the *School
of Athens* fresco, a vision of the wise and
learned in conversation is interrupted dra-
matically by the fresco of the *Fire in the
Borgo*. Both frescoes are in the *Stanze* of the
Vatican, and Dalí replicates the different
decorative arches without trying to make
them harmonize. (That of the *Fire in the
Borgo* is depicted as from a sharper angle
than the *School of Athens*.) The squares of
color, which Robert Descharnes says were
developed by Roger Lanne de Montebello
"to approach us visually along a spiral
axis," are slightly displaced according to
the different viewing positions of the right
and left eyes. They also resemble the initial

electronic imaging of color on a screen, before it is resolved into figures. When seen with the aid of angled mirrors, they spring into depth.

Dalí has also scattered his virtually monochrome replicas of the two paintings with confetti drifts of colored dots, with which he may have sought to replicate the "varied iridescences" of Señor Traite's optical theater, whose pictures "were edged and dotted with colored holes lighted from behind." These separations of color from the forms are a recognition of the optical role of color in producing the three-dimensional effect he sought.

The idea of presenting a different picture to each eye, which is a logical if unpromising extension of the stereoscopic technique, may also have a source in the procedure Raymond Roussel followed for his *Nouvelles Impressions d'Afrique*. As he described this in *Comment j'ai ecrit certain de mes livres*, he started with "a tiny pendant opera-glass, of which each tube, two millimeters across and made to go tight against the eye, contains a photograph on glass: one of Cairo bazaars, the other of a quay at Luxor."[1]

¹ Raymond Roussel, *Comment j'ai ecrit certain de mes livres*, 1935, p. 36.

68

The Infanta Margarita of Velázquez
appearing in the Silhouette of Horsemen
in the Courtyard of the Escorial, 1982
Oil on canvas, 28¾ × 23⅝ in.
Fundació Gala–Salvador Dalí, Figueres

Velázquez's portrait of the Infanta, in this particular
version in the Prado, was a frequent source of inspiration
for Dalí. The Infanta is repeated in the rear of a mounted
horseman to create a double image. Other appearances
of this prolific icon within double images include the
altered photograph reproduced by Dalí in *The Secret Life*
in 1942, "Apparition of Velázquez' Infanta in the summit
of a piece of Hindu architecture." The head of the
armored rider is also a barred and pedimented window in
the façade of the Escorial, in turn reflected in the ghostly
image of another horseman. The use of the hindquarters
of a horse in a double image goes back to the 1930s, in
such paintings as the *Suburb of the Paranoiac-critical
Town,* where the muscular rear of the horse is repeated
in the bunch of grapes held out by Gala.

A wave of pointillist dots, similar to those seen in
cat. 57 and 58, brushes the side of the Infanta's face as
well as the horsemen, suggesting that Dalí was going to
thicken the use of color to define the outlines. Dalí's
replication of the Velázquez portrait itself is done with
somber care, almost monochrome except for the touches
of pink, and gleaming in the light.

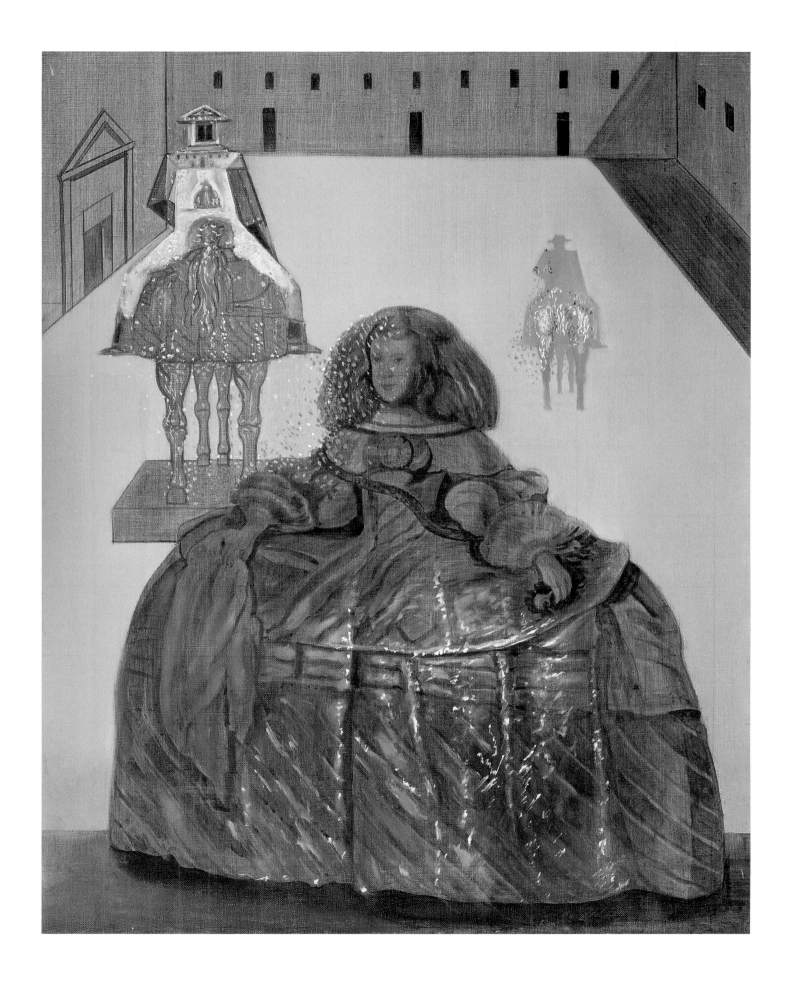

69

Garden of Hours, 1982
Oil on canvas, 25⅝ × 21⅜ in.
Fundació Gala–Salvador Dalí, Figueres

Among Dalí's last paintings, this departs from the strident classicism of some of his works towards a gentler and more rococo archaism. The mood is, if fleetingly, that of Watteau, the master of nostalgia, one of the painters to whom Dalí had planned since the early 1930s to devote a paranoiac-art-historical study. As in Watteau's *Embarkation from Cythera*, a bust or "herm" is embosomed in trees; absent, though invoked by this neo-classical half-human fragment of garden architecture is the procession of couples leaving the island of love with infinite regret. The passage of time is inscribed everywhere, from clock-faces, to the god Mercury and the long beard of the old man on the left. The trees are the cypresses of another of Dalí's chosen paintings, Arnold Böcklin's *Isle of the Dead* (fig. 10.2). Familiar motifs from earlier paintings are ghostly, like the bread on the head of the clock-headed bust, memory tokens of earlier inventions stripped of their original psychic dynamism. Dalí painted this during Gala's last illness; it is a personal allegory of time passing, which is like a counterpart to the famous soft watches of *The Persistence of Memory* (fig. 38), metaphors of the mysteries of the curvature of the space–time continuum.

70

Three Glorious Enigmas of Gala (second version), 1982
Oil on canvas, 39⅜ × 39⅜ in.
Fundació Gala–Salvador Dalí, Figueres

The giant steely grey fragment of a face lying on its side and repeated twice is one of Dalí's last paranoiac-critical double images. As it is repeated the nose, mouth and chin reveal secondary forms which appear to be rocks, though in the final head near the horizon the central curved shape could also be a veiled figure. The features of the foreground head are carved deeply, and suggest more broadly the concavities and convexities of the human body. But this face lying horizontal with prominent nose also oddly recalls the dissolving self-portrait masks from the early paintings. As it recedes the configuration diminishes in size according to a perspective whose vanishing point would be up in the heavens, and the slopes of the rock/face catch, like the clouds, the gold light of the sun.

The features of the face are strongly classical in form, and relate closely to the 1981 *Apparition of the Visage of Aphrodite of Cnidos in a Landscape*. In his last paintings Dalí often borrowed from the classical statuary of Greece and Rome, and also from Michelangelo. More than once he refers to the head of David, to the head of Giuliano de Medici, and also to the head of Christ in Michelangelo's *Pietà*, as in his own 1982 *Pietà*. In the first study for the *Three Glorious Enigmas of Gala*, Dalí juxtaposes his Christ from this Pietà with the fragment of the classical head, in such a way that the latter reads partially as part of Christ's body. Just as he identifies himself with Christ in *Corpus Hypercubicus* and in *Perpignan Station*, so here there seems to be a reprise of the interwoven Gala–Dalí and Holy Family themes.

Two other figures are seated by the giant stone fragment: firstly Dante, and secondly a figure wearing a multi-colored jacket and holding what appears to be a giant pair of dividers, pointing at the sky. Neither is looking at the apparition, and both faintly recall Fuseli's young artist seated by the giant foot of a statue, overcome by the grandeur of ancient ruins. But Dante's presence introduces the idea of the underworld and the realms of the dead, and the cavities of the deeply indented stone beside him take on another significance, that of the portal to the land of the dead. The dark voids of these cavernous forms contrast with the increasing sunlight as the head is refigured on the horizon. The dense associations in this image all point to a meditation on the myth of Gala–Dalí and the mystery and imminence of death. A few weeks after it was painted, Gala died.

71

Topological Contortion of a Female Figure, 1983
Oil on canvas, 23⅝ × 28¾ in.
Fundació Gala–Salvador Dalí, Figueres

Dalí's indefatigable interest in new developments in scientific theory continued to the end of his life, and he dedicated another painting of this year, *Topological Detachment of Europe,* to the mathematician René Thom. How far and in what ways *Topological Contortion of a Female Figure* may be informed by Thom's theories is difficult to assess, but Dalí certainly read them, and Thom's wide culture, the integral nature of his ideas, and their relevance to the question of "reality" not just in science but philosophy, society and art (he even mentions the surrealists) appealed to Dalí. Indeed, Thom's section on "Three great types of human activity: Art, Delirium and Play" suggests the degree of shared concerns.

Dalí here has stretched a female body into a kind of dynamic Moebius strip. This painting was closely followed by another "topological contortion" in which the female figure becomes a cello. It seems as if Dalí is distending, or perhaps applying his paranoiac critical method to, Thom's catastrophe theory and his general theory of a topology of biology. Thom was concerned with what D'Arcy Thompson had called "so many riddles of form, so many problems of morphology" – the problem of the succession of forms, the incessant movement of nature. What determines the different morphologies of clouds, mountains, waves, mushrooms, butterflies, crystals, people, and why are they different? Thom "tried to show, in detail and with precision, just how the global regularities with which biology deals can be envisaged as structures within a many-dimensioned space."[1] The dictionary definition of Catastrophe theory states that "continuous changes in the input of a system cause discontinuous changes in the output." Morphogenesis, or the construction and destruction of forms, can be described, in the process that Thom called catastrophe, "by the disappearance of the attractors representing the initial forms and their replacement through capture by the attractors representing the final forms."[2] The transformation of the female body into a cello might be Dalí's version of a "catastrophe."

In the case of this painting, Dalí could be responding to Thom's pursuit of the "topological structure of internal dynamism": "It is by the topological richness of internal dynamics…that the almost infinite diversity of appearances in the external world finally can be explained, and perhaps also the fundamental distinction between life and non-life."[3] The topological contortion of the female form here, leg and arm still just visible, into elliptical parabolas that may take mathematical diagrams as their starting point, perhaps is once again a projection of Dalí's metaphysical anxiety about physical dissolution.

[1] C. H. Waddington, Preface to René Thom, *Stabilité structurelle et morphogénèse,* W. A. Benajamin Inc., Massachusetts 1972, p. 7.
[2] Thom, ibid., p. 321.
[3] ibid., p. 25.

Woman Sleeping in a Landscape, 1931
Oil on canvas, 10¾ × 13⅕ in.
Peggy Guggenheim Collection, Venice
(Solomon R. Guggenheim Foundation, New York)

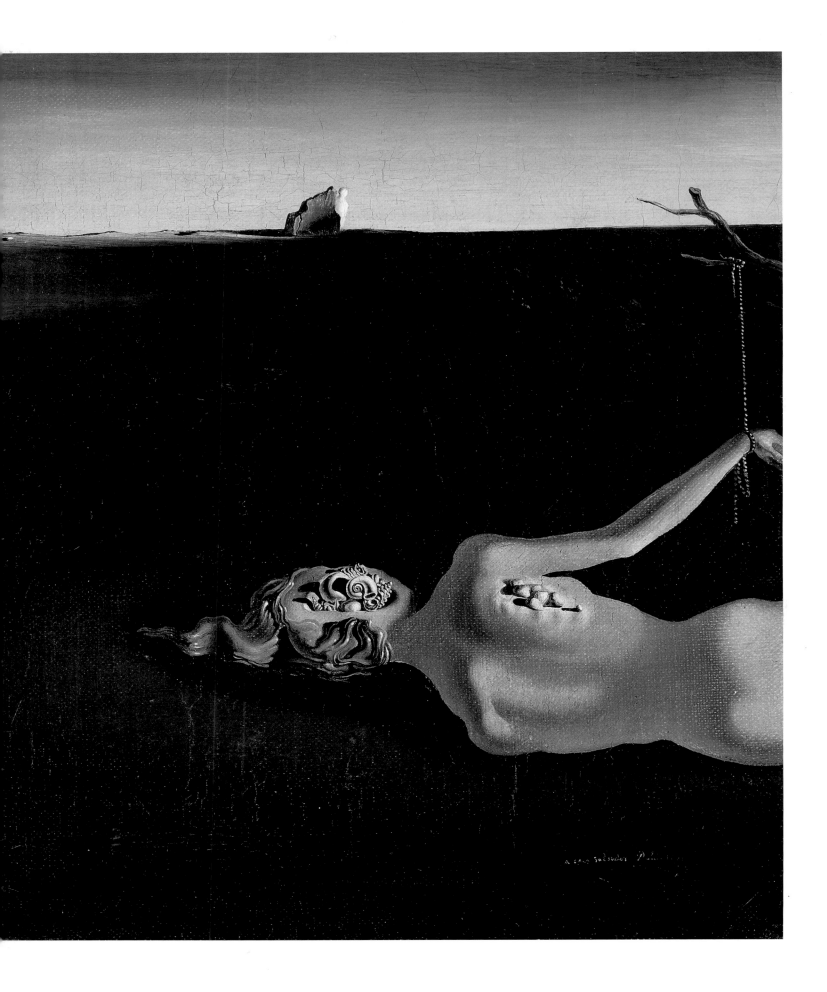